# Black and White:
# From
# Snapshots to
# Great Shots

**John Batdorff**

Peachpit
Press

Black and White: From Snapshots to Great Shots
John Batdorff

Peachpit Press
1249 Eighth Street
Berkeley, CA 94710
510/524-2178
510/524-2221 (fax)

Find us on the Web at www.peachpit.com
To report errors, please send a note to errata@peachpit.com
Peachpit Press is a division of Pearson Education

**Project Editor:** Susan Rimerman
**Development/Copy Editor:** Peggy Nauts
**Production Editor:** Lisa Brazieal
**Proofreader:** Elaine Merrill
**Interior Design:** Riezebos Holzbaur Design Group
**Compositor:** WolfsonDesign
**Indexer:** James Minkin
**Cover Design:** Aren Straiger
**Cover Image:** John Batdorff

ISBN-13   978-0-321-77457-6
ISBN-10       0-321-77457-4

9 8 7 6 5 4 3 2

Printed and bound in the United States of America

# ACKNOWLEDGMENTS

To my love, Staci—none of this would have been possible without your support, love, and encouragement. I know you're not much into PWA (public writing affection), so I'll simply say you're the best—I love you.

To Anna, my daughter, I'm not sure there's much to say that you don't already know. We simply get each other. I love seeing life through your eyes and hearing it in your laugh. Just remember what we always talk about: Be true to yourself, never lie, and work hard (but I think the $5 sitting fee you charged me was a little over the top. I'm just saying…).

Mom, thanks for giving me my first camera, lending me your vision, and encouraging me to do more with my art. I wish you were here today to share in it all.

Dad, your gift for writing and your love for the arts have been an inspiration. I appreciate the understanding and especially the trust you've bestowed on me throughout the years. You're a good friend and mentor, but you're an awfully messy travel partner.

My good friend John, thanks for providing honest feedback along the way.

The Peachpit crew: Thank you for believing in me. It's always a pleasure working with a team of professionals.

Peggy Nauts, thanks for scrubbing my copy, making me sound smarter than I am (always a tough job), and not making me feel guilty every time I said I'd have copy to you in a hour but it ended up being more like eight. You're simply the best!

Susan Rimerman, thanks for all your support and guidance. I truly appreciate your direct and honest approach.

My appreciation to Lisa Brazieal and her team for creating a wonderful layout and making my images look good.

Finally, a very special thanks to all the blog followers who have supported me along the way. This book would never have happened without you. Most important, to you, the reader of this book—I hope you enjoy it. My blog door is always open for your questions.

# Contents

# Introduction

I've been taking photographs for nearly my entire life. My passion began when my mother handed me my first Kodak Instamatic in 1977. What started out as a way to keep a young boy out of mischief blossomed into a lifelong pursuit of personal expression. I have taken tens of thousands of photos since then and have come to love black-and-white photography for its honest feel and the potential for a simple frame to become a piece of art. The medium has changed a lot over the years, and while I have clocked my share of hours in the darkroom, I've always been intrigued by new technology. Film will continue to hold a special place in my heart, but I'll never regret the day I picked up a digital camera.

The quality of today's digital cameras has granted me the freedom to create the black-and-white images I always intended without spending hours in the darkroom. It's a brave new world. Black-and-white photography is no longer reserved for those of us with darkrooms, but instead embraces anyone with a love of the monochrome world. And for those of you who have a portfolio chock-full of film images, this is a great time to convert them to digital and explore the multitude of techniques available with today's digital darkroom.

## KEEP IT SIMPLE

My number one goal for this book has been to simplify a complicated subject matter to the best of my ability. Photography can be confusing at times, but it doesn't need to be—it should make sense. While we'll be discussing nitty-gritty technical details some of the time, the true learning will come from an overall better understanding of the process of black-and-white photography. I hope you'll draw on my experience and combine it with your new knowledge to create your own style. There are many ways to create a black-and-white image: My goal isn't to overwhelm you with a laundry list of techniques but instead to provide you with a handful of tools that I've used successfully throughout the years. Simplicity leads to creativity!

## WHAT WILL WE ACCOMPLISH?

We'll start off by discussing my basic camera kit, settings, composition, and exposure. My equipment is near and dear to my heart, but this book is not meant to focus only on what I use. You can apply the techniques regardless of what digital single-lens reflex camera (dSLR) and lens kit that you have.

We'll discuss what to look for when scouting out a black-and-white image. We will cover my mental checklist of characteristics for shooting in black and white: tonal quality, contrast, strong lines, and so on. Once we have our image, we are going to go over how to manage images in Lightroom and convert them to black and white using postprocessing techniques.

Finally, we'll spend a lot of time in Adobe Lightroom and delve even further into Silver Efex Pro 2 to harness its amazing black-and-white processing capabilities. I'll outline why I use these two programs, when I decide to use one over the other, and the detailed steps taken in editing an image from start to finish. We will cover mood, selective color, texture, how digital filters are used by today's black-and-white photographer, and other aspects that help you create your unique style.

## HOW MUCH EXPERIENCE DO YOU NEED?

This book has been written with the beginning to intermediate photographer in mind. Regardless of your level, my hope is that you'll find the book to be a resource loaded with useful information, personal experiences, valuable assignments, and helpful shortcuts. Black-and-white photography can be fun and beautiful, so I encourage you to share your images on our Flickr site as you work your way through the book. This book is intended to be an open conversation, so please feel free to drop me a note to share your feedback. Learning is a two-way street; I enjoy learning from you as much as I hope you enjoy learning from me.

If you aren't enjoying the process, you won't be happy with the outcome, so let's relax and have some fun.

*Share your results with the book's Flickr group!*

*Join the group here: www.flickr.com/groups/blackandwhitefromsnapshotstogreatshots*

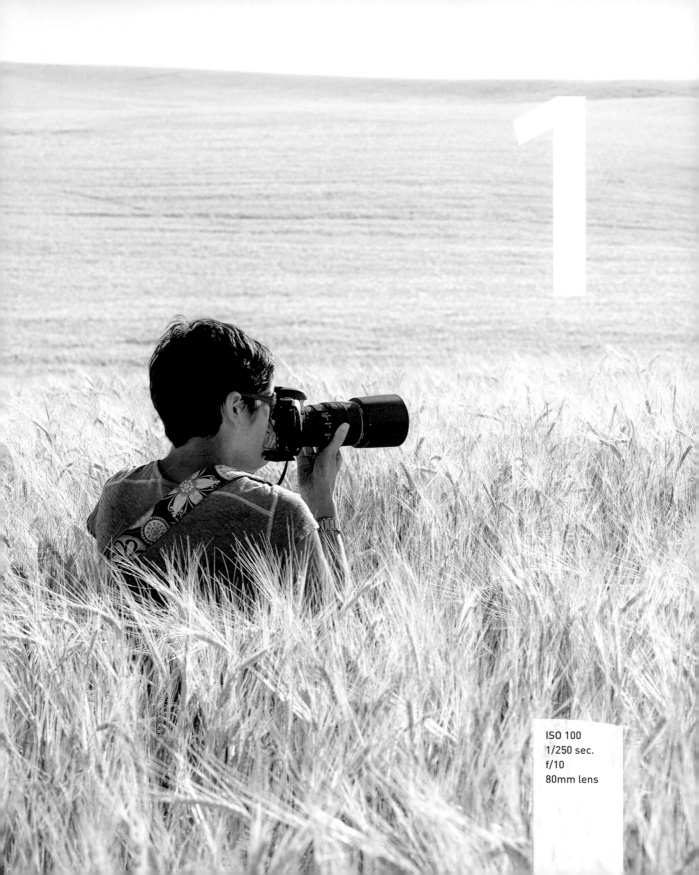

1

ISO 100
1/250 sec.
f/10
80mm lens

# Equipment and Settings

## STARTING WITH A STRONG FOUNDATION

You have probably heard that it's the photographer that takes a great photo, not the camera. I could not agree with this statement more, but with that said, most of the photographers I've come to know and admire seem to own what I like to call their "essential kit." The kit may vary by photographer or setting, but we all have our favorite tools to help us with our craft.

For me, a recovering gear addict, the trick is to avoid spending too much money on gear I don't really need. The key to building a strong foundation for my photography, while at the same time avoiding the temptation to purchase the newest, shiniest piece of gear that comes along, has been to ask myself two questions: "How is this going to improve my photography?" and "Have I really mastered my current setup?" I know it sounds simple, but trust me, if you answer these questions honestly, you will be that much closer to distinguishing a want from a need.

1

# PORING OVER THE PICTURE

I was enjoying a beautiful sunset in Africa when I noticed this interesting tree overlooking the Masai Mara National Park. The light was amazing, and the sky was filled with rich, active clouds reaching far off into the distance. I quickly set up, and what was originally intended to be a colorful shot ended up being one of my favorite black-and-whites from the trip.

This was a very long exposure, so I used a tripod, cable release, and mirror lock-up to avoid camera shake.

ISO 100
4 sec.
f/14
35mm lens

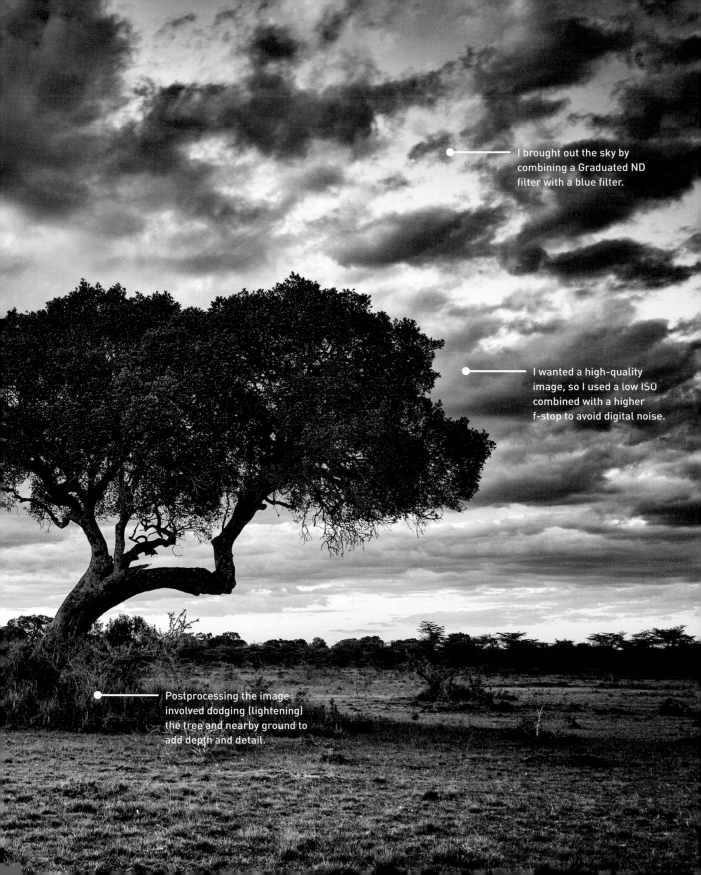

I brought out the sky by combining a Graduated ND filter with a blue filter.

I wanted a high-quality image, so I used a low ISO combined with a higher f-stop to avoid digital noise.

Postprocessing the image involved dodging (lightening) the tree and nearby ground to add depth and detail.

## PORING OVER THE EQUIPMENT

Here are some essential things you should look for when you're building your own kit.

First, I'm a firm believer in owning a camera you're going to enjoy using. To get better at photography you are going to need to take a lot of photographs, so working with a camera that feels right to you is essential. I don't care if it's Nikon, Canon, Sony, or one of the many others on the market. What does matter is whether you're going to use it.

## WHAT'S IN MY BAG

### LENS SELECTION

If there is one thing that really improves the quality of an image, it's a decent lens. Invest in a solid lens. People always think it's their camera that needs to be upgraded, but in many cases they would get better results by upgrading their glass first. I always recommend trying to build an essential kit of quality lenses (**Figure 1.1**) that will fit any future generations of camera upgrades.

FIGURE 1.1
Building your essential kit doesn't need to happen overnight. I have built my kit over many years of trial and error, with a few upgrades along the path of discovering who I am as a photographer.

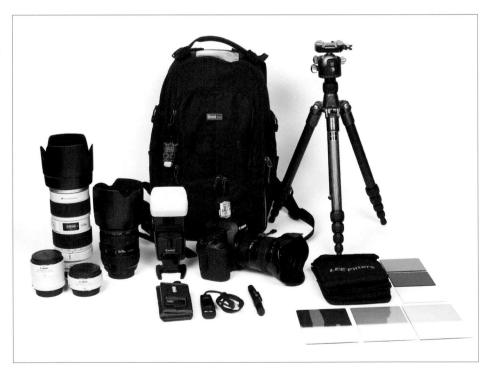

I shoot in a lot of low-light conditions, so I like fast lenses (**Figure 1.2**) that are a minimum f/2.8 aperture. Fast lenses tend be heavier due to the better quality glass and construction, and all that costs more, too. My essential kit includes a 16–35mm (f/2.8), a 24–70mm (f/2.8), and a 70–200mm (f/2.8) lens. In situations where I need a little extra reach I'll use a teleconverter (**Figure 1.3**).

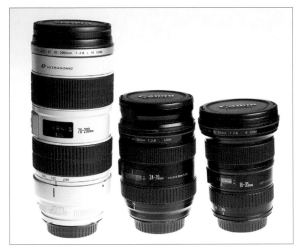

### FIGURE 1.2
The maximum aperture of your lens is what determines how fast it is. One of the benefits of a larger aperture is that it allows you to shoot in low-light conditions using faster speeds than would be possible at a smaller aperture. A fast lens is usually considered to have a maximum aperture of f/4. Your lens aperture rating is usually located on the front of the lens. The smaller the number (f/1.2, f/4, or f/5.6, for instance), the larger the aperture.

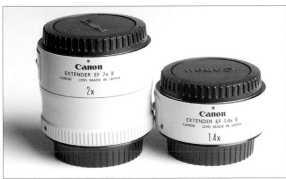

### FIGURE 1.3
Teleconverters are an inexpensive way to get a longer focal distance out of a high-quality lens while keeping your camera kit light and flexible. I use 1.4x on my 70–200mm on a regular basis with very little loss in quality. Remember that extenders don't work on all lenses, so check with your camera's manufacturer first.

## FLASH CARDS

It is very important to read your manual and buy a flash card that is rated for your camera (**Figure 1.4**). My mom always said, "You get what you pay for," and this is one situation where that is true. Here is another suggestion: Own more than one card. It is like having a second camera battery—you will use it!

### FIGURE 1.4
Notice the speed and UDMA rating. Make sure you get a card that meets the basic requirements of your camera.

## TRIPOD KIT

Photography is not an inexpensive hobby, and it can suck your wallet dry. Make sure you invest in things that make sense—get a tripod kit you are going to use. That means a model that is sturdy and rated for the weight of your camera and lens. Having a solid tripod head with a quick-release plate is must for those of us who want the flexibility of quickly removing the camera from the tripod. A good tripod will set you back, but like good luggage, it should last the rest of your life, and you'll use it. I love my carbon-fiber Gitzo GT-1550 Traveler. Carbon fiber is strong enough to hold even the heaviest of lenses but light enough to put on my backpack for long backcountry excursions.

## CABLE RELEASE OR REMOTE TRIGGER

These are incredibly helpful for reducing camera shake during long exposures. I have owned both types of release, but I prefer the cable release (**Figure 1.5**). I've been in too many places way off the beaten path and had a dead remote because of used-up batteries.

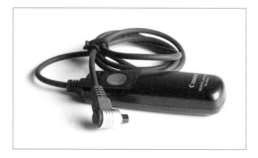

**FIGURE 1.5**
A cable release is indispensable for avoiding camera shake during long exposures.

## FILTERS

I know everyone thinks they can do all of their effects in Photoshop, but take it from me—they're wrong. A graduated neutral density (ND) filter (**Figure 1.6**) is a wonderful tool to have available when you need to correctly expose a landscape or darken a sky. I often use a yellow, green, red, or orange filter to assist in visualizing a black-and-white image while in the field. I'm a huge fan of the Lee Filters' 100mm system. We will discuss filters further in Chapter 3.

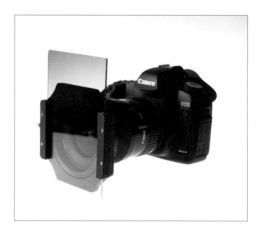

**FIGURE 1.6**
Lee has an easy-to-use design that allows me to use one filter on several lenses with a simple adapter.

## BUBBLE LEVEL

Even with a tripod, setting up on uneven ground is all too common. Nothing is worse than shooting a beautiful landscape image only to find that the horizon is sloping to one side. The best part is that bubble levels (**Figure 1.7**) are inexpensive and will save you a lot of time in postprocessing.

FIGURE 1.7
This double-axis level mounts to the hot shoe and keeps me centered in portrait or landscape orientation.

## LENS CLEANING SOLUTIONS

These are small microfiber rags for cleaning your lens (**Figure 1.8**). They are easy to use and store. Hot tip: Keep one out and handy whenever you're shooting. If it's tucked away in the camera bag, chances are you're going to grab whatever is available to wipe off your lens, which is probably your T-shirt, and that's not such a good idea. Clip your Spudz rag somewhere that you will actually use it, and you could save your lens. LensPen is another convenient cleaning solution, with a nonliquid cleaning element, designed to never dry out (**Figure 1.9**).

FIGURE 1.8
Microfiber is great for cleaning your lens, and this clips right onto your camera strap for accessibility.

FIGURE 1.9
I always have one of these tucked away in my pocket when I'm out shooting. The LensPen is great for clearing your lens of fine dust and smudges.

# POSTPROCESSING SOFTWARE

Lightroom (**Figure 1.10**), Silver Efex Pro 2 (**Figure 1.11**), and Photoshop (in that order) are as essential to my black-and-white photography kit as my camera is. I like to keep things simple, and reducing steps in my workflow allows me to focus on my creative process. This might come as a shock to you, but I rarely use Photoshop. Don't get me wrong, I think Photoshop is a wonderful and incredibly powerful program, but it can be a bit overwhelming. I typically only use it when I have to. What might take me three or four steps in Photoshop can be handled with the click of a button in Lightroom. Coupled with plug-ins like Silver Efex Pro 2, Lightroom lets me focus more on creating images and less on being a technician.

FIGURE 1.10
Adobe's incredible, powerful post-editing software works seamlessly with Macintosh and Windows operating systems.

**FIGURE 1.11**
Ninety five percent of my black-and-white photography is processed in Silver Efex Pro 2 after it's been imported into Lightroom.

# MONITOR CALIBRATION

Creating a strong foundation starts with being able to trust your equipment. Tell me if this sounds familiar: You've just spent hours editing one of your favorite images, and as it rolls off your printer or arrives from a print house, you realize it doesn't even remotely look like what you edited on the screen. Monitor calibration helps us reduce such problems by creating a baseline that we can match throughout the editing and printing process.

Calibrating your monitor is not just about matching your color, but making sure contrast is accurately displayed as well. Many excellent, easy-to-use calibration systems are available. The thing to remember is that a good system will take into consideration ambient light. Even if your monitor and printer are calibrated, if your ambient light changes significantly, you increase the likelihood of postprocessing error. I do most of my editing in a room where I can control the ambient light by using shades or a dimmer switch. Remember, calibrating your system is not a one-time deal; it needs to be done on a regular schedule. Since it only takes about five minutes, I like to calibrate my monitor every two weeks with my Datacolor Spyder system (**Figure 1.12**).

**FIGURE 1.12**
Monitor calibration
is an essential part
of my workflow.
Having a calibrated
monitor helps me
know what a print
will look like before
it gets produced.

# CAMERA SETTINGS

## ISO

The ISO is your camera sensor's sensitivity to light. Most photographers know that in order to get a great-looking image, it's best to use as low as an ISO as possible. Generally speaking, the lower the ISO the better quality of the image and the more light that is needed to expose it. I try to shoot most of my images in the 100 to 250 ISO range. But here's the thing: Today's digital camera manufacturers are making huge advances in sensor technology and really pushing the standard on what is an acceptable ISO. I've taken photographs in low-light conditions at 800–3200 ISO that I never would have considered taking years ago because the quality would have been so poor. Keeping your ISO low is one part of the equation, but use technology to your advantage and don't let a high ISO stop you from getting the shot.

## SHOOTING IN MONOCHROME

This is a good tip even for seasoned photographers: One of the best ways to learn to see your environment in black and white is to use the monochrome setting on your camera (**Figure 1.13**). This feature will generate a black-and-white preview on the LCD. As long as you are shooting in Raw mode, you do not need to worry because your color information is still being saved and will be available in postprocessing. However, JPEG shooters should note that all their color information is being discarded when they use the monochrome setting, so unless you are 100 percent committed to an image in black and white, you might consider photographing it in both color and black and white, or switching to Raw.

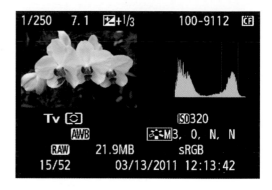

**FIGURE 1.13**
Setting your camera to shoot in monochrome is an effective way to see your environment in black and white. Please consult your manual to turn this feature on and remember to shoot in Raw mode.

## HIGHLIGHT WARNING

Setting your camera up to display highlight warnings is an excellent way to help obtain the proper exposure. Areas that are too bright and lack any detail will flash black and white on your LCD—this indicator simply flags a potential problem with your exposure. The areas that are blinking are those where you have potentially lost all detail. It's up to you to decide whether or not an exposure adjustment is needed. If you have a highlight warning in an area where you definitely need detail, you will want to adjust. However, remember that sometimes if you are shooting with a backlit sky, you will lose some detail, and that may be OK. A great book to refer to on the topic of exposure is Jeff Revell's *Exposure: From Snapshots to Great Shots* (Peachpit Press, 2010).

## WHITE BALANCE

I am a big fan of setting your white balance before shooting. Even though I shoot in Raw mode and have the ability to change my white balance during the postprocessing stage, I still find it beneficial to set the white balance according the conditions. The best part is you do not need any special training to know what setting to use. Most cameras today use simple symbols, like clouds, suns, and lightbulbs, to represent the different temperatures of light presented by various light sources. It is relatively easy to choose which white balance you need; the trick is remembering to change your selection as conditions change.

Another important thing to remember is that getting the correct white balance isn't only for color photography. If your white balance is off, it could affect the tonal range of the objects you are shooting (this is a larger issue for JPEG shooters). In turn, this can change the way the image looks when you convert to black and white. So take the time to adjust your white balance in the camera before taking the shot. It will save you a lot of time in postprocessing.

## FILE FORMAT

I have been shooting in Raw for nearly eight years now and I have never regretted it. Whenever I'm doing a workshop, the first thing I try to convince people to consider is switching to the Raw file format. For those of you who already shoot in Raw, you know the benefits of this powerful format. But for those of you who are new to it, here are some thoughts to consider.

1. **Raw has more potential** I know some people will take offense at this analogy, but think of it this way: JPEG is like a Polaroid, easy and quick to print and nice to look at, but not as high quality as a print made from a negative. Raw is just that, a digital negative.

2. **Raw contains more data** JPEGs typically record only 8 bits of information, whereas a raw file records 12 to 14 bits of color data, depending upon the camera manufacturer. This means a raw file contains more information, which means more detail, more color information, and a better dynamic range. A larger dynamic range means you can get more details in the highlights and shadows (highly important in black-and-white photography). New 14-bit raw files have even more information than their 12-bit counterparts, with literally trillions of graduated colors creating even smoother tonal transitions.

3. **Raw gives you more control** You simply have better control of important elements, like white balance, tint, and exposure, to name a few, in a raw file versus a JPEG.

Highlight recovery is another benefit of shooting in Raw, and it's important enough to merit a special note. Even with the highlight warning feature on, you still may make mistakes with exposure. A raw file has enough data to let you recover lost highlights in postprocessing, where a JPEG file may not.

A raw file requires more space and a little extra time in postprocessing, but it is worth it for the benefit of nondestructive editing. Instead of having the camera make the decisions on saturation, color, and so on for you, as it does with a JPEG file, working with a raw file requires you to process the image and make all of these decisions yourself using postprocessing software, like Lightroom, Photoshop, or Aperture.

How much time this takes depends on how familiar you are with the software, but it becomes more fluid with practice.

Using these software programs to process your images is very powerful because it allows you to make nondestructive adjustments to white balance, color grading, contrast, and saturation, as well as many other things. This means you can work the same image over and over again without ever compromising the quality of the original file.

## SHOOTING IN JPEG

Can you shoot in JPEG and convert images to black and white using Lightroom or Photoshop? Sure you can, but I don't recommend it. This book is about taking your photography to the next level, and for many people that means taking control of the editing process. In order to take more control you need the best file possible to work with, and JPEG just does not cut it for the long run. Each time you open, edit, and save a JPEG file it degrades the file, which means you are losing quality. However, you can feel much more comfortable editing a raw file multiple times without losing quality.

Here's what I recommend for those of you who are new to raw files and may be hesitant to make the leap: Enjoy the best of both worlds. Most cameras today allow you to shoot files in Raw+JPEG mode (**Figure 1.14**). This means whenever you take a photo the image is recorded to your memory card in both formats. This gives you a chance to experiment with the raw file while still having the JPEG file on hand, too. Of course the downside to this technique is that it takes up more memory card space as well as hard drive space. My guess is in time you'll love the power of Raw mode and convert to shooting in it exclusively.

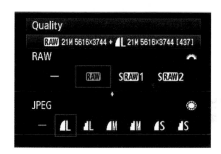

**FIGURE 1.14**
Most post popular SLRs today have a RAW+JPEG mode. Refer to your camera manual to locate the proper setting.

## METERING MODES

Most of my photographs are taken using Matrix (Nikon) or Evaluative (Canon) metering modes because they take into consideration the entire frame when metering an image. They do this by metering segments of the frame, then computing an overall exposure for the entire frame. I find this form of metering to be incredibly accurate for most of my work. For my landscape images I use this mode almost exclusively.

## CENTER WEIGHTED METERING

While I spend most of my time in Evaluative mode, I have found Center Weighted to be very useful when my subject is in the center of the frame and I have less concern about exposing correctly near the border of the frame. Portraits are an excellent example of when I would use this mode.

## SPOT METERING

Spot metering is very accurate at metering a specific point within your frame. I don't use spot metering often, but when I do it is typically when I have a subject that is backlit or when I'm concerned with exposing a particular part of a frame accurately. The area you are metering is the same area on which you are focusing.

Evaluative metering    Partial metering    Spot metering    Center Weighted metering

# SHOOTING MODES

## APERTURE PRIORITY

 This is my primary shooting mode. The reason I love Aperture Priority is that it allows me to focus on my creativity. If I want a shallow depth of field (meaning things close to me in focus and the background blurry), then I use a large aperture (f/2.8). If I want a deeper depth of field (meaning more in-focus details throughout the image), then I use a small aperture (f/8). The camera handles the rest. As you work the aperture, the camera adjusts the shutter speed accordingly.

A general rule I follow: Do not hand-hold your camera at speeds below the focal length of the lens—for example, using a 200mm lens on a full-frame camera would mean not going slower than 1/200 of a second (**Figure 1.15**). If your camera has a crop factor, like many do, keep that in mind when you are calculating your handholding speed. For example, the Canon 7D has a crop factor of x1.6, so you would want a minimum speed of 1/320 second for the same 200mm lens. Also, try to never hand-hold at lower than 1/60 of a second unless you want a blurry image.

## FIGURE 1.15

This table shows the bare-minimum suggested shutter speed to avoid camera shake while hand-holding a camera. Make sure to check your manual to correctly identify your sensor's crop ratio. All full-frame sensors will have a one-to-one ratio, as indicated in the table. Results will vary, so if your nickname is Butterfingers, then you might be better off doubling the values in this chart.

| Lens | 28mm | 35mm | 50mm | 85mm | 105mm | 135mm | 200mm | 400mm |
|---|---|---|---|---|---|---|---|---|
| Full frame | 1/30 sec. | 1/40 sec. | 1/60 sec. | 1/85 sec. | 1/125 sec. | 1/160 sec. | 1/200 sec. | 1/400 sec. |
| Crop factor 1.3 | 1/40 sec. | 1/50 sec. | 1/80 sec. | 1/115 sec. | 1/160 sec. | 1/200 sec. | 1/320 sec. | 1/640 sec. |
| Crop factor 1.5 | 1/50 sec. | 1/60 sec. | 1/80 sec. | 1/130 sec. | 1/160 sec. | 1/250 sec. | 1/320 sec. | 1/640 sec. |
| Crop factor 1.6 | 1/50 sec. | 1/60 sec. | 1/80 sec. | 1/140 sec. | 1/200 sec. | 1/250 sec. | 1/320 sec. | 1/640 sec. |
| Crop factor 2 | 1/60 sec. | 1/80 sec. | 1/100 sec. | 1/170 sec. | 1/250 sec. | 1/320 sec. | 1/400 sec. | 1/800 sec. |

## SHUTTER PRIORITY

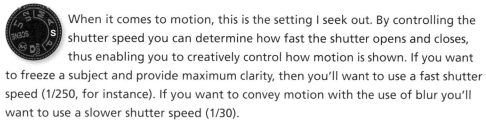 When it comes to motion, this is the setting I seek out. By controlling the shutter speed you can determine how fast the shutter opens and closes, thus enabling you to creatively control how motion is shown. If you want to freeze a subject and provide maximum clarity, then you'll want to use a fast shutter speed (1/250, for instance). If you want to convey motion with the use of blur you'll want to use a slower shutter speed (1/30).

## MANUAL MODE

 Some people call this the purist mode. I like to think of it as the control freak mode. There are moments when I want to control all aspects of my exposure. Manual mode will meter the scene and allow me to adjust both the aperture (f-stop) and speed accordingly. I use manual exposure almost exclusively in the studio and during very low-light conditions.

# WHEN TO CHOOSE BLACK AND WHITE

The question for me isn't when do I shoot in black and white, but when do I process an image as color, because I mostly look for images in black and white. There is something timeless about a good black and white, and in my mind there is less to get wrong. I shoot plenty of color images, too, but getting color right and not dating your work in the process can be difficult. For me, black and white just feels natural, and hopefully by the end of this book it will for you, too. While many images can work well in both color and black and white, without a doubt some shots are better suited to monochrome.

Good black-and-white images have strong tonal contrast. Lots of texture, strong lines, shapes, or patterns also make for interesting black-and-white images. I know what you're thinking: Don't we look for these things in color photography, too? Yes, we do, and guess what, they're even more important in black-and-white photography. In Chapter 2 we'll be discussing them further.

# UNDERSTANDING COLOR

Although it may seem counterintuitive to discuss color in a black-and-white book, the reality is that we see in color, and in order to improve your photography, you should have a minimal understanding of its principles. We need to understand the relationship color plays in creating tonal contrast. The principles of color theory date back to as early as the 14th century—even Leonardo da Vinci's notebooks cite some of the early principles of color. I could devote this entire book to the study of color and its relationship to creating black-and-white images, but I still wouldn't come close to covering it entirely. Here, then, are some quick hints about color.

## HUE, SATURATION, AND TONE

Colors have three main elements: hue, saturation, and lightness. Hue is the name of the color, such as red, yellow, or green. Saturation is the intensity of the color, while lightness is the amount of white or black mixed into the color (these may sound the same, but they are in fact different).

In the most basic terms, hue is what you are taking away from the photograph when you convert it to black and white. Saturation and lightness, or contrast, are what remain in the gray scale to create tonal contrast. Think of contrast as nothing more than light versus dark, or white versus black, and everything in between is shades of

gray. So it is those two elements that become important when working in black and white. Hue doesn't matter as much, because it has been removed. The saturation of the colors, their lightness or darkness, and their relative quantities within the frame are what will make your image pop once you convert to black and white.

## COLOR WHEEL

So how do we manipulate these elements of color? Looking at the color wheel (**Figure 1.16**), notice that we can increase contrast by increasing or decreasing satura-

tion, thus affecting the color's overall brightness when converted to black and white. The hues are represented in the slices of the pie chart, with the lighter, less saturated colors toward the center of the circle and the darker, more saturated colors to the outside of the circle. You can see that there is more tonal contrast between the colors at the outside versus the inside than there is between the different hues. Of course, some hues are lighter than others; for example, yellow will typically be lighter than blue. But a dark, saturated yellow compared with a light, unsaturated blue may provide a bit of contrast.

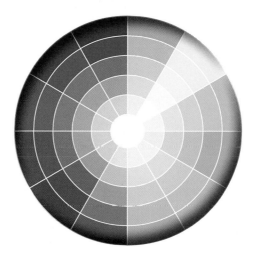

FIGURE 1.16
Notice how saturation or brightness affects the tonal contrast of colors.

Here is a real-life example. Do you ever have those moments when color is what draws you into a photograph? While wandering the streets of Cusco, Peru, I came across red and blue Volkswagen bugs parked back to back. The colors of the Volkswagens and their orientation to one another were what initially drew my eyes into the scene. But you'll notice that although the hues are different—one is red and one is blue—their saturation and lightness are almost identical (**Figure 1.17**). So once I convert the image to black and white (**Figure 1.18**) the image loses much of its power. However, if I decrease the saturation of one of the bugs (the blue one) while increasing the saturation of the red one, you can see the distinction that arises between the two cars. One is still blue and the other red, but there is a big difference in tonal contrast (**Figure 1.19**).

**FIGURE 1.17**
This is the processed color that originally drew me into the image.

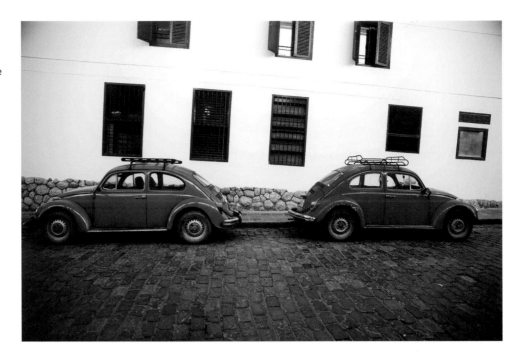

**FIGURE 1.18**
Notice how the bugs appear almost identical in shade.

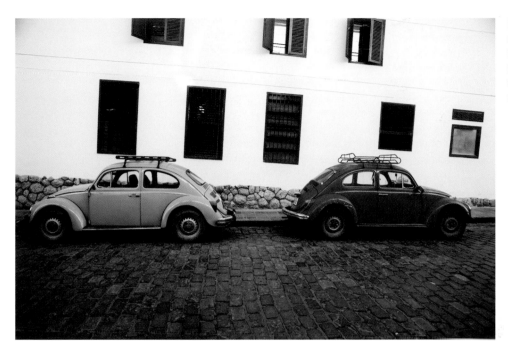

FIGURE 1.19
Simply by manipulating the saturation we're able to create tonal contrast.

This point is made even clearer when we convert the exact same color wheel to black and white (**Figure 1.20**). Notice that you cannot tell which hues are which, but you can see how the amounts of saturation and darkness provide contrast. You can also see that the warmer colors, or those with yellow, contrast well with those on the cooler side, or the hues with mostly blues.

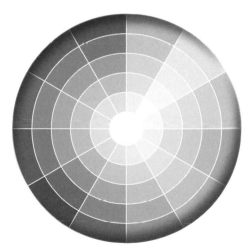

FIGURE 1.20
You want to train your eyes to look for contrast more than color. Look for light versus dark, and for saturated colors with unsaturated colors. This is also something to remember if you have a great impromptu portrait and the colors of your subjects' clothing clash. Try a black-and-white conversion, and depending on the tonal contrast, or the lightness and saturation, you may prefer the image without color.

- **Dynamic range**  The luminance range between white and black within an image.

- **Postprocessing**  The steps a photographer uses to manipulate an image into its final printed form.

- **Raw**  A camera's raw image file contains minimally processed data from the image sensor. Like a photographic negative, a raw digital image may have a wider dynamic range or color gamut than the eventual final image, and it preserves most of the information of the captured image.

# Chapter 1 Assignments

### Seeing in Black and White

Consult your camera manual and set your camera to shoot in monochrome. Now don't worry too much about processing your images and think more about practicing seeing the world in black and white. Take photos that interest you and observe the LCD and how different subjects look without color. This is a great primer for chapters ahead.

### New to Raw?

Consult your manual and set your camera to shoot in Raw+JPEG mode (most new dSLRs have this feature). Make sure you have plenty of room on your memory card because you're going to have two files (one raw and one JPEG) for each frame you shoot. Now that you're all set up, go out and have some fun shooting. When you have finished capturing some frames, import them into your favorite post-editing software, like Lightroom, Photoshop, or Aperture. Now it's time for you to take control with your raw file—play with the temperature, tint, exposure, and vibrance sliders to see how they affect the image. Remember, this is all nondestructive editing, so your file is 100 percent safe, and you still have your JPEG file that you imported to use as a reference point. You can always hit the Reset button!

*Share your results with the book's Flickr group!*

*Join the group here: www.flickr.com/groups/blackandwhitefromsnapshotstogreatshots*

ISO 320
1/200 sec.
f/2.8
65mm lens

# Composition and Light

## VISUALIZING YOUR MASTERPIECE

In this chapter we are going to discuss some key ingredients that will help us create beautiful black-and-white images. I often liken photography to baking: You can have all the best intentions to bake the perfect pie, but if you don't have the experience or a basic recipe—temperature, proportion of ingredients, and time—then everything is left to chance. In this chapter I am going to try to take luck out of the equation and give you a strong recipe for a great black-and-white photo.

I like to think every chapter has a message. The first chapter was about building an essential kit over time. This chapter is all about photographing with intent. Often the difference between a snapshot and a great shot lies within the choices you make before releasing the shutter. If you roll the dice enough times, you're apt to get a good shot now and then, but I want to increase your probability of getting great shots every time. Your goal in this chapter is to learn how composition, lighting, textures, and lines all work in harmony in creating an intentional image.

# PORING OVER THE PICTURE

Prior to any photographic journey I try to visualize what sort of images I'm hoping to achieve. This mental shot list helps me create a plan of attack when an opportunity actually presents itself. Before my trip to Africa, I had already started mentally composing images that I was hoping to accomplish. I had visualized all sorts of scenarios, including a lone lion lying in the tall grass with his mane blowing in the breeze. I know it sounds like a shampoo commercial, but it works. Visualization is an excellent mental exercise and tool for composing an image.

ISO 320
1/400 sec.
f/5.6
420mm lens

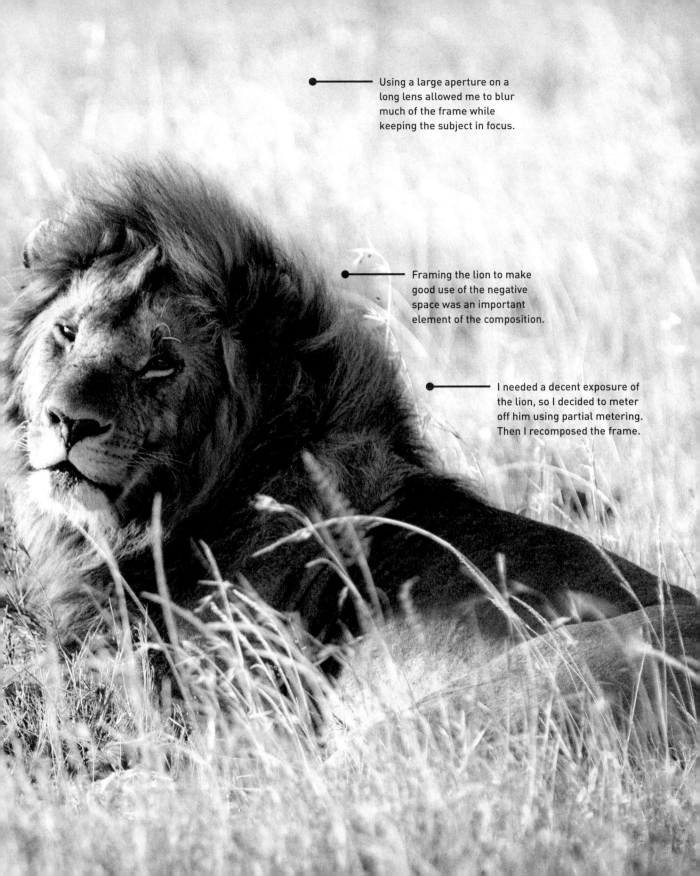

Using a large aperture on a long lens allowed me to blur much of the frame while keeping the subject in focus.

Framing the lion to make good use of the negative space was an important element of the composition.

I needed a decent exposure of the lion, so I decided to meter off him using partial metering. Then I recomposed the frame.

I had a bright sun and wanted to achieve a starburst effect, so I used a very high f-stop. On a sunny day this can usually be achieved with f/16 or higher.

Using Silver Efex Pro 2, I was able to bring out the texture in the tall grass by using a control point and increasing the structure.

ISO 200
1/100 sec.
f/22
24mm lens

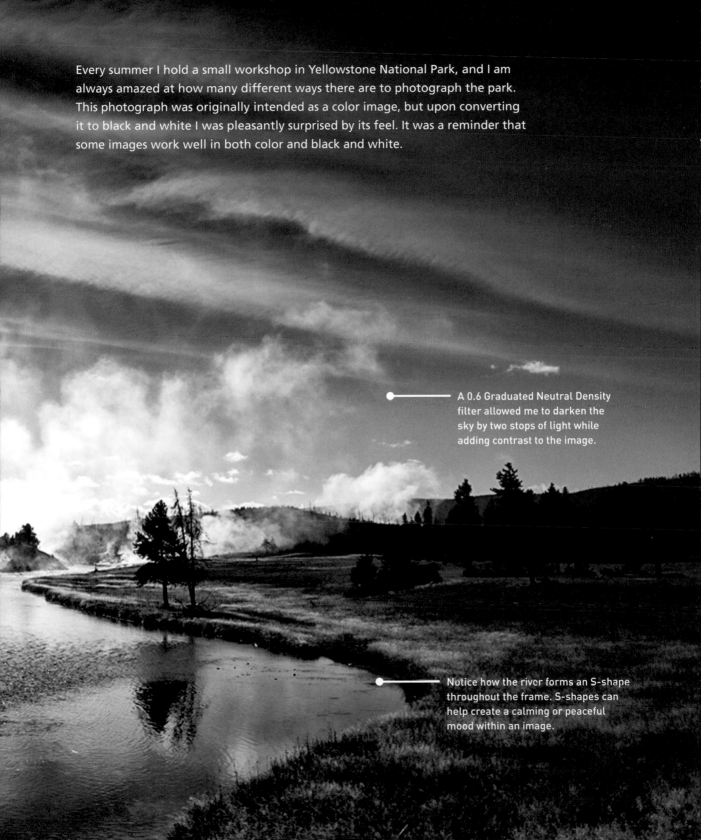

Every summer I hold a small workshop in Yellowstone National Park, and I am always amazed at how many different ways there are to photograph the park. This photograph was originally intended as a color image, but upon converting it to black and white I was pleasantly surprised by its feel. It was a reminder that some images work well in both color and black and white.

A 0.6 Graduated Neutral Density filter allowed me to darken the sky by two stops of light while adding contrast to the image.

Notice how the river forms an S-shape throughout the frame. S-shapes can help create a calming or peaceful mood within an image.

# LIGHTING

Light is probably the single most important factor in creating a black-and-white image, or any image, for that matter. Photographers are always in search of what we call the good light. I remember when I was having my portfolio reviewed by Steve McCurry and we came upon an image that I had taken in, shall we say, less than stellar light. It was harsh, horrible light, to be exact. Steve turned to me and said, "No, no. You're never here," referring to the image. "You're somewhere else, anywhere else, looking for the good light." I never forgot his advice. Even though McCurry is world renowned for his color work, his comment carries over into black-and-white photography as well. The point he was making is that there is always good light available, or at least decent light, but it's about knowing where to look for it and not settling for anything less.

Capturing good-quality light and controlling it to create a strong image requires understanding the role light plays in a black-and-white world. Light is instrumental in creating highlights and shadows (contrast), which allows us to identify forms, shapes, lines, and texture. Not all light is created equal, and different times of the day will provide different quality and duration of light. Many photographers seek out the golden hour. The golden hour, or those first or last few hours of light during the beginning and end of the day when the angle of the sun is low, provides an excellent opportunity to photograph shadows, silhouettes, and subtle textures. It's called the magical hour for good reason (**Figure 2.1**).

Afternoon sun can be harsh and many photographers try to avoid it altogether, especially for portraits, but this is an excellent opportunity to look for shadows being cast by vertical structures. Often, these shadows take on a life of their own and can be very well defined. Keep in mind, when you go shadow hunting you don't need to stick to the outdoors 100 percent of the time. Look for shadows from inside structures where the bright sunlight is creating lines and forms from the architecture that surrounds you.

I was in Paris visiting the Louvre when I noticed a building with a long corridor that was flooded with light. Once I stepped back into the shadows of the hallway I fell in love with the repeating patterns and the way the shadows filled the chamber around me (**Figure 2.2**). The pillars create a nice line for our eyes to follow and add depth to the image. The arches provide a feeling of elegance and strength.

ISO 400
1/40 sec.
f/3.5
35mm lens

FIGURE 2.1
The golden hour:
A late-afternoon
thunderstorm had
passed through and
the sun was setting
in the distance.

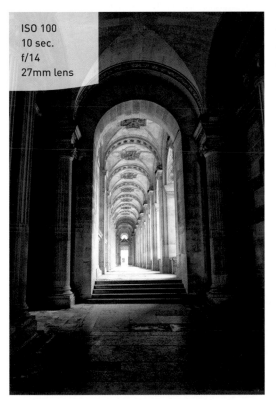

ISO 100
10 sec.
f/14
27mm lens

FIGURE 2.2
This image was taken from inside the
walkway to the Louvre in Paris. When
shooting architecture, I like to look for
strong lines and shapes that are comple-
mented by shadows that pull our eyes
through a frame.

## HIGH KEY

High-key images are created using very little contrast and are primarily white in appearance. This style of black and white works well when trying to convey soft, happy, or content moods. Technically it requires the photographer to slightly overexpose the image while maintaining just enough contrast, or dark areas, to allow for shape and form. While I don't shoot a lot of high-key photography, I do find myself dabbling from time to time in the studio, where it's easier to control the light and exposure. An easy way to identify such images is via the histogram. A high-key image will have a histogram that stacks up to the right.

This image was taken in the studio using two lights with a white background (**Figure 2.3**). The intention of the image was to focus on the subject's eyes.

FIGURE 2.3
Controlling the exposure was critical, and I allowed just enough contrast to bring attention to the eyes and form.

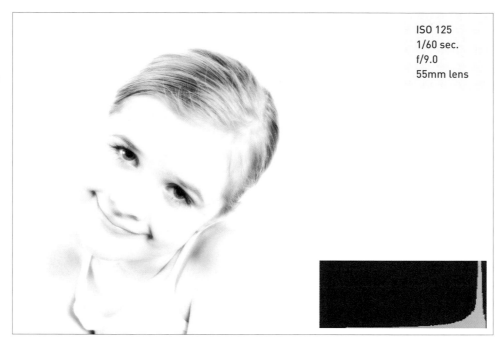

ISO 125
1/60 sec.
f/9.0
55mm lens

## LOW KEY

Low-key images are primarily black and generally employ high contrast within the image (**Figure 2.4**). Such an image is great for creating dramatic moods or a feeling of suspense. A photographer needs to pay special attention to the use of shadows when creating a low-key image. You'll notice that a low-key image will have a histogram that stacks up to the left.

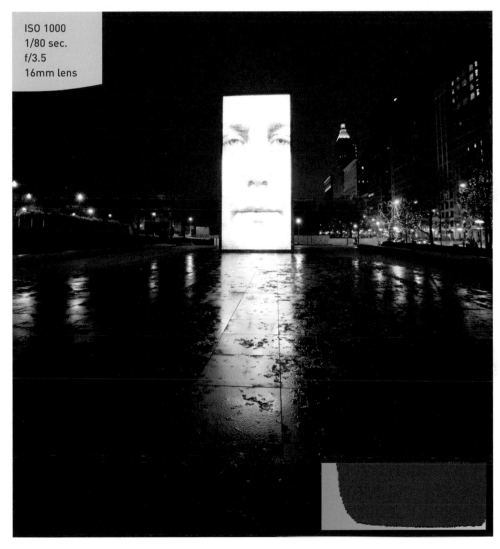

ISO 1000
1/80 sec.
f/3.5
16mm lens

FIGURE 2.4
I shot this image on a very quiet evening in Chicago as I was wandering the streets alone with my camera in tow. I wanted to convey what I was feeling at the time and that eerie feeling that someone was watching me.

## HISTOGRAMS 101

We'll discuss histograms in much more detail in the chapter on exposure, but you'll need some background information on them to get through the next section, on contrast. The short version is that a histogram is a two-dimensional representation of your image in graph form (**Figure 2.5**). The graph represents the entire tonal range that your camera can capture, from the whitest whites to the blackest blacks. The left side represents black, and all the way to the right side represents white, with all of the midtones, or gray, in between.

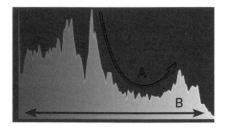

FIGURE 2.5

This is a typical histogram. The U-shape (line A) represents contrast within the image. Line B represents the tonal range of an image.

Consult your manual to determine how you can set up your camera to show you the histogram in your display. Also, when you're processing images, get in the habit of paying attention to the histogram because it holds vital information about your image—we'll learn more about that in the next section.

# IT'S ALL ABOUT CONTRAST

There are a lot of things to consider when creating a black-and-white image, but contrast is near the top of the list, following light. Broadly defined, contrast is the difference in brightness between the lightest and darkest areas of an image. It is what allows our eyes to see shapes and forms, and that is why contrast is such a critical aspect of black-and-white photography.

If used correctly, contrast also helps create mood within your images. A high-contrast image conveys power and boldness (**Figure 2.6**), while a low-contrast one might evoke a gentler, softer reaction (**Figure 2.7**). When I'm creating an image I think about contrast as much as I do about lens choice and composition. I ask myself, "What is the intention of this shot? How can I use the contrast within this image to express what I'm seeing?" Without contrast, black-and-white photography would be a pretty boring place.

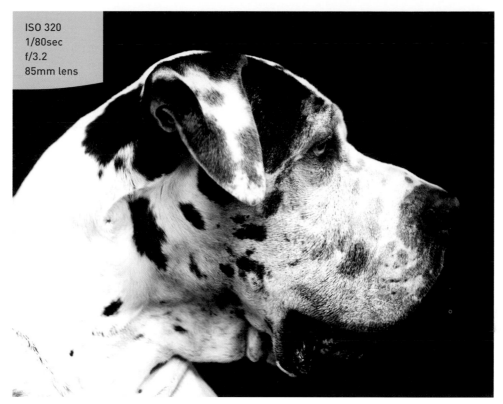

ISO 320
1/80sec
f/3.2
85mm lens

**FIGURE 2.6**
Rodrigo was a very large Great Dane I met in Mexico. I decided to create a high-contrast image of him to play up his size and distinguishing black-and-white markings.

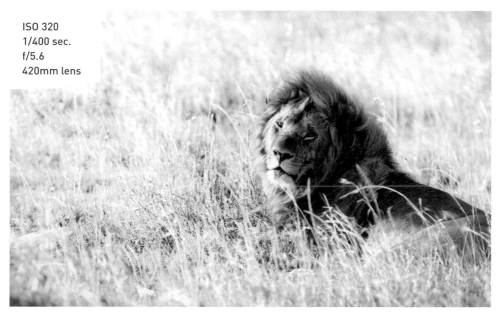

ISO 320
1/400 sec.
f/5.6
420mm lens

**FIGURE 2.7**
This image of the lion could be considered a high-key image. There is very little contrast in it, creating a softer feel.

There are two similar but fundamentally different aspects to consider when looking at contrast: tonal range and tonal contrast. Tonal range refers to how wide or narrow the range is between the lightest area of the scene and the darkest area of the scene. While some of this depends on your camera's ability to record highlights and shadows, you still maintain a lot of control over tonal range. An image with the whitest whites and the darkest darks, with a full range of gray in between, would be considered to have a high tonal range.

Now, it's possible to have a low-contrast image with a high tonal value. Let's look at my image of the haystacks; this image has a very wide range of tonal values from its darkest point to its lightest point (**Figure 2.8**). As you can see the histogram is also very wide, stretching to each side of the graph. Yet we would not consider this a high-contrast image.

## FIGURE 2.8
This image has a very large tonal range and strong midtones, indicated by the middle section of the histogram. There's no real defined U-shape to the histogram (a U-shape is the hallmark of good contrast).

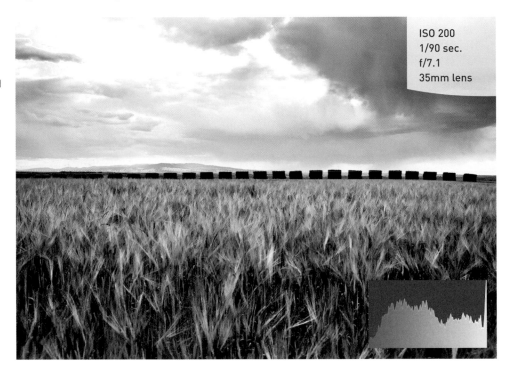

ISO 200
1/90 sec.
f/7.1
35mm lens

An image with a narrow tonal range (**Figure 2.9**) would have only midtones and would lack bright highlights and dark shadows. Narrow tonal contrast images have a narrow histogram and look like a single peak in the middle of the graph. These images tend to be flat in appearance.

We can break an image down into three categories of tonal contrast: high, normal, and low. A high-tonal-contrast image would consist primarily of white and black with very little gray (**Figure 2.10**). The histogram would look like a large U-shape.

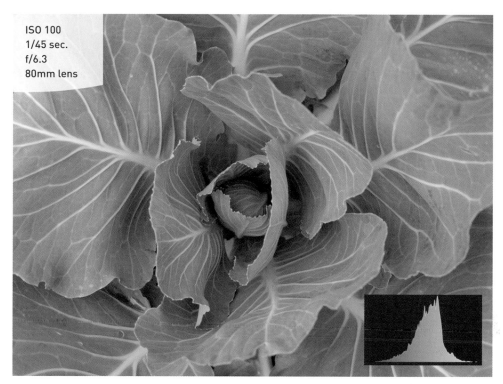

ISO 100
1/45 sec.
f/6.3
80mm lens

**FIGURE 2.9**
Notice how flat this image of the decorative kale appears. Take note of the high peak in the histogram that represents an image dominated by midtones.

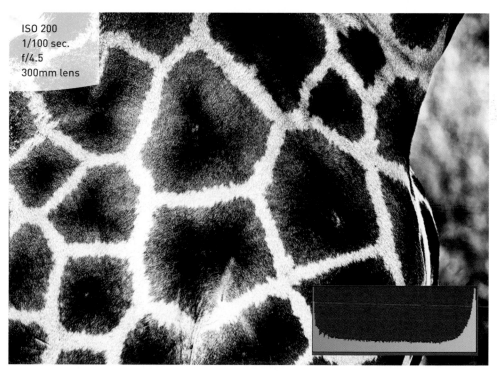

ISO 200
1/100 sec.
f/4.5
300mm lens

**FIGURE 2.10**
Notice how shallow midtones and spikes on the left (dark) and right (light) area of the histogram create a classic U-shape.

A normal tonal contrast image consists of a balance of all three (**Figure 2.11**). Its histogram would look like a mountain range. A low tonal contrast image can appear very flat since there's little distinction between colors or tones within the image (**Figure 2.12**). This histogram would look like a sharp, high mountain, much like the histogram showing narrow tonal range.

**FIGURE 2.11**
This image has a good tonal range as well as tonal contrast, as indicated by the U-shape within the histogram.

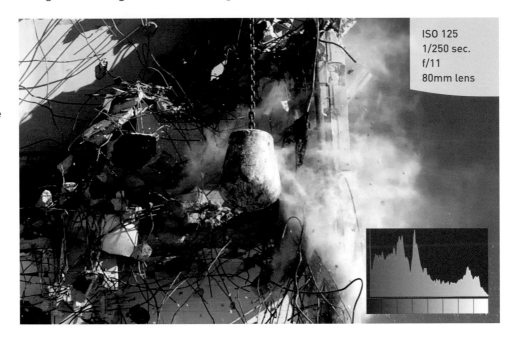

ISO 125
1/250 sec.
f/11
80mm lens

**FIGURE 2.12**
After the contrast is reduced to zero in Lightroom, notice how the midtones spike in the middle of the histogram.

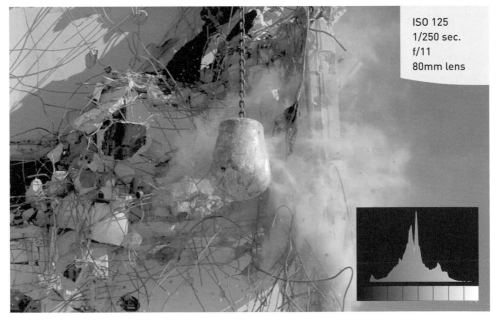

ISO 125
1/250 sec.
f/11
80mm lens

In case I've totally confused you, try thinking of it this way. Have you ever noticed how your histogram looks like a mountain? Well, it is a mountain of data. We have two mountain ranges on each side of the histogram, the dark mountain on the left and the light mountain on the right. The distance we travel between these two mountain ranges is the tonal range (left to right). The altitude of each mountain determines the tonal contrast.

How do tonal range and tonal contrast affect an image? An image with high tonal contrast must have a high tonal range. Its histogram must reach to the far edges of the graph and have dark areas and light areas to draw our attention and create depth and contrast. However, a high-tonal-range image may not have as much contrast as a high-tonal-contrast image because it may be full of midtones. In order to have contrast in your image, you want to have a high tonal range as well as high tonal contrast. This means you should look for a histogram that reaches near the far edges of the graph and hopefully has some sort of U-shape in it.

## AVOID THE NO-CONTRAST TRAP

Some people (me included) can struggle at times with seeing contrast within a color image, so I want to revisit Chapter 1, where we discussed using the monochrome setting on your camera. Shooting in Raw and using the monochrome setting is one of the best ways to visualize contrast within a black-and-white image and can help avoid what I call the no-contrast trap. Also, check out your histogram as you go to see your tonal range and to make sure that it is wide enough to ensure good contrast.

In color photography, our eyes use variances in color as a way to distinguish shapes and forms within an image. If we desaturate an image by converting to black and white, then variances in gray or tone are how our eyes identify shapes and forms within an image. Why is this important? Images with very low tonal variances don't always work well when shapes and forms are major composition factors.

Let's take the example of this giraffe eating in the leaves of a tree. This image works in color because we are able to easily identify the outline of the golden brown giraffe against the green leaves (**Figure 2.13**). However, as a black and white (**Figure 2.14**) it is too difficult to identify the giraffe's outline among the similar tones. Since I was shooting in monochrome I quickly identified the problem and refocused my lens on the skin of the giraffe, which made for more compelling, higher contrast black and white (**Figure 2.15**).

**FIGURE 2.13**
The reddish-orange neck of the giraffe is easily identifiable in color.

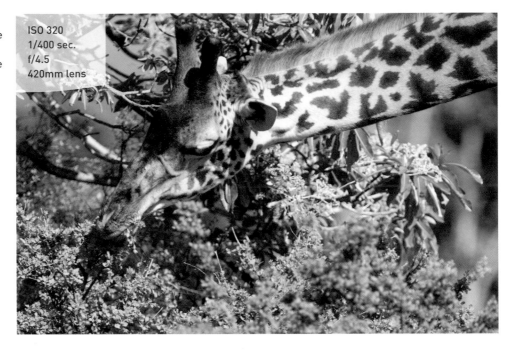

ISO 320
1/400 sec.
f/4.5
420mm lens

**FIGURE 2.14**
The giraffe's form is much harder to see in black and white due to the poor contrast between the giraffe and its background.

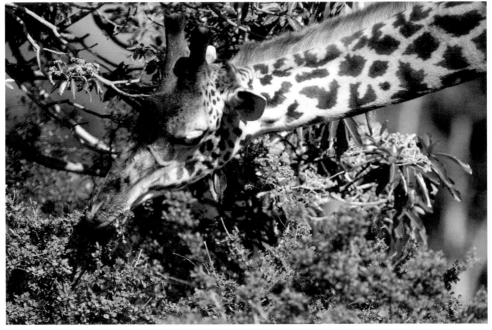

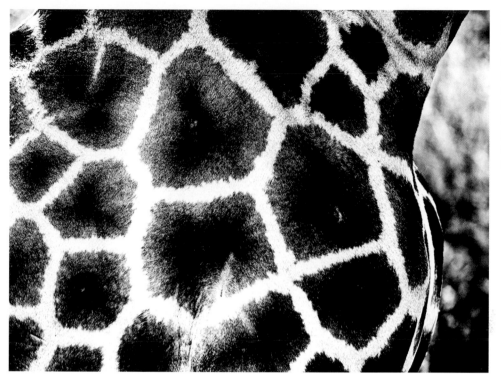

**FIGURE 2.15**
By using my mono-
chrome setting I
was quickly able
to identify the poor
contrast and save
the shot by focus-
ing in on a different
part of the giraffe,
where the contrast
was greater.

## COMPOSITION

There are many rules to composition, so many, in fact, that entire books have been
written on the subject. However, when it comes to black-and-white photography,
I like to keep things simple and keep one rule in mind at all times: Less is more.

In the coming pages we're going to explore the building blocks of creating a great
black-and-white image, and as we progress I want those words to be our mantra:
Less is more. The beauty of a black-and-white image is its ability to isolate shapes,
lines, textures, and patterns while removing distracting or competing color elements.
My goal as a photographer is to identify one or two elements in a scene and compose
a frame that encapsulates my vision. Many great books have been written on compo-
sition alone. Consider reading *Composition: From Snapshots to Great Shots* (Peachpit
Press, 2010) for an in-depth exploration of composition.

There are six basic components to a great black-and-white image. Contrast and light-
ing, which we've already discussed, patterns, shapes and forms, leading lines, and
texture. Now let's focus on the remaining four components.

## PATTERNS

We see patterns every day in color, but nothing makes a pattern more obvious than a black-and-white image. Keep your eyes open for repeating patterns that are interesting and create a sense of symmetry and rhythm (**Figure 2.16**).

FIGURE 2.16
Keep your eyes peeled—we are surrounded by patterns. These wine barrels were lined up in a way that caught my eye at a South African winery.

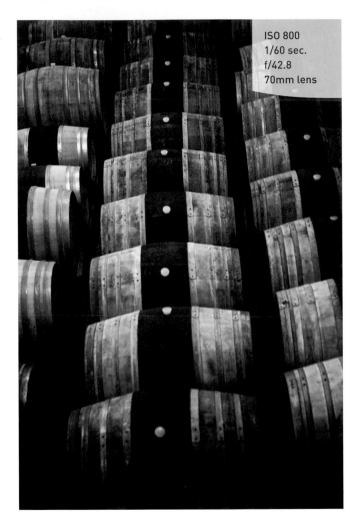

ISO 800
1/60 sec.
f/42.8
70mm lens

## SHAPES AND FORMS

Be on the lookout for arresting or thought-provoking images that have well-defined shapes and forms. Strong shadows often lend a hand in creating such images, and using a silhouette is a great way to emphasize shape and form (**Figure 2.17**). The key to getting a silhouette right is having a recognizable image placed in front of a bright light source. Try to either place your subject in front of a very bright window or seek out locations where your subject will be backlit. Just remember to keep your flash turned off and use matrix metering. A good time to practice this technique is during sunset and sunrise by placing your subject in front of the light source, which is the setting or rising sun.

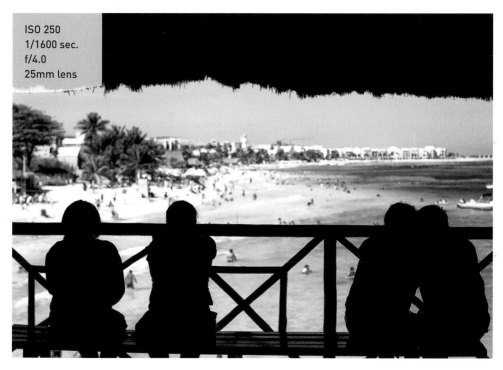

ISO 250
1/1600 sec.
f/4.0
25mm lens

**FIGURE 2.17**
What drew me into this scene was the polarizing imagery of the couples sharing the bench overlooking the ocean. One couple was embracing while the other sat apart with their arms crossed.

## LINES

A well-crafted black-and-white image will make good use of lines by drawing the viewer into the image and directing the eyes throughout. I like to think of lines as road maps for our viewers, and the best part is that we as photographers get to direct traffic throughout the frame.

Lines are a powerful way for photographers to establish the mood of an image. Vertical lines feel bold and rigid, while S-curve lines usually give a sense of relaxing or going with the flow. When you are visualizing your image and preparing your composition, try to strike a balance between your intentions and composition.

Lines are like contrast; they're a wonderful instrument in creating mood, but if you fail to use them correctly they can ruin a well-intended image. For instance, make sure your lines are directing "traffic" to and not away from the intended subject of the frame.

There are six basic lines we use in photography: leading, vertical, horizontal, diagonal, curved, and converging. I know it sounds like a lot, but once you train your eyes you'll start noticing lines all around you.

A leading line is basically any line that draws you to a particular point of interest within the frame. I was out shooting on a bitter winter night in Chicago when I came across this bike locked to a rack (**Figure 2.18**). I found the image to be slightly ironic, given that it was February, so I decided to take a photograph. I used the rack to create a leading diagonal line to the bike, enabling me to draw attention to the icy snow and lead the viewer's eyes down to the bike. It makes for a more compelling point of view than simply shooting the bike head on. Often, diagonal and curved lines will serve as great leading lines throughout an image.

Vertical and horizontal lines are usually easy to recognize in an image. Vertical lines can help manipulate an image by implying height and greatness. Often I'll seek out vertical lines when shooting people standing, architecture, or landscape images with mountains (**Figure 2.19**). Horizontal lines help convey a sense of structure and calmness. A good example is the horizon in a sunset or sunrise on your favorite beach or field of wheat.

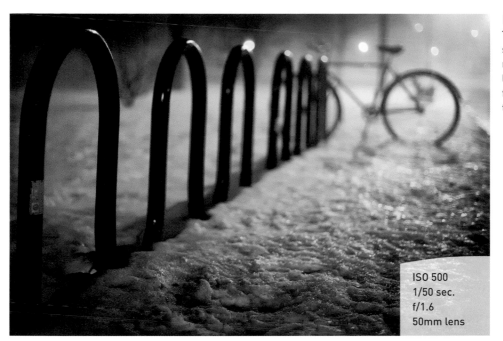

FIGURE 2.18
The bike rack
serves as a diago-
nal and leading
line—your eyes
follow the rack to
the bike at the end.

ISO 500
1/50 sec.
f/1.6
50mm lens

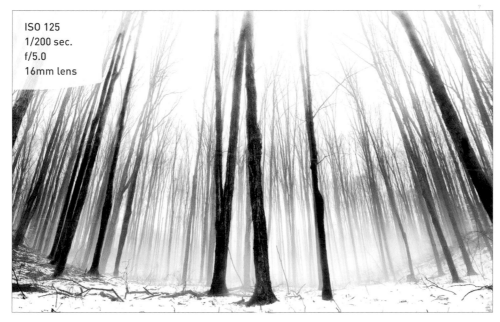

ISO 125
1/200 sec.
f/5.0
16mm lens

FIGURE 2.19
I shot this image
on a foggy morn-
ing in Michigan.
I was down flat on
my stomach and
photographed it
with my wide-angle
16-35mm lens to
help create a great
sense of height.

Some of the more difficult types of lines to train yourself to see are S-curve or curved lines, but for me they are the most rewarding. I have a natural bias toward images with gentle S-curve lines that pull the eyes through the frame. I guess it's a result of growing up in a small town in Michigan where the river literally flowed from one end of town to the other, and of spending endless evenings fishing it with my sisters. An S-curve line should be balanced and create a mood of tranquility and refinement (**Figure 2.20**).

**FIGURE 2.20**
This image has a soothing S-curve that leads your eyes through the frame.

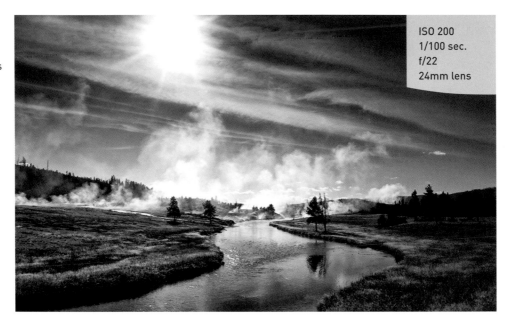

ISO 200
1/100 sec.
f/22
24mm lens

Converging lines are lines that merge together, giving a sense of dimension to an image (**Figure 2.21**). A classic example is a vanishing-point image, such as railroad tracks leading off into the distance. I like to use a wide-angle lens when photographing converging lines, and I always try to keep the rule of thirds in mind when framing the image (more on the rule of thirds later in this chapter). Remember to take your time and shoot from several points of view when composing your frame. I find that the biggest mistake a lot of beginning photographers make is taking one shot and thinking they've nailed it. It's not like we're wasting film here, so take your time and experiment—it's one big advantage to shooting digital.

ISO 1250
1/13 sec.
f/2.8
16mm lens

FIGURE 2.21
I took this shot while wandering the streets of London. The white strip near the curb and the angle pulled me in. The converging lines provide a classic vanishing point in the center of the frame.

## TEXTURE

What on earth is texture? It is one of those words that gets thrown around a lot, and the definition can feel vague at best. The easiest way to think of texture is as a physical sensation. If I can imagine running my hands over aged, rough, splintered wood, then that's texture. If I'm looking at "The Bean" in Chicago (a sculpture that resembles, naturally, a giant bean) and want to run my hands over its shiny smooth surface, then that's texture.

Textures can run the gamut from smooth to rough, but the angle of your light always plays a huge role in determining the feel of an image. It adds another dimension, making a black and white come to life and giving it an almost three-dimensional feeling. Texture is a great way to establish the mood of an image and to focus on the features that attracted you to your subject in the first place.

I spent a few days in Cusco, Peru, while I acclimated for my hike along the Inca Trail to Machu Picchu. Cusco was a wonderful city, alive with color and amazing people. I came across a woman in a village market dressed in the very colorful traditional Peruvian clothing (**Figure 2.22**). What caught my attention was not her clothing, however, it was her face. The lines on her face seemed to tell a story all by themselves, so I decided to convert the image to black and white and focus on the texture

of her face. By desaturating the image we're able to eliminate distracting color elements, such as the clothing, and focus on what made me photograph her in the first place—her face (**Figure 2.23**).

**FIGURE 2.22**
The colors of her traditional dress were interesting, but I could have photographed countless Peruvian women if that was the story I was looking for.

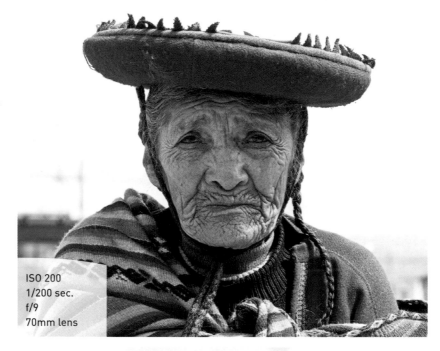

ISO 200
1/200 sec.
f/9
70mm lens

**FIGURE 2.23**
Once I strip away the color and make sure there is a nice amount of contrast in the image, you are really drawn in to her amazing face.

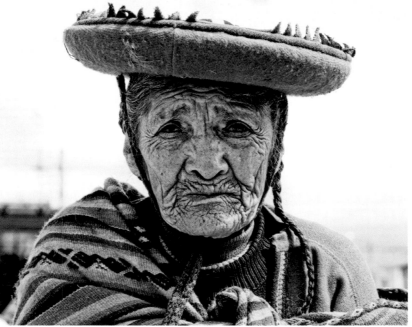

# MOTION

There's something poetic and timeless about capturing motion with a black-and-white image. What I love about motion is it's the one constant that I feel I have total control over as a photographer. My decision to freeze motion or show motion depends upon my creative goal and the authenticity I'm trying to achieve.

Freezing motion is all about shutter speed, and the easiest way to do it is to set your camera to Shutter Priority and select a speed that's fast enough to stop motion. Most of the time when I want to freeze motion I use a shutter speed of 1/250 or faster. Typically I freeze motion out of pure curiosity or when I want to highlight a specific event within an image. I was watching the Chicago Marathon a few years back and one of the first groups to come racing by was the wheelchair division. I was amazed and inspired by the athletes' strength and conviction, so I decided to freeze motion for further reflection (**Figure 2.24**).

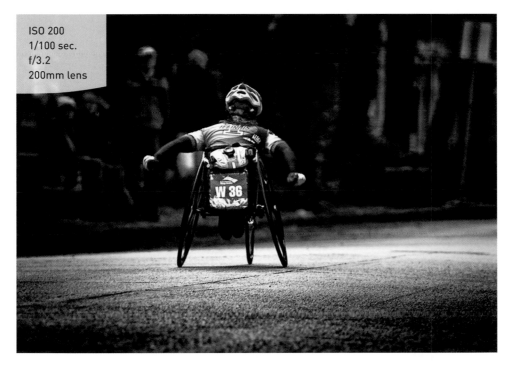

ISO 200
1/100 sec.
f/3.2
200mm lens

**FIGURE 2.24**
I was able to freeze motion at 1/100 second as the subject was moving away from me.

Keep in mind, when a subject is moving toward or away from you it typically doesn't require as fast a shutter speed as a subject passing directly across your field of vision. To visualize this example, think of a car that is traveling toward you or away from you versus a car that is passing from left to right directly in front of you.

Another time I like to freeze motion is when I'm trying to convey an action-versus-reaction story. Whether it be a wrecking ball hitting an old building or a cowboy being thrown from a horse, freezing motion works well when explaining these sort of push/pull themes.

Motion blur is an excellent way to communicate that an image has motion while maintaining an authentic feel. The evening is one of my favorite times of the day to convey motion and a great time to take advantage of available lights with subjects such as automobiles and buses. I usually scout out a busy corner that has plenty of road traffic with a stationary, yet identifiable object in the background (**Figure 2.25**). This setup allows me to blur the motion of the passing vehicles while maintaining a sense of location. To get this shot I set my tripod up with a cable release and experimented with exposures until I got the right mix of speed and aperture.

**FIGURE 2.25**
We have three elements working very nicely here: (a) an identifiable, static landmark, (b) the blurred motion of the bus, and (c) people crossing the road.

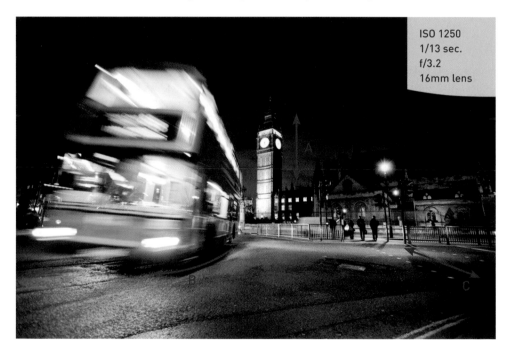

ISO 1250
1/13 sec.
f/3.2
16mm lens

# FRAMING

Now that we've identified all the critical building blocks of a great black-and-white image, it's time to think about how we're going to compose our masterpiece. Being a self-taught photographer, I know the struggle of learning the rules of composition. There are so many rules that at times it can feel like paralysis of analysis, but I'm here to tell you, that all changes over time. The more time you spend shooting and

practicing, the quicker you'll learn what works and what does not. Now, I know this book might be the first one some of you have read that discusses composition, so I'm going to spend some time on a few of the basics. For those of you with plenty of experience, it's always nice to revisit some of the rules.

## FRAMES WITHIN FRAMES

The outer edge of your photograph acts as a frame to hold all the visual elements of the photograph. One way to add emphasis to your subject is through the use of internal frames. Depending on how the frame is used, it can create the illusion of a third dimension, giving a feeling of depth. Look to frame your subject using windows, doors, arches, tree branches, mountains, and so on. Exposure can be critical when framing from shadow areas, so if your subject is in the light while you're composing your frame from a dark area, make sure to take a meter reading off your subject (**Figure 2.26**). This will create the silhouette effect discussed earlier.

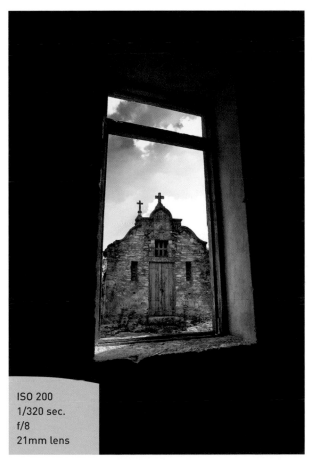

ISO 200
1/320 sec.
f/8
21mm lens

FIGURE 2.26
I photographed this image from an adjacent church on Cat Island in Bahamas. I was able to silhouette the frame by making sure my flash was off and taking a meter reading from the church outside.

## RULE OF THIRDS

There are quite a few philosophies concerning composition, the easiest being the rule of thirds. Using this principle, you simply divide your viewfinder into thirds by imagining two horizontal and two vertical lines that divide the frame equally. The key to using this method of composition is to have your main subject located at or near one of the intersecting points.

FIGURE 2.27
I composed this image of dead trees at Yellowstone National Park with the nearest tree in the bottom right corner. It created a more compelling composition than centering the tree.

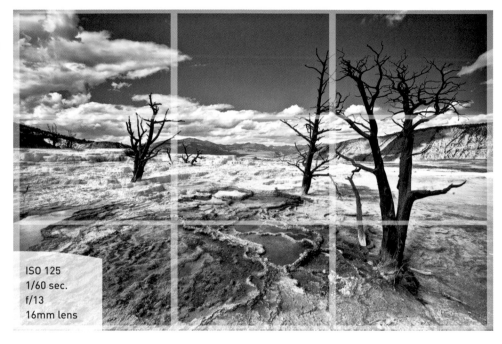

ISO 125
1/60 sec.
f/13
16mm lens

By placing your subject near the intersecting lines, you are giving the viewer space to move within the frame (**Figure 2.27**). You seldom want to put your subject smack-dab in the middle of the frame, sometimes referred to as the bull's-eye composition. Centering the subject is not always wrong, but it will usually be less appealing and may not hold the viewer's attention.

Speaking of the middle of the frame, another part of the rule of thirds deals with horizontal lines. Generally speaking, you should position the horizon one-third of the way up or down in the frame. Splitting the frame in half by placing the horizon in the middle of the picture is akin to placing the subject in the middle of the frame; it doesn't lend a sense of importance to either the sky or the ground.

# BREAKING THE RULES

Much of what I know has come from years of experience. In my photographic journey I've stumbled along the learning curve, picking up pieces of knowledge here and there in an effort to become better at my craft. Getting where I am today, where I can mentor others with their photography, has required tons of practice and, most of all, dedication. I've learned many rules along the way for getting a great shot, but if there is one thing I've concluded it's this: Break the rules!

In many ways rules are wonderful. They provide comforting order, protect us from the unknown, and help us grasp the basics of any discipline. Much of this book is dedicated to rules and you need to embrace them and learn from them before you can successfully ignore them. But remember to break them from time to time, too.

Photography is about having fun and growing. If you're always preoccupied by rules then you'll fail to see the bigger picture—which is learning to experiment and create a style all your own. That's right: experimentation! Take a few risks. Dare I say it—try splitting a horizon or two (**Figure 2.28**). You'll never get better at this if you're not willing to make mistakes. I've failed miserably many times, but for every hundred mistakes I get one killer image, and it doesn't always play by the rules! So take a few risks (**Figure 2.29**). Start by focusing on one rule or suggestion at a time and have a little fun.

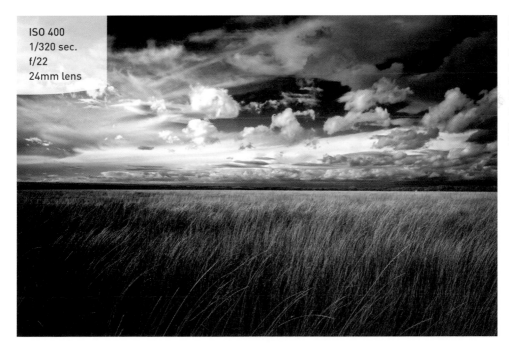

ISO 400
1/320 sec.
f/22
24mm lens

## FIGURE 2.28
I've been known to occasionally split an image in half at the horizon line. Don't let the rules of photography stop you from following your own vision.

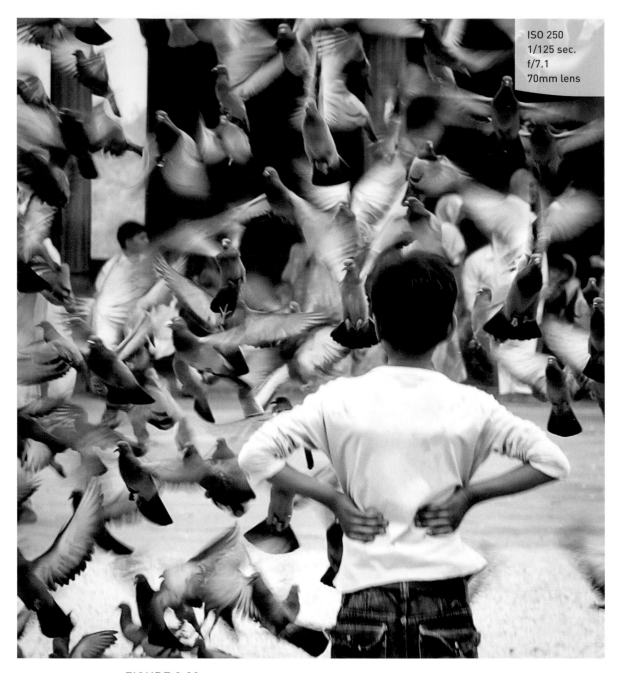

ISO 250
1/125 sec.
f/7.1
70mm lens

FIGURE 2.29
While I was visiting a temple in India I noticed a large group of pigeons eating birdseed off the ground.
A young boy slowly crept up. Having once been a young boy I knew what was to come next. He rushed
up on the birds until the ground exploded in front of him. I had my camera at eye level the entire time,
but I'll admit it took some willpower not to join him.

# Chapter 2 Assignments

### Practice Reading Your Histogram

We learned a lot about contrast in this chapter, so let's see if we can identify what a high-contrast and a low-contrast subject look like on our camera's histogram.

### Searching for the Good Light

Scout for a location that's interesting to photograph and easy to access at different times of the day. Possibilities include local parks, zoos, city centers, or nearby landscapes. Now experiment with photographing this area at different times of the day. No, you don't have to do it all in one day. Pace yourself and get a feel for how the light changes throughout the day. Learning to identify the "good light" is every bit as important to a photographer as his or her ability to compose an image.

### Practice the Rule of Thirds

If you really want to improve your framing, this is the rule to know. Practice it by moving your subject around the frame. Try to imagine a grid of two horizontal and two vertical lines spaced evenly. Now, try placing your subject at or near those intersecting points. To help matters,
some cameras ship with a grid that looks surprisingly like, you guessed it, the rule of thirds. Check your camera manual for a grid display and activate it if it's not currently on.

### Find a Pattern

We are constantly surrounded by patterns. Keep your eyes peeled inside buildings and out. Some examples are merchandise displayed in a row, bicycles lined up, mailboxes, and architecture. Take a walk around your neighborhood or through your favorite store and look for a repeating pattern within a few blocks of where you live or work. I bet you'll find more than you realized. Also, if you want to get some ideas, search a photo website such as Flickr for repetitive patterns to get inspired for new patterns and perspectives.

*Share your results with the book's Flickr group!*

*Join the group here: www.flickr.com/groups/blackandwhitefromsnapshotstogreatshots*

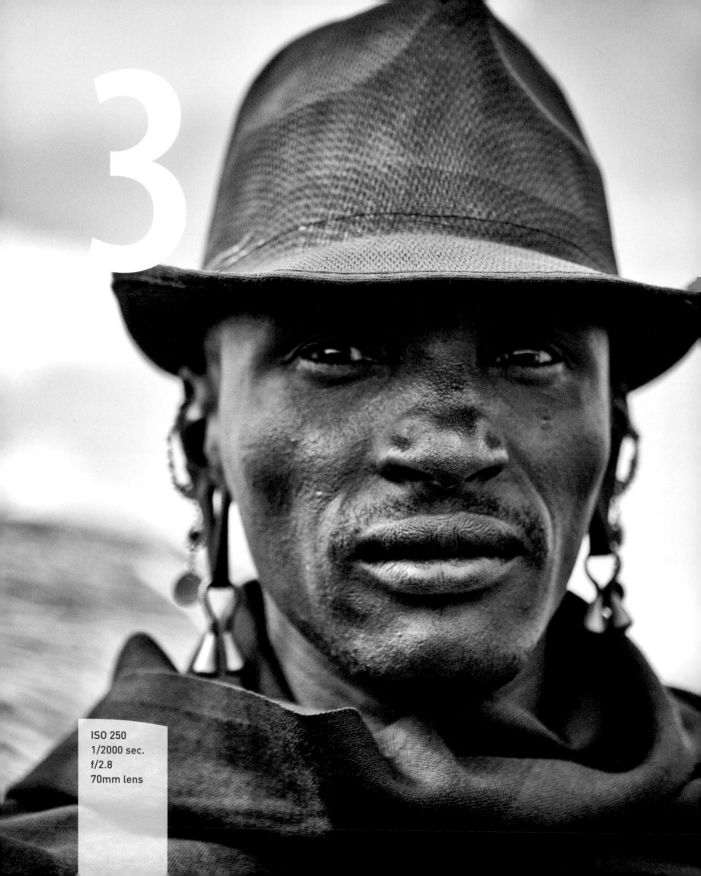

3

ISO 250
1/2000 sec.
f/2.8
70mm lens

# Exposure

## GETTING THE SHOT

Understanding exposure and knowing how to influence your camera's interpretation of a scene are critical to creating your vision. My goal in this chapter is to give you enough confidence to take your camera off autopilot and start shaping your own exposures. At times this chapter will seem a bit technical, but don't feel bad—I also find the technical aspects challenging at times. I'm going to share with you some of my best tricks for understanding aperture, speed, and ISO and how they work together to create exposure. Then, once the heavy lifting is done, we will touch on some of my favorite subjects, like landscape, portrait, and studio photography. Keep in mind that whether you're shooting in a color or black-and-white world, many of the basics to capturing a great image remain the same.

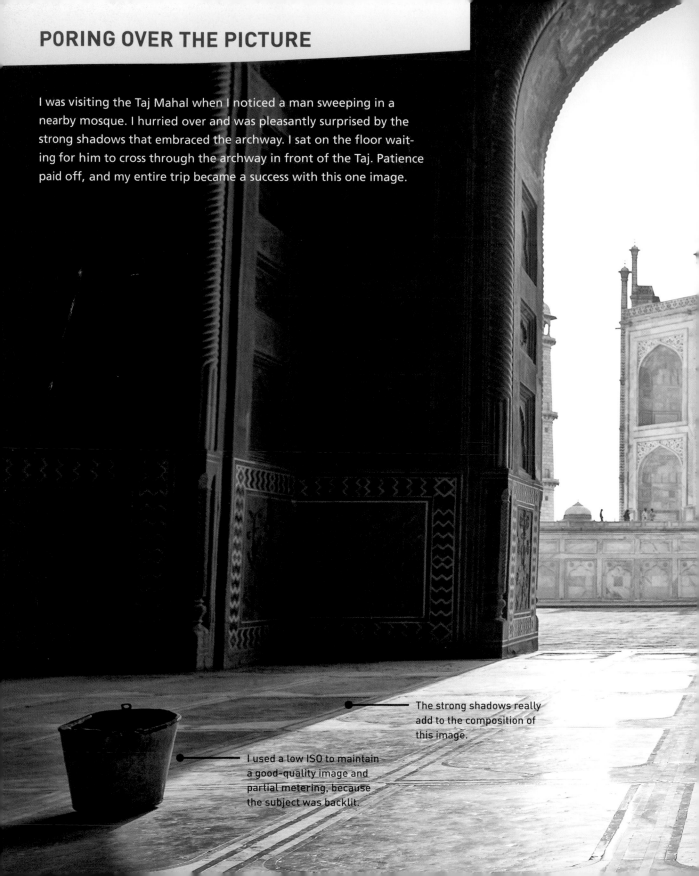

# PORING OVER THE PICTURE

I was visiting the Taj Mahal when I noticed a man sweeping in a nearby mosque. I hurried over and was pleasantly surprised by the strong shadows that embraced the archway. I sat on the floor waiting for him to cross through the archway in front of the Taj. Patience paid off, and my entire trip became a success with this one image.

The strong shadows really add to the composition of this image.

I used a low ISO to maintain a good-quality image and partial metering, because the subject was backlit.

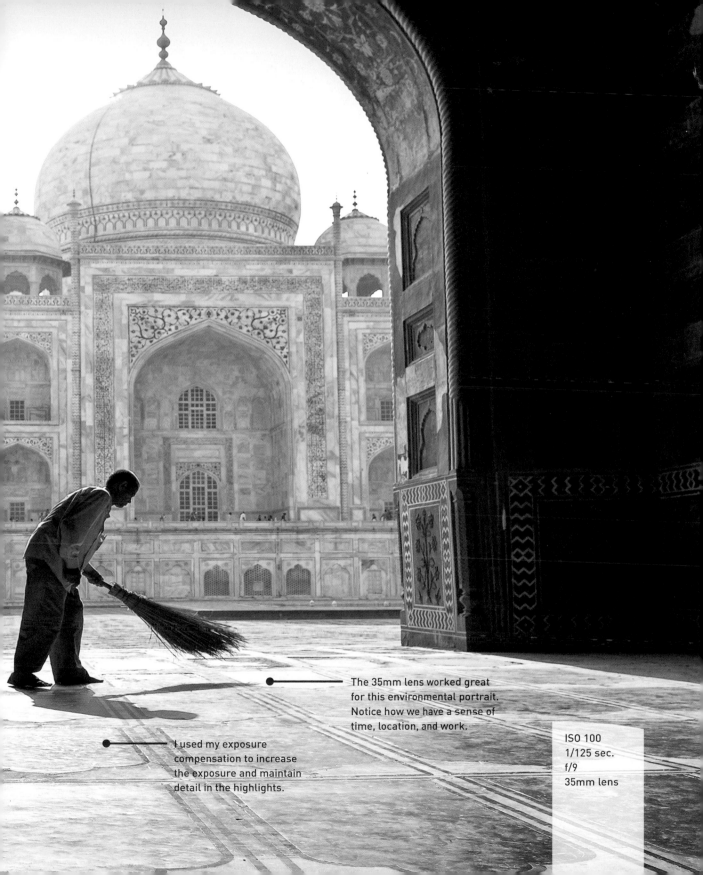

The 35mm lens worked great for this environmental portrait. Notice how we have a sense of time, location, and work.

I used my exposure compensation to increase the exposure and maintain detail in the highlights.

ISO 100
1/125 sec.
f/9
35mm lens

# PORING OVER THE PICTURE

I took the trip of a lifetime to Africa with my best friend, aka my father. We were out in the bush for three weeks straight, and while visiting the Amboseli National Park in Kenya, I was greeted by this single line of elephants working their way to the water. It was a magical moment and I was glad I could share it with my dad.

The elephants were walking toward the sun, so I decided to use my graduated neutral density filter to balance the exposure and darken the sky.

Elephants move quicker than you might think, so using a fast shutter speed of 1/640 allowed me to freeze motion and avoid camera shake.

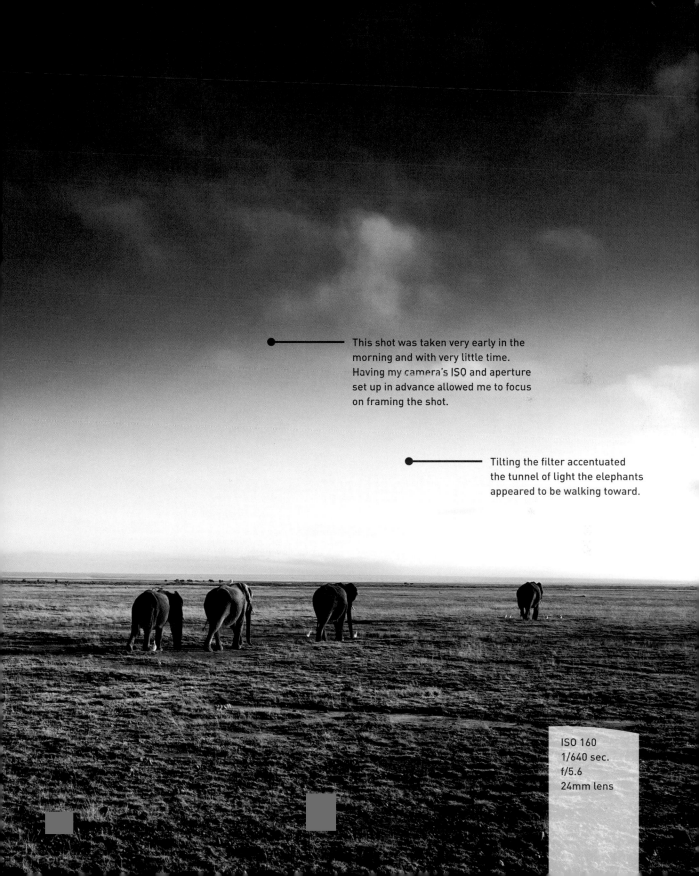

This shot was taken very early in the morning and with very little time. Having my camera's ISO and aperture set up in advance allowed me to focus on framing the shot.

Tilting the filter accentuated the tunnel of light the elephants appeared to be walking toward.

ISO 160
1/640 sec.
f/5.6
24mm lens

# EXPOSURE

Getting my intended exposure is as rewarding for me as catching fish with my own hand-tied flies. It's about bringing science and art together in an effort to create your desired effect. Don't expect to learn everything about exposure overnight, but instead experiment with each variable separately in an effort to better understand how to control light.

Many excellent books have been written on exposure. For an in-depth discussion, I highly recommend *Exposure: From Snapshots to Great Shots,* by Jeff Revell (Peachpit Press, 2010). For our purposes, I will cover some of the basics here to help you make educated decisions in determining how best to photograph a subject (**Figure 3.1**).

**FIGURE 3.1**
This image was taken at dusk and the light was changing very quickly. I needed to adjust my ISO several times to get the proper exposure.

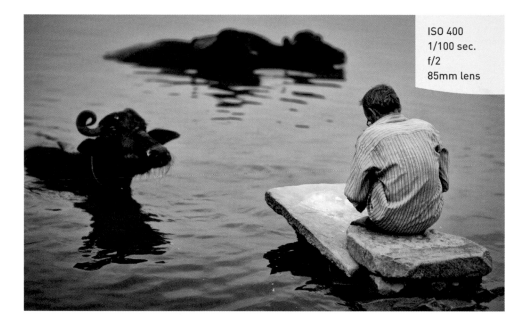

ISO 400
1/100 sec.
f/2
85mm lens

Exposure works the same way whether you're shooting with film or a digital camera. Light does a simple three-step dance; it first reflects off an object, then it bounces back toward your camera and heads through your lens to finally expose your sensor or film for a predetermined period of time until the shutter closes. The period of time your sensor is exposed to light is determined by aperture (size of the shutter opening), shutter speed, (time the shutter is open), and ISO (sensor sensitivity). These three factors are often referred to as the exposure triangle (**Figure 3.2**).

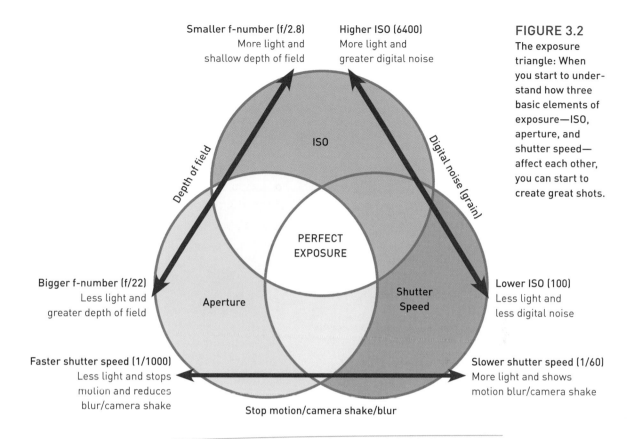

Smaller f-number (f/2.8)
More light and
shallow depth of field

Higher ISO (6400)
More light and
greater digital noise

ISO

Depth of field

Digital noise (grain)

PERFECT
EXPOSURE

Bigger f-number (f/22)
Less light and
greater depth of field

Aperture

Shutter
Speed

Lower ISO (100)
Less light and
less digital noise

Faster shutter speed (1/1000)
Less light and stops
motion and reduces
blur/camera shake

Slower shutter speed (1/60)
More light and shows
motion blur/camera shake

Stop motion/camera shake/blur

FIGURE 3.2
The exposure triangle: When you start to understand how three basic elements of exposure—ISO, aperture, and shutter speed—affect each other, you can start to create great shots.

## DIGITAL NOISE

Digital noise is similar to the grain that we are used to seeing in old black and whites. Digital noise is a result of using a higher ISO in lower light conditions. The sensor heats up, which creates artifacts in the image that appear pixelated or grainy. If you do end up with more noise than you intended, try converting to black and white, because monochrome is slightly more forgiving to the eye.

## ISO

The first setting I adjust on my camera before I begin to shoot is my ISO, even if I'm guessing. ISO determines your camera sensor's sensitivity to light. A typical ISO range on modern dSLR cameras is from 100 to 3200. As we learned in Chapter 1, the lower the ISO, the better the quality of the image because less digital noise is introduced.

I try to use the lowest possible ISO after assessing the available light. This is where experience and time will play a big role in improving your photography: Being able to judge the current lighting situation and picking an ISO that still allows you the proper shutter speed and aperture are critical.

Let's review how changing either ISO, aperture, or shutter speed affects exposure (**Figure 3.3**).

FIGURE 3.3

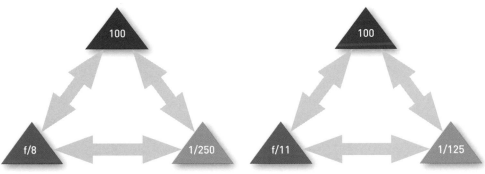

If your ISO is set at 100 and your aperture to f/8, then the resulting speed will be 1/250 sec.

ISO remains at 100, but we change to a smaller aperture of f/11; then the speed slows down to 1/125 sec. from 1/250.

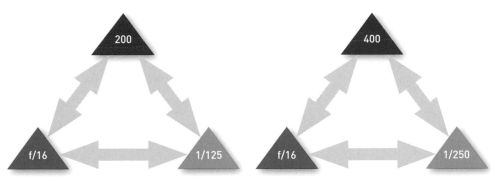

If your settings are 200 ISO, f/16 at 1/125, and you want to shoot at f/16 but need a faster shutter speed, you'll need to increase your ISO.

By increasing the ISO to 400 we were able to maintain f/16 as well as increase our shutter speed to 1/250.

## APERTURE

The aperture is the size of the opening in your lens. A fast lens will have a very large aperture, or wide opening. This allows you to shoot in very low light conditions because more light is allowed in to expose the sensor.

Trying to understand aperture can be confusing, but I'm going to give you a few visual cues to help you along. The reason it can be hard to grasp is that f/2.8 is considered a large aperture while f/16 is a small aperture. A smaller number indicates a larger diameter in aperture. Let's look at the graph below (**Figure 3.4**). Think of the lens as a pie dish and f-stops as pieces of pie. If I had to divide my pie by 2.8, I would have about three large pieces of pie. If I had to divide that same pie by 16, I would have much smaller pieces. When you get confused, simply replace the letter f with a 1 and ask yourself which fraction is larger: 1 divided by 2.8 or 1 divided by 16?

f/2.8    f/4    f/5.6    f/8    f/11    f/16

**FIGURE 3.4**
This is a typical aperture range. Note that the smaller the number, the larger the aperture.

As mentioned in Chapter 1, I shoot mainly in Aperture Priority mode. The reason is that aperture is the major influence on depth of field and shutter speed. Because a large aperture (f/2.8, for instance) allows more light to hit the sensor, it requires less time to expose the image. That's why we get a faster shutter speed with a larger aperture.

## SHUTTER SPEED

Shutter speed is the duration of time your shutter is open, allowing light to expose your sensor. The duration of time is determined by a combination of ISO and aperture. Notice that as we increase the size of our aperture, it decreases our shutter speeds (**Figure 3.5**).

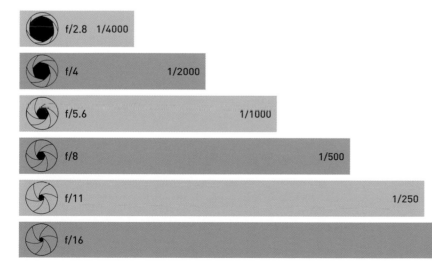

f/2.8  1/4000
f/4  1/2000
f/5.6  1/1000
f/8  1/500
f/11  1/250
f/16  1/60

**FIGURE 3.5**
Reciprocal exposures: When we increase our aperture size, it decreases our shutter speed.

I like to mention the famous water-bucket analogy to my students—imagine you're in charge of filling a bucket full of water. You can only control the volume of water that comes out of the faucet and the duration for which the faucet is left open. Your goal is to fill the bucket without its overflowing (overexposing). Now, you can fill the bucket very slowly over a long period of time or you can fill it very quickly in a short period of time. Think of f-stop as being the measurement of the volume of water coming out of the faucet and shutter speed as being the duration of time before you turn the faucet off.

# EXPOSING FOR POSTPROCESSING

Two exposures are rarely identical, but generally I try to expose my images a tad on the light side in order to protect the shadows. When things are pushed too far to the left (dark) on the histogram you lose details in the shadows and your creative control in postprocessing becomes very limited. It's much easier to add black to an image in postprocessing than to lighten an image. If you don't have any details in the shadows you may lose your ability to define shape and form, as discussed in Chapter 2.

## HISTOGRAM DEFIANCE

Here's where we need to pause and think about our objective, our creative goal. Traditionally we are taught to expose every image as perfectly as possible by making sure we have detail in our blacks and whites. If your goal is to have a perfect histogram with perfect exposure, then by all means adjust accordingly. However, some of us tend to like a darker image, some a lighter image, and might find ourselves creating exposures that push the histogram to the left (dark) or right (light). Some of your most compelling images will reside at extreme ends of a histogram.

As mentioned in Chapter 2, it's all about creating images with intent and fulfilling your vision. There are no histogram police or roadblocks ahead, so feel free to cross the centerline and hammer down. Just be aware that you could lose control of the image. If you underexpose it too much you'll sacrifice detail in your shadows . If you overexpose it too much you run the risk of losing detail in your highlights (light areas) (**Figure 3.6**).

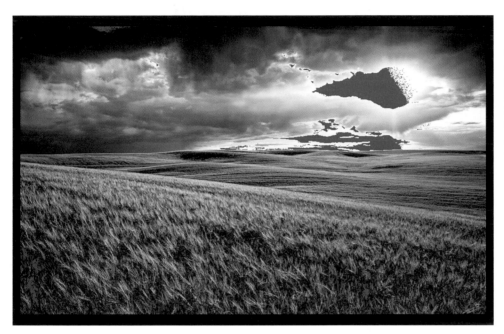

FIGURE 3.6
Blue represents detail lost in the shadows and red represents detail lost in the highlights. I was willing to sacrifice these areas in creating this image.

If exposure is still new to you, then play it safe and expose your image accordingly. If you're a little more seasoned and understand what it means to lose detail in the highlights, then feel free to push yourself a bit in camera and worry less about perfection and a little more about style. When you push it a little you'll be able to get some more high-contrast and stylized images.

## HOW TO READ A HISTOGRAM

As mentioned previously, histograms are two-dimensional representations of your images in graph form. The histogram you need to be concerned with is the luminance histogram. Luminance is referred to as brightness and is most valuable when evaluating your exposures. In **Figure** 3.7, you see what looks like a mountain range. The graph represents the entire tonal range that your camera can capture, from the whitest whites to the blackest blacks. The left side represents black, and all the way to the right side represents white. The peaks represent the number of pixels that contain those luminance levels (a tall peak in the middle means your image contains a large amount of medium bright pixels).

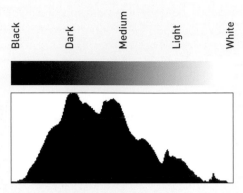

**FIGURE 3.7**
This is a typical histogram, where the dark to light tones run from left to right. (The black-to-white gradient above the graph would not appear on your camera histogram display.)

When just looking at an image, it is hard to determine where all of the ranges of light and dark areas fall. However, if I look at the histogram I can see that the largest peak of the graph is in the middle and trails off as it reaches the edges. In most cases, you want images to have this type of histogram, indicating that you captured the entire range of tones, from dark to light, in your image.

Knowing that is fine, but here is where the information really gets useful. A histogram that has a spike or peak riding up the far left or right side of the graph means that you are clipping detail from your image. In essence, you are trying to record values that are either too dark or too light for your sensor to accurately record. This is usually an indication of over- or underexposing an image. It also means that you need to correct your exposure so that the important details will not record as solid black or white pixels (which is what happens when clipping occurs).

Occasionally, however, some clipping is acceptable. If you are photographing a scene where the sun will be in the frame, you can expect to get some clipping because the sun is just too bright to hold any detail. Likewise, if you are shooting something that has true blacks in it—think coal in a mine at midnight—there are going to be some true blacks with no detail in your shot. The main goal is to ensure that you aren't clipping any important visual information, and that is achieved by keeping an eye on your histogram.

Take a look at **Figure 3.8**. The histogram displayed in the top image shows a heavy skew toward the left, with almost no part of the mountain touching the right side. This is a good example of what the histogram for an underexposed image looks like. Now look at the histogram in the correctly exposed image below it, and compare the two histograms. Notice that even though the graph in the bottom histogram has distinct peaks, there is a fairly even distribution across the entire histogram.

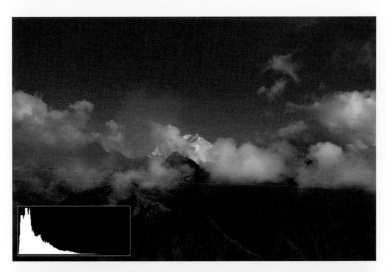

**FIGURE 3.8**
The image on the top is about two stops underexposed. Notice how its histogram is skewed to the left. The histogram in the bottom image reflects a correctly exposed image.

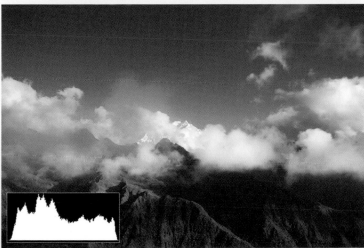

# USING FILTERS

Black-and-white photographers used color filters to control contrast well before the digital revolution. However, with today's digital cameras it is no longer necessary to use color filters at the time of capture. In Lightroom, users have the ability to simulate color filters by taking advantage of available presets (**Figure 3.9**). I find some of Lightroom's color filter presets to be a bit exaggerated. I get my best results by using Silver Efex Pro, which makes switching between color filters as simple as clicking a button (**Figure 3.10**).

FIGURE 3.9
You can use Lightroom presets to create color filter effects.

**FIGURE 3.10**
Silver Efex Pro 2 gives me the best color filter control over my image. You can increase or decrease the effect of the filter with a simple slider.

So why bother with a filter at all? Although I rarely create a black-and-white image with a color filter on camera, occasionally I use a color filter to help guide me in creating an image. It is helpful when I have plenty of time to create a landscape image and I'm assessing the shot for contrast. If I place a red filter on the lens it gives me an idea of what the sky will look like when I decide to apply an effect in post-processing. I then remove the color filter and take the shot. This may seem like an unnecessary step, but at times it's an indispensable tool to visualize my final image. Some cameras allow you to apply filter effects in camera, so check your manual to see if this is an option for your model.

The traditional black-and-white filter kit consists of red, yellow, green, and orange filters. These work by absorbing light and lightening colors similar to their own while darkening other colors. Lighter color filters will have more minor effects on an image; darker colored filters will have more intense effects. It's useful to understand how each of these filters works (**Figures 3.11–3.14**), whether you're using them on camera or applying the effects in postprocessing. A red filter, for instance, will lighten skin tone and darken green foliage.

In the following examples we'll see how the color image is processed in Silver Efex Pro 2 once the filter has been applied. I like to start by studying the color image. Pay attention to areas that the filter should affect as well as the overall brightness of the image. Once in Silver Efex Pro 2, take note of the split screen. On the left side you'll see what the unaltered grayscale image looks like; on the right side you'll see what it looks like once the color filter is applied. All these filters have a slider that controls the overall strength of the effect (that's the beauty of using a digital filter).

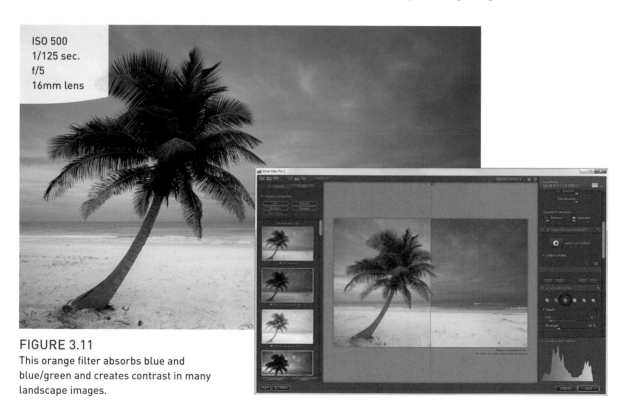

ISO 500
1/125 sec.
f/5
16mm lens

FIGURE 3.11
This orange filter absorbs blue and blue/green and creates contrast in many landscape images.

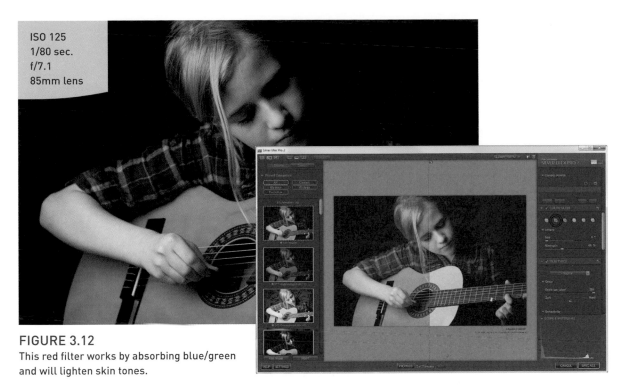

ISO 125
1/80 sec.
f/7.1
85mm lens

**FIGURE 3.12**
This red filter works by absorbing blue/green
and will lighten skin tones.

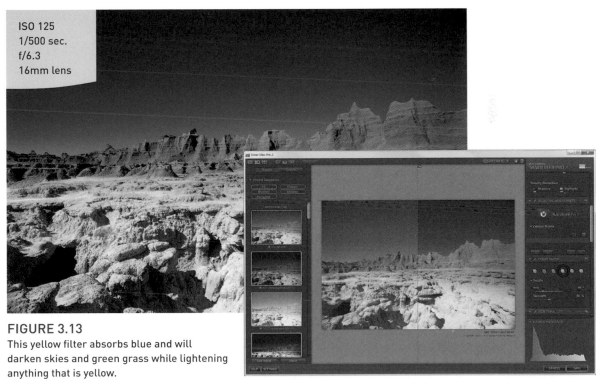

ISO 125
1/500 sec.
f/6.3
16mm lens

**FIGURE 3.13**
This yellow filter absorbs blue and will
darken skies and green grass while lightening
anything that is yellow.

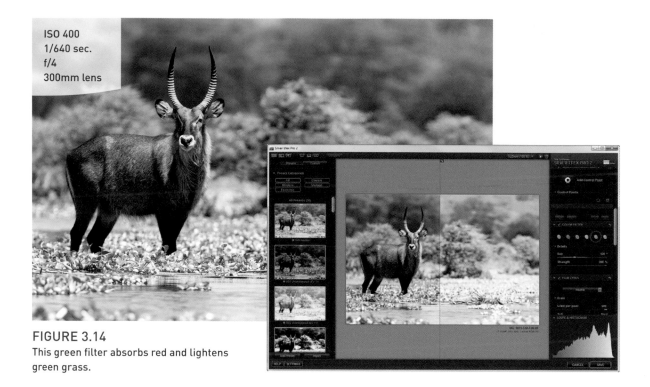

ISO 400
1/640 sec.
f/4
300mm lens

**FIGURE 3.14**
This green filter absorbs red and lightens green grass.

# LANDSCAPE

I grew up in northern Michigan and spent most of my life enjoying the wilderness with my friends and family. On Sundays it was a tradition to load up the station wagon and go for drives in the countryside. When I wasn't picking on my sister I could be found staring out the backseat window, drifting in and out of conscious thought and dreaming of places I wanted to see. Now, some 30 years later, I find myself drawn to visiting many of nature's wonders—this time with camera in tow.

I wouldn't say I have a set formula for photographing landscapes, but instead more of a ritual that I've come to embrace. Much of my photography is about capturing moments that evoke an emotional response. To me, photography is more than just an art form; it's documentation of our important experiences. I'm drawn to images that tell a story and evoke an emotional response.

## SCOUTING FOR IMAGES

For me, scouting typically involves loading up my camera bag and hitting the road. Many of my favorite landscape shots have been photographed off or near roads that I frequent when traveling or camping out West. Ideally, I look for locations I know I'll be able to photograph several times throughout a day or during a trip.

The exception to this ritual, of course, is if something unexpected happens, like the storm that rolled in on me while I was traveling through Teton National Park (**Figure 3.15**). These are the moments you need to seize right away. Remember, keep your eyes peeled for images with strong shadows, textures, and lines because these characteristics will matter even more when you convert to black and white.

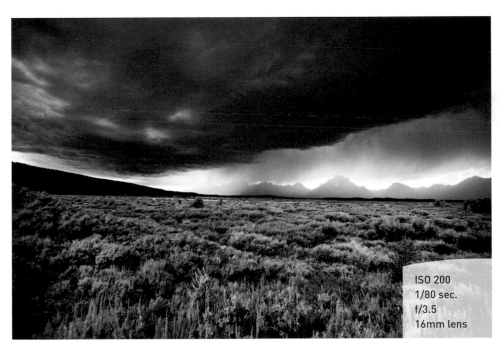

ISO 200
1/80 sec.
f/3.5
16mm lens

**FIGURE 3.15**
When I'm shooting an image that is already quite dark I will increase my exposure anywhere from 2/3 of an f-stop to a full f-stop to protect detail in the shadows.

Once I've located a landscape I'm interested in photographing I find myself running through a checklist in my head: Why am I interested in this image? Are there lines, layers, shapes, textures that pull me in? Knowing the why allows me to focus on how. How am I going to frame the image? What's the best way to bring out those features that originally drew me into the landscape? For instance, while I was traveling back and forth between Idaho and Montana I found myself being drawn into wheat fields that surrounded me (**Figure 3.16**). As the sun sets the field comes alive with texture and strong shadows that create layers or lines through the wheat. It reminded me of the long Sunday drives we took when I was a child.

**FIGURE 3.16**
Using my monochrome setting was crucial to understanding the strength of the image as defined by the shadows and lines. In this case I decided to decrease my exposure a bit.

ISO 200
1/320 sec.
f/7.1
35mm lens

## DRAMATIC LANDSCAPES

Learn to embrace nasty weather. If you follow my blog (batdorffphotography.com/blog), you know I love bad weather. Often when I'm out in the western United States shooting landscapes, I try to capitalize on the inclement weather. If the forecast calls for snow, rain, or better yet, severe thunderstorms, I'm packed and out the door. Of course, you don't want to get struck by lightning, but using some common sense (like shooting from inside your car with the window rolled down, and stopping at the first hint of thunder) can put you in a great, relatively safe spot when the amazing clouds come rolling in.

Now, you might be thinking to yourself, this guy is nuts! But this is what you need to remember: We're always in search of the "good light." Weather that's on the cusp of going awry creates some of the most amazing light you'll ever see. Light bends through the clouds like they're a giant soft box, creating shapes, forms, textures, moods, and even the occasional rainbow (**Figure 3.17**).

## GET DIRTY

That's right, get dirty. Changing your point of view (POV) means you might need to get down on your hands and knees. Getting an interesting photo means changing your POV and trying to see things in a different way. Generally, I like to approach a shot in the traditional manner—standing. But, eventually I find myself on my hands

and knees, or worse yet, on my stomach, or lying on my back searching for an interesting perspective. A professor once told me to take 50 shots of a statue and then shouted, "ONE had better be interesting!" It was a good lesson in creative framing and searching out the less obvious angle (**Figure 3.18**).

ISO 250
1/1000 sec.
f/8
23mm lens

**FIGURE 3.17**
This is a perfect example of having to wait for it. I was in Montana when a typical afternoon rain shower blew through, and the sun was working its way through the clouds. I pulled my car over and waited for the shot.

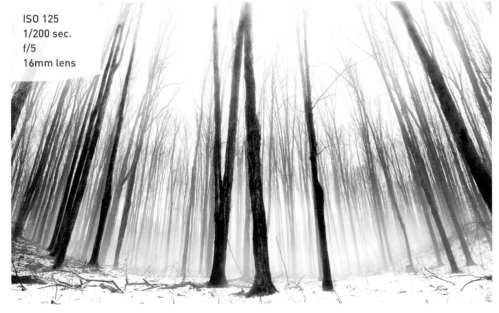

ISO 125
1/200 sec.
f/5
16mm lens

**FIGURE 3.18**
I really struggled with this image but eventually I found myself lying in the snow using my wide-angle lens to create a more interesting perspective.

## USING A GRADUATED NEUTRAL DENSITY FILTER

As I mentioned in Chapter 1, this is the filter I use the most, and it never leaves my essential kit. It's my tool of choice when I have a very bright sky and dark foreground (**Figure 3.19**). The filter allows me to get a proper exposure for the scene by darkening the sky.

I'm always searching for "active skies" that are rich with clouds. A perfect blue sky can be quite beautiful, but it doesn't offer much contrast when converted to black and white. In a black-and-white image, a blue sky will be a solid tone, so a sky with active clouds creates a nice tonal and textural contrast. Typically, I use my graduated ND filter when I have a dull or hazy sky that needs to be enhanced or a bright sky that needs to be darkened—or even when I wish to make dark, stormy clouds darker.

FIGURE 3.19
I used my graduated neutral density filter to darken the sky and help shape the direction of the light.

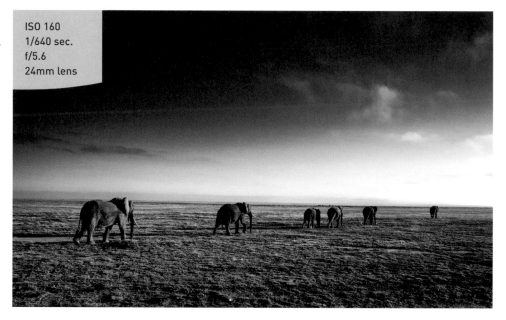

ISO 160
1/640 sec.
f/5.6
24mm lens

## FIND THE SWEET SPOT

We learned that a higher aperture allows for more depth of field, while a lower aperture provides a shallow depth of field. A lot of people think in order to get a super-sharp landscape image they need to use the highest f-stop possible, and that's simply not true. A lens has a sweet spot just a like a tennis racket, and it varies from lens to lens.

Try taking some test shots at different apertures and analyze them closely in your postprocessing. You'll soon discover where your lens's sweet spot is. I shoot most of my landscape photography using my 16–35mm f/2.8, and some of my sharpest images range from f/8–f/16 (**Figure 3.20**).

ISO 200
1/125 sec
f/10
16mm lens

FIGURE 3.20
I shot this image of the salt flats in Peru using my favorite landscape lens, the 16–35mm.

## CUSTOM SETTINGS

Most of today's digital cameras allow you to create custom picture styles or modes. These custom settings enable you to increase or decrease sharpness, contrast, saturation, and color tone (**Figure 3.21**). Whenever I'm shooting landscapes I use a custom setting that has the contrast and sharpening increased. How much of an increase will depend upon your personal taste, but I recommend taking several test shots using different levels of contrast, sharpening, or both and then comparing them in your editing software. Check your manual to locate your camera's custom settings.

FIGURE 3.21
Don't settle for your camera's default settings; create your own custom setting based upon your own preferences.

### TIPS FOR TAKING A GREAT LANDSCAPE SHOT

Use a low ISO when shooting landscapes to ensure the best-quality image. I strongly suggest using an ISO setting of 100 with a tripod or cable release whenever possible. Remember, black-and-white images are all about simplicity and clarity. You don't want to introduce any noise if you don't have to.

Whenever I'm shooting a landscape I like to place my mirror in lockup mode to avoid mirror shake. Consult your owner's manual on how to enable mirror-up when shooting landscape.

If you're using image stabilization/vibration reduction lenses on your camera, you need to remember to turn this feature off when using a tripod or it may create noise. Vibration reduction systems are meant for handholding only. They actually produce movement in the lens in an effort to stabilize the optics while shooting freehand. Since the lens is already on a stable tripod there's no need to have vibration reduction on.

Use manual focus and turn off automatic focus. I've seen this happen quite often: You set up the perfect landscape shot, press the shutter button, and the lens refocuses on you. To avoid this I recommend either focusing manually or using the autofocus and then turning it off prior to clicking the shutter.

## SLOW DOWN!

I can't say this enough. Slow down. Take your time to work the image through in your head. The great thing about landscape photography is that chances are not much is going to move any time soon. So why should you? Think about the shot and how you want it to look in the end. Run through the mental checklist I mentioned earlier. Determine why you decided to stop for an image so you can figure out how you're going to do it justice.

Start to ask yourself questions. Do I want a bright or moody image? Will I need to expose for high key or low key? What's happening with the sky? If it's too bright, can I wait for a cloud to pass in front of the sun? Is the sky active? Do I need a filter or can I make the adjustments in postprocessing? All these questions are the building blocks for your creativity, and the more layers you resolve in the field, the closer you will be to your goal once you hit postprocessing.

# PORTRAITS

I remember as a child looking at a black-and-white portrait my mother took of an oil field worker. I couldn't stop staring at his face; I studied every feature and found myself wondering what it was like to be him. A black-and-white portrait can be very powerful—once you strip an image of its color and free the mind of distractions, you truly begin to see things for what they are. My goal when creating a portrait is to capture an authentic moment in as sincere a manner as possible (**Figure 3.22**). In this shot, I used a large aperture (f/2.8) to create a smooth bokeh (blurry) background.

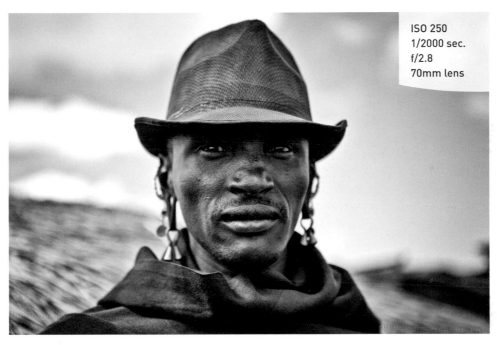

ISO 250
1/2000 sec.
f/2.8
70mm lens

**FIGURE 3.22**
Bokeh can be very effective when creating a shallow depth of field. It puts the focus on your subject.

## THE HEAD SHOT

When we think of portraits, the first thing that probably comes to mind is the closeup of someone's face. Or maybe you think of the most famous of all portraits, Leonardo da Vinci's *Mona Lisa* (**Figure 3.23**). What Leonardo knew and what still holds true to this day is that everything comes down to the eyes. A good portrait can communicate almost entirely through the eyes, so establishing the goal of the image and engaging with the subject are vital to the creative process. The expression in your subject's eyes can shape the mood of the image. Light also creates the mood, so consider if you want a high-key or low-key image.

FIGURE 3.23

I don't delete all my blurry images because you never know if you might like them processed differently. In this case I used a sketch effect to create a little irony.

ISO 800
1/60 sec.
f/2.8
40mm lens

The environmental portrait provides viewers with a glimpse into the life and surroundings where the subject works or lives. To put myself into the right mindset I envision myself as a photographer on assignment for National Geographic. I ask myself, what would the reader want to know about the subject? What's unique to his or her lifestyle? Keep it authentic, and try to create a sense of time, place, and lifestyle.

## PORTRAITS ARE ABOUT THE PEOPLE

Portrait photography is less about technical skills and more about good people skills. Instead of just sticking a camera in someone's face, you need to create a sense of trust. Even most photographers I know hate having their photographs taken, let alone an actual formal portrait. Many people feel the same way. Remember, your subject is probably worried that he or she isn't going to look good. She may be worried about her hair, clothes, teeth, weight, or a slew of other issues. He needs to trust that you'll show him in his best possible light. Remember to communicate with your subject to build a level of comfort and trust. When you like the way she is standing or the expression in her eyes, comment on it. Good people skills go a long way in setting the stage for great portraits.

Case in point: I met Jodi (**Figure 3.24**) recently as I was building my image portfolio for this book. We had never met before, nor had she ever done any modeling. In fact, she's an occupational therapist for the public schools in Chicago. I spent some time getting to know her and discussing the shoot, the book, and her family. Light, friendly conversation was critical to making her feel comfortable with the surroundings (**Figure 3.25**), and in no time her unique personality was coming through.

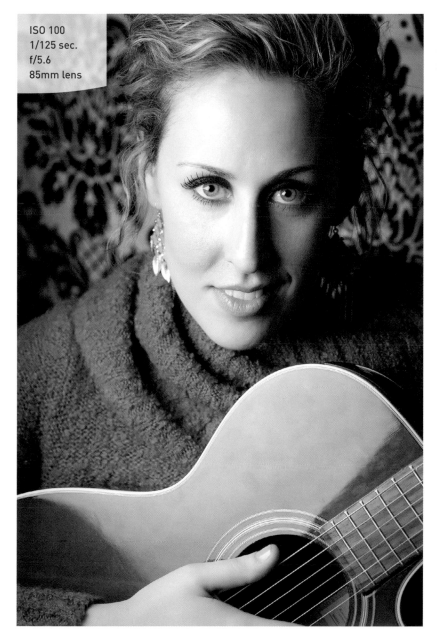

ISO 100
1/125 sec.
f/5.6
85mm lens

FIGURE 3.24
I shot this image with my camera tethered to Lightroom so that I could get instant feedback. I processed it in Silver Efex Pro 2 and applied the red filter.

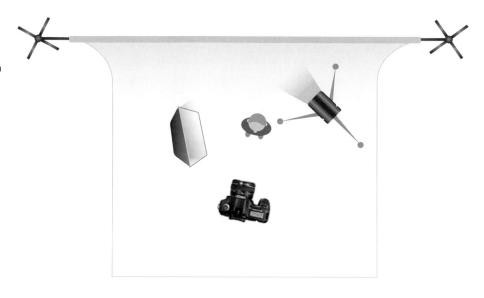

**FIGURE 3.25**
I lit my subject, Jodi, with a small light box and used a small flash to light the background.

## TIPS FOR TAKING GREAT PORTRAITS

I shoot most portraits within a focal length between 50–85mm. Avoid using a wide-angle lens for a portrait—it will distort the face.

Avoid backgrounds that are busy or make it look like objects are sprouting from your subject's head.

Depth of field is your friend in creating beautiful portraits. I like to shoot with a larger aperture (2.8–5.5) to create a smooth, creamy, bokeh effect in the background. This intensifies the focus on the face and eyes.

Use your own expressions as a way to solicit a desired response. If you're looking for a smile, smile yourself. It doesn't matter where you are; humans react to facial expressions. Telling a joke or two or poking fun at myself has always been a great technique for getting a smile from the most resistant subject.

Ask questions and get people talking. Some of my favorite images are when people aren't expecting the click of the shutter. As time goes on people tend to relax and forget about the camera, and it is in those candid moments that I hope to capture that one expression that defines my subject.

I can't say it too many times: Build trust. It's the key to getting a good portrait. It doesn't matter if I'm traveling or shooting clients or family, I need to establish some sort of connection and win a person's trust. Develop a connection or a relationship, and watch a person's true personality come to life through your lens.

## POSTPROCESSING PORTRAITS

The next chapter is all about postprocessing, but I thought I would take a few minutes to point out my favorite portrait tool—the Clarity slider in Adobe's Lightroom (**Figure 3.26**). The Clarity slider works great with portraits where texture plays an important role. We've all seen portraits, often of women and children, where the skin tones are very smooth. I know of very few women who

FIGURE 3.26
Start by making small adjustments with the slider. Remember, try to keep the portrait as authentic as possible.

appreciate having their wrinkles exaggerated in their portraits. However, we've also seen portraits where the skin is rough and wrinkled in an intriguing way, like the one I took of the Peruvian woman. The Clarity tool is one of the easiest ways to enhance these effects.

By decreasing the Clarity slider you can help achieve the smooth, soft skin that we see in photos in magazines and of children. If you want to achieve the opposite effect, increasing the slider will highlight unique aging characteristics of a face. It's all a matter of personal taste, but I typically make small adjustments to the slider, while keeping the overall image as authentic as possible.

## BLACK AND WHITE IN THE STUDIO

I don't shoot a lot in a studio, but nothing gives you a better understanding of exposure than a controlled environment. The great thing about studio photography is it doesn't require a ton of equipment or a dedicated space. As a matter of fact, I do most of my studio work out of my house (**Figure 3.27**). What you do need is a place where you either have great natural light, like a large window, or have the space to set up temporary artificial light, like a small soft box.

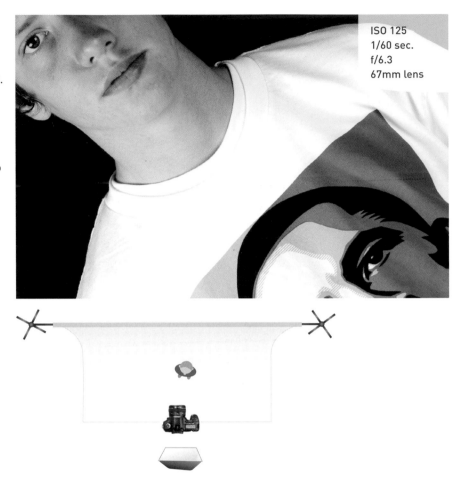

**FIGURE 3.27**
This senior year portrait was taken the year President Obama was elected. The goal was to create a simple timestamp for this young man to remember. See below for my studio lighting set up.

ISO 125
1/60 sec.
f/6.3
67mm lens

## USE AVAILABLE LIGHT

Windows make for great light sources (indirect light is best) and can transform a living space into a nice little studio in a matter of minutes. Try to place your subject near the window and compose your shot while leaving the window out of the image.

If the light is too harsh or bright, consider using a diffuser to soften it, or use a translucent curtain or sheet to control it. Try placing your subject closer to the light source and shooting at a large aperture to create a softer effect.

## USING ARTIFICIAL LIGHT

A lot of people get nervous when it comes to artificial light, but the techniques aren't too tough. The number one thing we want to do is get the flash off the camera and get creative. I like keeping things simple, so for me working with an external flash and small soft box allows me to stay flexible and portable for on-location shoots.

# STORYTELLING

I grew up reading newspapers, or more truthfully, looking at the pictures. For me, the power of an image is in its ability to communicate a story instantly. A good story deserves images that sum up its events or meaning in a single image or series of images. The beauty of black and white is that it lends a certain archival tone, an official, ageless feel.

## THE PHOTOJOURNALIST

Public events such as parades or demonstrations are great places to get your feet wet (**Figure 3.28**). Look for that one image that tells a story or a series of cohesive images that bring a together a theme. Remember to capture environmental data and people. Try to hone in on what the real story is— it might not always be what you think. The more interesting story may be behind the scenes, or capturing it may require stepping back and getting the big picture. It may be in getting one great portrait. Really think through what your intention is and what you're trying to communicate.

ISO 200
1/320 sec.
f/10
70mm lens

FIGURE 3.28
Public demonstrations are great places to practice capturing stories and emotions.

## THE STREET PHOTOGRAPHER

I liken street photography to "people-watching with a camera." It's about record-ing the human experience in everyday life, whether that be a couple holding hands in the park, a family enjoying a picnic, or a pair of old men playing chess by the lake-shore (**Figure 3.29**). It's about pausing, recording, and walking away with a tangible memory. Remember, don't limit yourself to shooting only during the day. Some of my best black-and-white work has been shot in the evening while wandering the streets of the city. Be smart and stay alert to your surroundings, but enjoy the shadows that night brings.

**FIGURE 3.29**
Try not to draw too much attention to yourself and con-sider shooting with a zoom so you have some focal length options.

ISO 200
1/80 sec.
f/13
85mm lens

## THE TRAVEL PHOTOGRAPHER

When traveling abroad, try to connect with someone who can help you get the images you need. Using a local guide can be incredibly beneficial to breaking down potential language and cultural barriers. I try to travel light and take with me only what I need. I like to carry one lens for long-distance shots (70–200mm) and another for all my other work (24–70mm). When shooting environmental portraits, I go wide enough to give the reader a sense of place (**Figure 3.30**) and then shoot another image that's tighter in on the face, focusing on some element that ties it all together.

**FIGURE 3.30**
The scene struck me as odd, but to this South African it was just another day living with a penguin.

ISO 250
1/40 sec.
f/8
70mm lens

# Chapter 3 Assignments

### Understanding Depth of Field

Grab your favorite portrait subject and head outdoors to the brick wall. Have your subject lean at an angle to the wall. Now place yourself in front of your subject, and you should have a good vantage point of the person and the wall behind him or her. Select a large aperture—say, f/5.6—and take a few shots. Now select a small aperture like f/16 and take a few more shots. Review the images on the back of your camera, and you'll notice that the shots taken with the large aperture create a blurry background while the images created with the smaller aperture have a well-defined background.

### Find Your Sweet Spot

Place your camera on a tripod and set it to Aperture Priority. Now, take several photographs of your subject while increasing your f-stops. Make sure to use a cable release or self-timer to avoid any camera shake. Once you've completed your series of images, then open them up in your favorite postprocessing software. Magnify the images and compare them side by side. Once you've determined your sharpest image, locate the image's metadata to determine your lens's sweet spot.

## Photograph Two Stationary Objects

Take a minimum of 20 images of each subject, such as a statue or a building, working every conceivable point of view. This is about trying to see things from different angles and learning how our vantage point can change with a simple bend of the knees.

## Show Me Your Mug

What we learn from doing a self-portrait is what it's like to be on the other end of the camera. When you're preparing for your self-portrait, take inventory of what you're thinking. People can be very self-conscious and this exercise will better equip you to relate to your subject in the future.

## Tell Me a Story

Tell one cohesive story about something that interests you. Use a series of three photographs, one close-up image, one wide image giving us a feel for the surroundings, and one final image that ties it all together. Possible themes might be weddings, parades, or people working.

## Play with Filters

Set your camera to the monochrome setting and place a color filter on the lens. Take note of how your image as well as your histogram changes as you practice taking shots with different color filters.

*Share your results with the book's Flickr group!*

*Join the group here: www.flickr.com/groups/blackandwhitefromsnapshotstogreatshots*

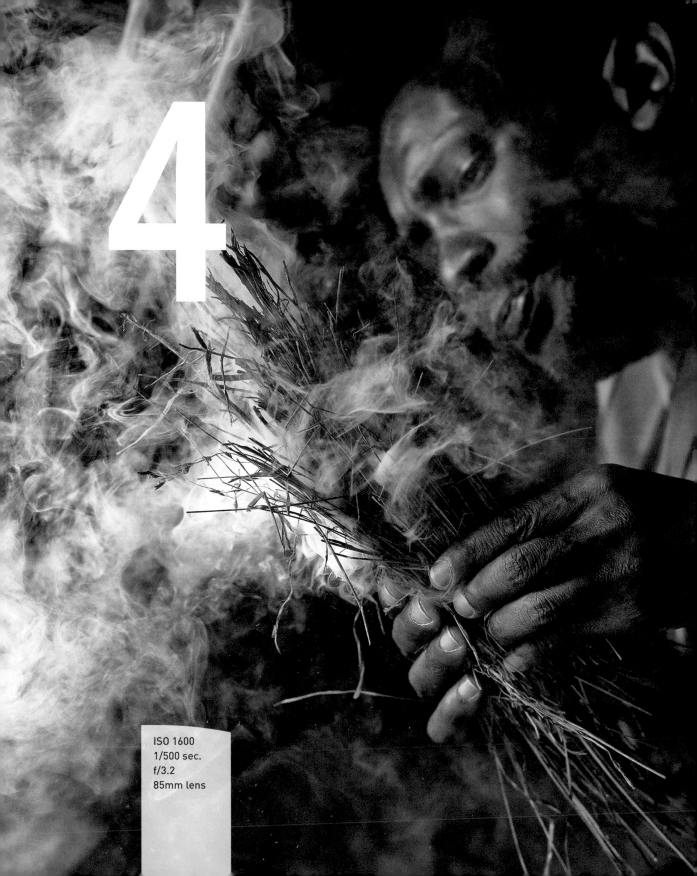

4

ISO 1600
1/500 sec.
f/3.2
85mm lens

# Postprocessing

## REALIZING YOUR VISION WITH LIGHTROOM

We've spent lot of time talking about how to get an image right in camera. In this chapter we're going to start to focus on taking that image out of the camera and creating your vision onscreen and eventually in print. Our goal in Chapter 4 will be to understand workflow and the basic tools available in Lightroom.

Without postprocessing software, it would be nearly impossible for me to create the black-and-white images I desire. I spent plenty of years in the darkroom, and while I get nostalgic every now and then, I've never enjoyed working in the dark. It's a brave new world, and Lightroom makes it all possible.

Now, I mentioned in earlier chapters that 95 percent of my work is done in Silver Efex Pro 2, but it's important to understand that 100 percent of my work flows through Lightroom in some fashion. The amount of time spent in either program really depends upon the image and what I'm trying to achieve, but more on that later. Let's go edit some photos.

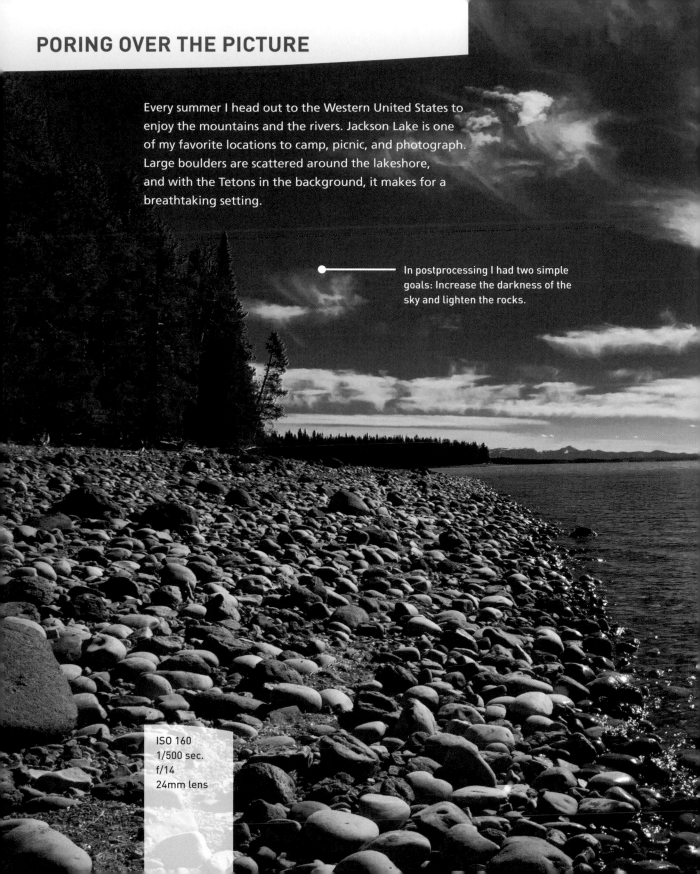

# PORING OVER THE PICTURE

Every summer I head out to the Western United States to enjoy the mountains and the rivers. Jackson Lake is one of my favorite locations to camp, picnic, and photograph. Large boulders are scattered around the lakeshore, and with the Tetons in the background, it makes for a breathtaking setting.

In postprocessing I had two simple goals: Increase the darkness of the sky and lighten the rocks.

ISO 160
1/500 sec.
f/14
24mm lens

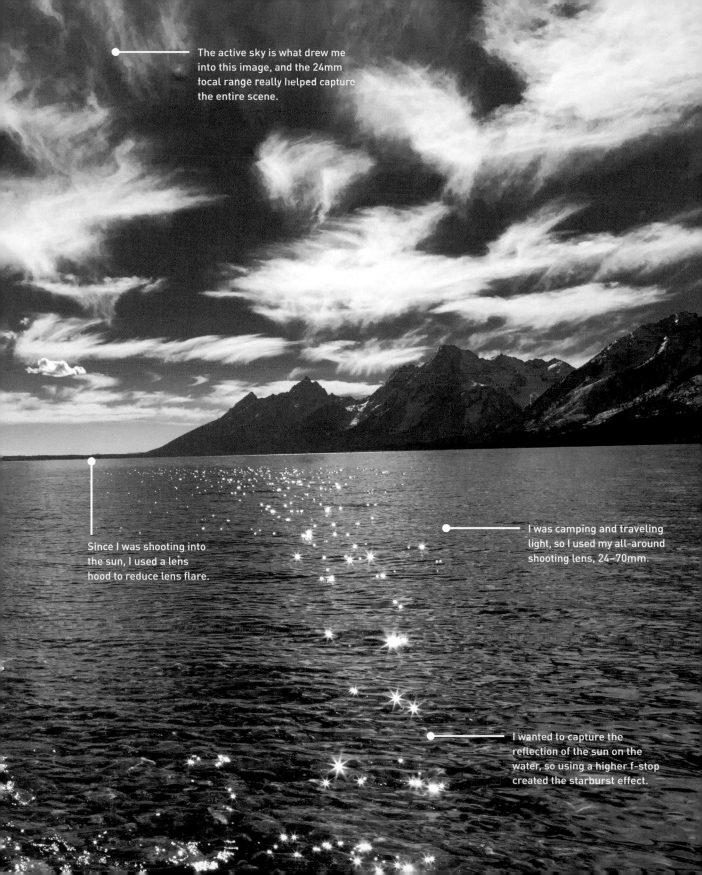

The active sky is what drew me into this image, and the 24mm focal range really helped capture the entire scene.

Since I was shooting into the sun, I used a lens hood to reduce lens flare.

I was camping and traveling light, so I used my all-around shooting lens, 24–70mm.

I wanted to capture the reflection of the sun on the water, so using a higher f-stop created the starburst effect.

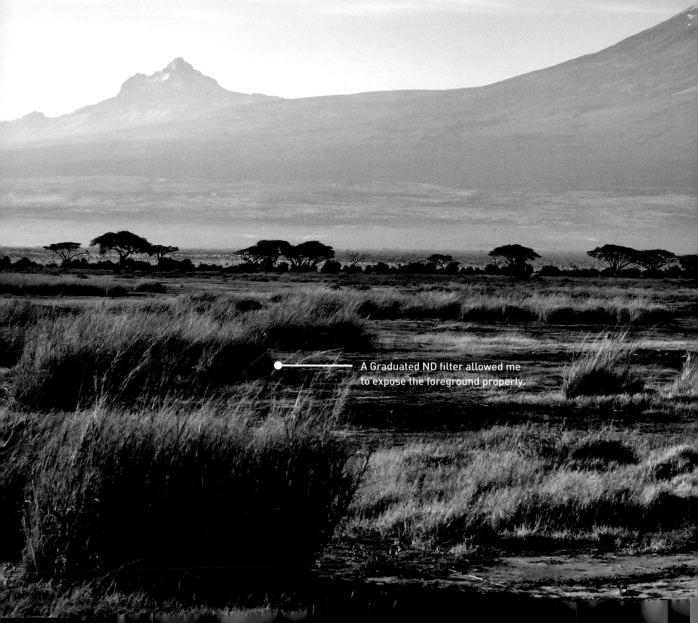

# PORING OVER THE PICTURE

Not all your images are going to go as planned. I had only one opportunity to photograph Mount Kilimanjaro at sunrise. That morning we were faced with considerable amounts of haze. Instead of getting upset, I made a few adjustments to capture the best Image possible and decided this would be an image I would need to spend a little time with in Lightroom.

A Graduated ND filter allowed me to expose the foreground properly.

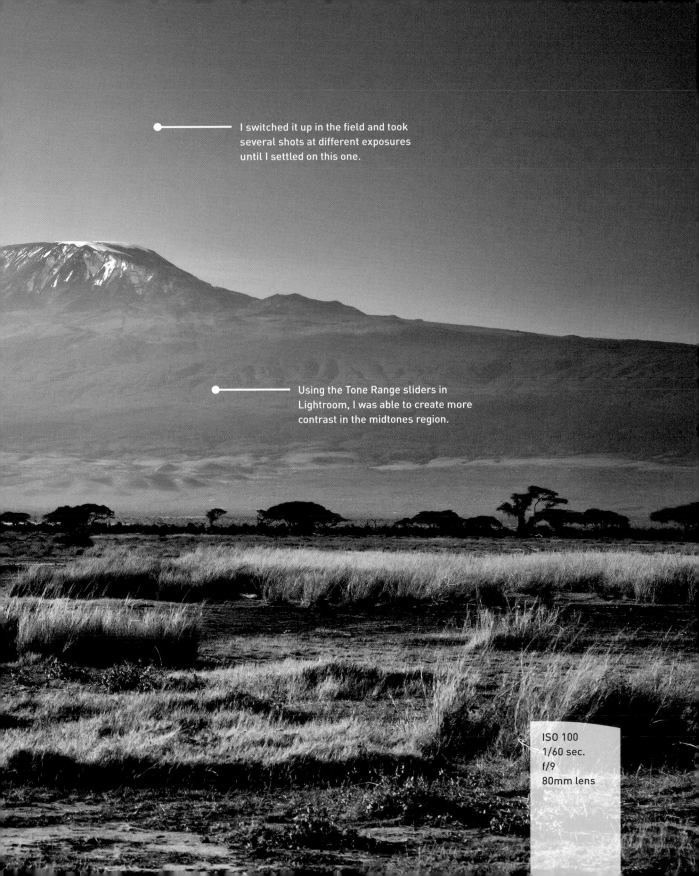

I switched it up in the field and took several shots at different exposures until I settled on this one.

Using the Tone Range sliders in Lightroom, I was able to create more contrast in the midtones region.

ISO 100
1/60 sec.
f/9
80mm lens

# MY WORKFLOW

I'm not the most organized person in the world (just ask my family), but when it comes to photography I like having things nailed down. This means creating a system that provides me with easy and well-organized access to my files and a rock-solid backup plan for peace of mind.

## IMPORTING INTO LIGHTROOM

Before we move on to editing images, I want to give you a quick overview of how I manage images. I think the key to managing any image library is organization and backups. Here's a quick rundown of my management essentials:

1. **Use a simple folder system that's easy to navigate.** I organize all of my images in one folder, labeled Pictures, and further group them into folders by year, then subject (as in Pictures>2011>Paris).

2. **Enter keywords before importing.** I'm a big fan of using keywords to help find images easily, so enter as many relevant keywords as possible before you import into Lightroom.

3. **Import each raw image and convert it to DNG (Adobe's Digital Negative format).** The benefit of this is having one archival-quality file.

4. **Pause before you delete images from your memory card.** First make sure you have imported them correctly and have at least one good backup. I recommend making a second backup to an external hard drive or RAID device, like a Drobo.

### HOT TIP

DNG is Adobe's open source alternative to camera manufacturers' proprietary Raw file format. Files converted to DNG will work with any software that supports the DNG format. For more information on the benefits of the DNG format visit Adobe.com.

# LIBRARY MODULE

Lightroom is an amazing image management database that allows you to quickly identify which images you want to select for future processing. Once I have finished importing my images (**Figure 4.1**), I navigate over to the Library module to select

images to be processed. I'm not going to process every image I photograph, so being selective in Library mode saves me a ton of unneeded processing time.

While in Grid (G) mode, I like to minimize the left and right panels (press the Tab key and adjust the Thumbnails slider), so I can review several images at time (**Figure 4.2**). When I land on an image of interest I toggle between Grid mode and Loupe (E) mode, where I can view the image larger (**Figure 4.3**).

I assign any image worthy of processing a five-star rating (press the 5 key) so that I can quickly group my "potential winners."

**HOT TIP**

Keep your rating system simple. The more complex it is, the less efficient it becomes. I use five stars for any image that's worth processing and a green label for an image that I have processed.

If you want to narrow down your team of winners even further, you can use Compare mode (C) to compare individual images to one another. This is a great feature to use in conjunction with the Zoom slider. I find it incredibly helpful when looking over portraits and trying to decide between them.

## FIGURE 4.2

I label all my potential winners with five stars.

## FIGURE 4.3

Use Loupe view when you want to see an image larger.

# DEVELOP MODULE

Now it's time to head on over to the Develop (D) module and start having some fun with our images. Let's review the options for converting a color image to black and white within the Develop module. Once we review all the different ways to convert, we'll cover the details and how-to instructions for each method.

## USING A PRESET

One of the simplest ways to do your black-and-white conversion is to use one of the many presets that come preloaded in Lightroom (**Figure 4.4**). A preset (**A**) is a set of adjustments that have been preconfigured to create a desired effect.

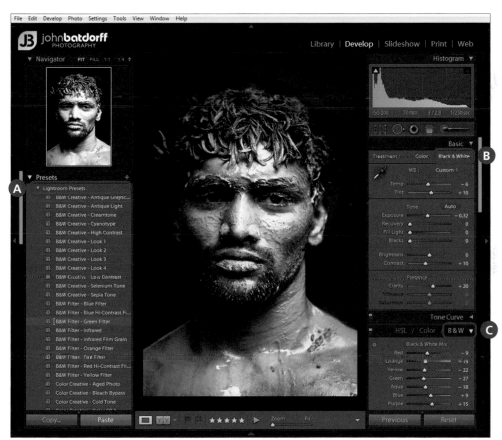

FIGURE 4.4
The Develop module is where you'll spend most of your time editing images in Lightroom.

The benefit of using a preset is it provides instant feedback on your image and can speed up your workflow. Many times I'll use presets to guide me in deciding which images I'll convert to black and white. It's like using a color filter in the field: It provides me with valuable feedback and a good starting point for my black-and-white conversion. Presets are so incredibly easy to use that you'll feel like you're cheating.

## USING THE PANELS

You can also convert to black and white by navigating over to the Basic panel and choosing the Black & White treatment (Figure 4.4, **B**), clicking on B&W in the HSL/Color/B&W panel (**C**), or simply pressing the letter V on your keyboard. Using any of these methods will generate a monochrome version of a color image. Now, don't fret, your color image is still intact, as you can see if you toggle back to the color setting. Lightroom won't alter your original file—feel free to play with the Develop module sliders without worrying about what's happening to the original. It's called nondestructive editing, and it means you can rework images to your heart's content.

### EDITING WITHOUT FEAR

How does Lightroom allow us to edit images without running the risk of altering our JPEG or raw files? It keeps a history of all adjustments to an image. Whenever we export, it generates a new file, which duplicates the original image, then applies the adjustments made in postprocessing; thus, it never alters the original.

The Basic panel Black & White conversion generates a monochrome image based on white balance. By moving the Temp and Tint sliders you can make global adjustments to the image.

The B&W selection within the HSL/Color/B&W panel offers the most control over a black-and-white image. Black & White Mix is very similar to Photoshop's channel mixer, creating a grayscale version of red, green, and blue color channels that make up the RGB version of the color image. We're able to influence independent colors that blend together to make the monochrome image simply by increasing or decreasing the saturation. (Refer back to the example of the Volkswagen Bugs, in Chapter 1, where we used saturation to increase contrast.)

## THE PRESET WORKFLOW

My number one goal in this book is to help you start making beautiful black-and-white images, and the best place to begin learning is with presets. Presets can be addictive, and for good reason. They do a pretty decent job. It is extremely rare, though, for me to bring an image into Lightroom, click on a preset, and say, "Wow, that's it, I'm done!" Typically, what happens is I land on a preset that gives me a great starting point or baseline that I can tweak as I move forward in creating my vision. We're going to look at a few examples in the coming pages, but first let's make a few adjustments to our workspace, as well as to Lightroom.

### WORKSPACE

As I mentioned in Chapter 3, controlling the light in your workspace is crucial to photo editing, so try to work in an environment where you can control it, whether by window shades, dimmer switches, or both. Shelter your monitor from direct light and try to avoid working in the dark, as well.

### BACKGROUND COLOR

Consider changing Lightroom's default background color. I like to work with a black background when I'm reviewing potential black-and-white images. It helps me visually when I'm looking for contrast within an image. You can change your background by right-clicking your mouse anywhere on the background and selecting a color (**Figure 4.5**).

FIGURE 4.5
Don't forget to consider your background color. I prefer to use a black background when viewing my images.

## PRESET PREFERENCES

Next, we want to make sure that our auto mix black-and-white conversion function is turned on. Whenever we make an adjustment to White Balance and click on Black & White in the Basic panel, it will automatically update the color channels (**Figure 4.6**).

**FIGURE 4.6**
Customize your presets to save time and energy.

1. Navigate to Lightroom Preferences.
2. Click on the Presets tab.
3. Make sure the check box "Apply auto mix when first converting to black and white" is checked.
4. Click OK.

## CREATING A PRESET

Presets are wonderful tools for streamlining repetitive tasks or creating your own particular style for future use. Let's review how to create a preset (**Figure 4.7**).

1. Start by making any adjustments in the Develop module that you wish to record for future use.
2. Go to the Presets module and click the + sign.
3. Give a name to your preset and put it in the folder of your choice.

4. Select and adjust only the settings you wish to correct.

5. Click Create.

**FIGURE 4.7**
Creating a preset with your signature style is a great way to add consistency to your work.

Begin by making adjustments in the develop module that you wish to save as a preset.

That's it. Now you have your very own preset that you can use on future edits. As I warned you, this can be addictive. But it can save you a whole lot of time!

## SELECTING AN IMAGE

The first thing I like to do in the Develop module is narrow down my field of candidates. I do this by filtering my view so that I see only my five-star-rated images. This allows me to focus on just those images I think are worth taking to the next level.

My next step is selecting images that I think will work well as black and whites. I start by scanning my five-star images, looking for those that have interesting light, shapes and forms, lines, or any of the other characteristics we discussed in Chapter 2.

Once I land on an image of interest I move my cursor over the Presets panel slowly, working my way down the black-and-white presets. I normally start by selecting BW Contrast while reviewing the effect on the image in the Navigator panel (**Figure 4.8**). Case in point: While I was in Africa visiting the Maasai, we ventured into one of the huts for a lesson on fire building. The hut was fairly dark, but we had nice light coming from the doorway. The image didn't work for me in color, but once I converted it using the B&W Creative - Look 2 it was an interesting, high-contrast image.

FIGURE 4.8
Highlighting pre-
sets and reviewing
the changes in the
Navigator window
helps me determine
if I should convert
an image to black
and white.

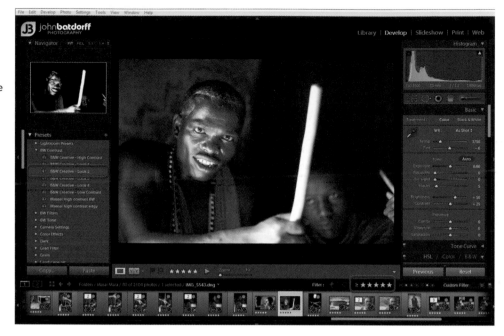

The presets are there for a good reason: They're a fast and easy approach to convert-
ing your color image. I'm not a big fan of reinventing the wheel (improving it, yes;
reinventing it, no), so if a preset is 75 percent of the way there, I'll use it. However,
one click of a preset will rarely get me to my final image. If that does work, trust me,
I wouldn't feel guilty about using the preset, and neither should you. That just leaves
us with more time to work on our other images. In the case of the Masai warrior I
ended up going one step further and cropping the image before I was finished.

## CROPPING

I try to do most of my cropping in camera by carefully composing my image, but
at times it doesn't work out or I simply miss something. In the case of the Masai
warrior, I found the hand on the right side of the frame distracting. Because it was
dark, I didn't see it when I was framing the shot. No need to worry; Lightroom has
an excellent cropping feature.

1. Click on the Crop Overlay mode button in the Develop module, or use the key-
   board shortcut R.

2. Select a crop overlay. You can do this by pressing the letter O while in the Crop
   & Straighten tool panel (**Figure 4.9**). You can also choose Tools from the menu,
   then select the Crop Overlay tool and choose your preferred overlay. I use only
   two overlay designs: Golden Ratio for cropping portraits, and Rule of Thirds for
   cropping landscapes.

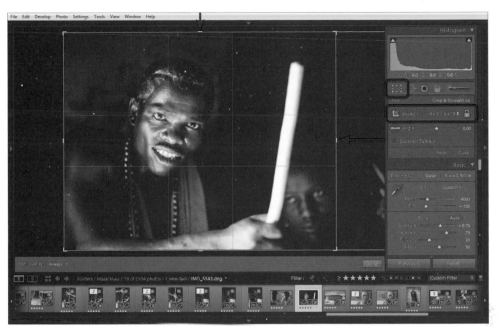

FIGURE 4.9
I used the
4x5 / 8x10 preset
to crop in tighter
on my image.

3. If you're going to do a lot of printing, try to crop using the aspect ratio of your desired print size. The crop tool preset will provide a list of some of the most common print sizes (**Figure 4.10**). Click on the word "original," left of the small lock icon, to view the available ratios.

### LEARN THE SHORTCUTS

Lightroom has a keyboard shortcut for nearly every action imaginable. Head over to Adobe.com and search for *Lightroom Shortcuts*. Learning these will save you a ton of time.

FIGURE 4.10
You can create your
own custom crop
preset or use one of
the many available.

FIGURE 4.11
Create a virtual
copy for images
that you wish to
have in color and
black and white.

# USING THE BASIC PANEL

Let's review using the Basic panel to convert your image to black and white. I'm going to convert an image that I like in color but I think will work well in black and white, too. First I'll create a virtual copy of the image by pressing Ctrl (PC) or Command (Mac) plus the apostrophe key. The virtual copy will be the thumbnail in the Filmstrip with the bottom corner turned over (**Figure 4.11**).

Next, I'll convert to monochrome using Black & White in the Basic panel. There are several schools of thought on converting an image using the White Balance setting in the Basic panel. Some people like to make all the adjustments to the image while it's in color, and others prefer to convert the image to black and white, then make the adjustments. I tend to do the latter, since I've already made most of my adjustments in camera. I feel that by converting the image up front I get a better feel for its overall aesthetics while adjusting its white balance (**Figure 4.12**).

**FIGURE 4.12**
I prefer to convert my image to black and white before making changes to its white balance.

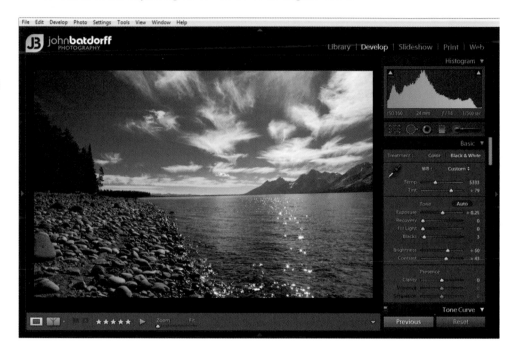

The Auto Tone setting is a good place to start when you first begin correcting image exposures. It will automatically adjust Exposure, Recovery, Fill Light, Blacks, Brightness, and Contrast settings. Many times it will create a nice starting point, and we can tweak as needed.

Occasionally, though, Auto Tone can make erratic adjustments. Don't worry—if this happens and you don't like the result, simply undo the last move by clicking Alt (Option on a Mac) and Reset Tone in the Basic panel, or go back to your history and click on the previous setting.

Slide the Temp and Tint sliders to adjust an image's white balance while reviewing the effects in the main window. I typically try to work the Temp slider first, then the Tint slider, until I get the desired effect. In the case of Figure 4.12, I wanted to darken the sky and lighten the rocks. I was able to achieve my goal by decreasing Temp and increasing Tint.

# USING THE HSL/COLOR/B&W PANEL

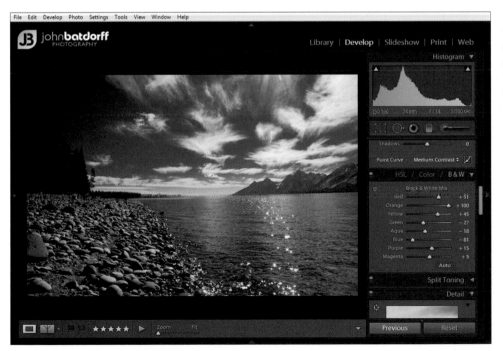

Overall, our results were not too bad, but let's take a different approach and see if we can make the image better. This time we're going to convert my virtual image using the B&W section of the HSL/Color/B&W Panel (**Figure 4.13**).

1. Convert the image using either B&W setting.
2. Click Auto for the Tone setting, as we did in our previous conversion.
3. Experiment by adjusting the color sliders.

**FIGURE 4.13**
Converting using this method will give you more control than using the White Balance sliders.

There are two approaches to working with color sliders. First, you can simply move the sliders around and stop when you achieve a desired look. Or (my preferred method), you can use the Targeted Adjustment tool to select specific areas you wish to lighten or darken. You can darken or lighten the sky, for instance, by selecting it with this tool and using your keyboard's arrow keys.

To darken the sky, tap your down arrow key; to lighten, tap your up arrow key. For this image I darkened the sky (-81 blue slider) and lightened the rocks (+100 orange and +45 yellow slider) (**Figure 4.14**). Let's compare the two images (**Figures 4.15** and **4.16**).

**FIGURE 4.14**
I darkened the sky and lightened the rocks using the Targeted Adjustment tool.

**FIGURE 4.15**
I converted this image using the Basic panel and adjusted the Temp and Tint sliders.

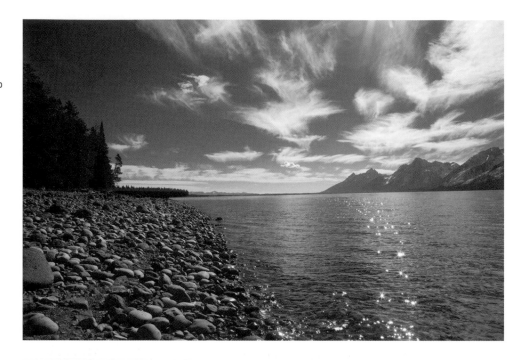

**FIGURE 4.16**
I converted this image using the HSL/Color/B&W panel and adjusting the color sliders.

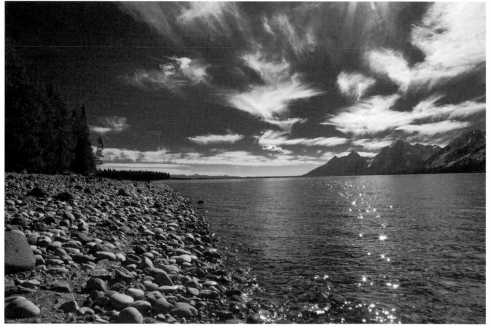

# CONTRAST ADJUSTMENTS

We've discussed contrast at length in earlier chapters. We know that contrast is highly important in black and white, so now let's discuss how to work with it in Lightroom. The tools for adjusting contrast in the Develop module range from the basic Contrast slider to the precise Tone Curve.

**FIGURE 4.17**
This is the basic Contrast slider—a good place for beginners to start.

The Contrast slider (**Figure 4.17**) is a very blunt tool that is available in many postprocessing software applications. Its ease of use and immediate global effects make it a favorite for photographers who are just starting out. If you're new to Lightroom, then start experimenting with contrast by using this slider.

By moving the slider to the left, you decrease contrast; by moving it to the right, you increase contrast. Take note of your histogram as you play with these adjustments. When you increase contrast, you get that classic "U" formation in the histogram.

Conversely, when you decrease contrast, you see a peak in the midtones. Observing the image as you make adjustments with the slider, and then checking out the resulting histogram, is a wonderful way to understand the relationship between contrast and histogram—and how histograms can help you.

The more advanced option, and my preferred method for manipulating contrast, is through the use of Tone Curve (**Figure 4.18**). It provides us with precision control over an image's highlights, lights, darks, and shadows with use of the independent sliders (**A**) or the Targeted Adjustment Tone tool (**B**). The Tone Range split sliders (**C**) below the tone graph allow you to increase or decrease the range of tones to be affected. Point Curve Presets can be set at Linear, Medium Contrast, or Strong Contrast (**D**). Let's review how I typically tackle Tone Curve.

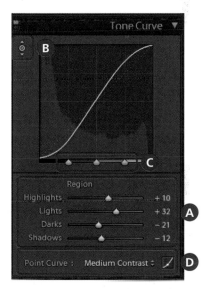

**FIGURE 4.18**
Tone Curve gives you precision control over contrast.

## USING TONE CURVE

1. First, finish making all of your main tone adjustments in the Basic panel (Exposure, Recovery, Fill Light, and so on). These will affect the Tone Curve adjustments that we're about to make.

2. Select a Point Curve preset: Linear, Medium Contrast, or Strong Contrast. Choose Medium or Strong Contrast if you want to lighten your highlights or darken your shadows.

3. Adjust the tone curve by using sliders or the Targeted Adjustment tool. I use the Targeted Adjustment tool and select an area on the image where I wish to increase or decrease the brightness. Often I end up with a very gentle S shape in my tone curves.

4. Fine tune the contrast with the Tone Range sliders.

# ADVANCED CURVE ADJUSTMENTS

If you want more control over adding contrast to your images, then let's unlock the power of the Tone Range split sliders. Take a look at this image of Mount Kilimanjaro that I photographed in the morning. I'll walk you through the process from start to finish. I've already made my adjustments to the tone curve, but now we want to use the Tone Range sliders to selectively add more contrast to the image (**Figure 4.19**).

**FIGURE 4.19**
The default position of the Tone Range splits is equally divided on the tone curve between shadows (black), darks (red), lights (blue), and high-lights (yellow).

The Tone Range split sliders are a great place to fine-tune contrast. If we wanted to add contrast to the midtones, then we would move the two outside sliders into the middle, thus compressing the midtone range and creating more contrast (**Figure 4.20**). If we move the two outside sliders to the furthest point from the center, then we decrease contrast in the midtone region (**Figure 4.21**).

If we wanted to add contrast to the light and highlight regions, we would move the Tone Range sliders to the right. This increases our shadow region while restricting our highlights region, thus making our image darker and creating more contrast in the highlights (**Figure 4.22**).

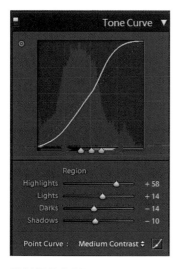

**FIGURE 4.20**
Moving the sliders to the center adds contrast to the midtones.

**FIGURE 4.21**
Move the sliders outward as indicated by the arrows to decrease midtone contrast.

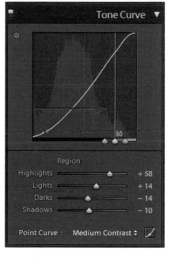

**FIGURE 4.22**
Moving the sliders to the right will increase our shadow region.

Moving our sliders all the way to the left will increase our highlights region and create contrast in our shadows. Keep in mind, any move to the far right or left might be too much (**Figure 4.23**), but understanding the basic idea is what matters here.

Moving the middle slider to the left and the right slider to the far right allows us to add contrast and detail in our shadow region without blowing out the image. This gives us our desired effect (**Figure 4.24**); I am now happy with the amount of contrast in the image.

**FIGURE 4.23**
Moving the sliders all the way over created way too much contrast in the shadows—not the desired look.

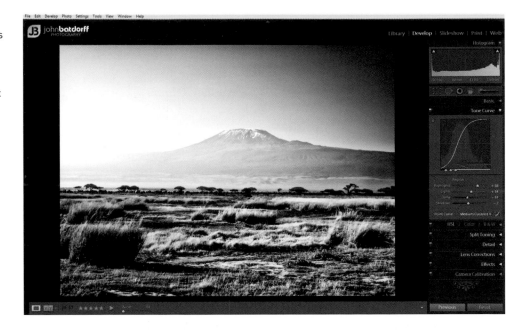

**FIGURE 4.24**
By experimenting with the Tone Range sliders we're able to add contrast to our shadows and get the desired effect.

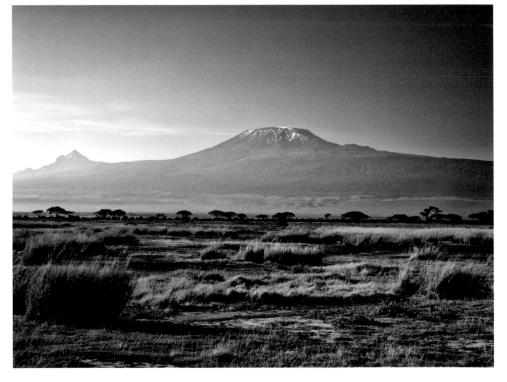

# SELECTIVE COLOR

Sometimes I like to add a little selective color back to my black-and-whites to help breathe some life back into the image. While I don't do this often, it's still a popular style of photography, especially with portraits. First we're going to create a new preset we can use in the future that will trick Lightroom into desaturating an image but still allow us to paint color into it.

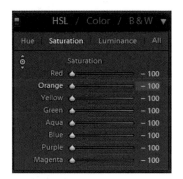

**FIGURE 4.25**
Move all color sliders to the left so they read -100.

1. Create an HSL B&W Preset.

2. Locate the HSL panel in the Develop module.

3. Move all the color sliders to -100 (**Figure 4.25**).

4. Head to the Presets panel and click the plus sign to add a preset.

5. Name the new preset HSL B&W.

6. Click Treatment (Color) and Color Adjustments. This way only these changes will be affected by this preset.

7. Click Create (**Figure 4.26**).

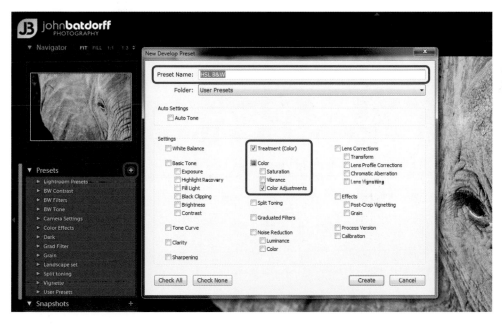

**FIGURE 4.26**
Now we've created a new preset we can use anytime.

Now that we've used our HSL preset to create a monochrome image, it's time to explore the benefits of this technique. We can add color back into an image using either the Targeted Adjustment tool or the adjustment brush. Let's review the pros and cons of both approaches.

## TARGETED ADJUSTMENT OR SLIDER

Let's say I want to add color to the eyes of this elephant to bring a little life into the image. I can select the Targeted Adjustment tool, click on the pupil, and use the up arrow key to add color back to the image. You'll notice that the red and orange sliders are both increasing in saturation, and color is being added back into the entire image (**Figure 4.27**). This is not what we want.

FIGURE 4.27
The Trageted Adjustment tool added too much color globally.

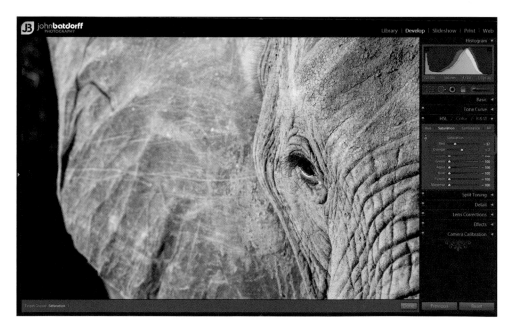

Essentially, using the Targeted Adjustment tool to add color is a quick process that often only works if you have isolated colors in the image (such as an extreme close-up portrait where the subject has blue eyes). Because there probably isn't any other blue within the frame, you can just increase the sliders. But if your subject's blue shirt is also in the frame, you'll reintroduce color there as well. Let's try a more direct approach.

## PAINTING WITH COLOR

Our other option is to use the adjustment brush to paint in the areas where we want to bring the color back. While we have more control with this method, the downside is that it takes a little extra time. However, it's worth it if it lets us achieve the effects we want. Let's go through how we would do this, step by step.

1. Zoom in on the elephant's eye by clicking in the screen or using the Navigator window to locate the elephant's pupil.

2. Select the adjustment brush and create a smaller brush by decreasing the Size slider. We want a small slider since we'll be painting in around the eyes. I like to do most of my painting using the Mask Overlay tool so that I can see what I'm doing. Check the Show Selected Mask Overlay box. Now we use our tool to paint in the eyes. Once we've finished, increase the Saturation slider to 100 percent. We press the letter O (not zero) on the keyboard to toggle our mask on and off so we can see the changes. If you missed a few spots, just fill them in, or if you went outside the lines click on erase and brush away your overspray.

3. Now, we'll zoom back out of the image and make some final adjustments using Tone Curve. We're going to place a gentle S in the tone curve, something I do quite often, but this time we're going to compress the Tone Range sliders, as we learned earlier in the chapter, so that we get more contrast in the midtones (**Figure 4.28**).

4. We are almost there. Since there's a lot of texture in this image, I'm going to add a little clarity by increasing the Clarity slider (**Figure 4.29**) and finish the image with a very small vignette using the Highlight Priority slider (**Figures 4.30** and **4.31**). Voilà!

**FIGURE 4.28**
We increase midtone contrast by moving all three sliders to the center.

**FIGURE 4.29**
We increase the Clarity slider to bring out the texture and lines.

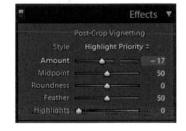

**FIGURE 4.30**
This is my preferred method for adding a vignette.

FIGURE 4.31
Here you can see
how all of these
adjustments came
together in the final
product.

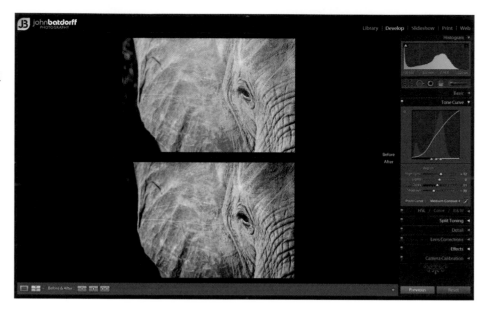

## PUTTING IT ALL TOGETHER

Let's step things up a notch and learn more about dodging, burning, adding contrast,
and sharpening. Imagine that you're helping me process a portrait that I took in India.
I'll walk you through it from beginning to end so that you can get a feel for my flow.
I think our original, **Figure 4.32**, will look great in black and white, too.

FIGURE 4.32
Create a virtual
copy so that we
can edit without
making changes
to the color version
of the image.

1. Create a virtual copy so that we can edit without making changes to the color version of the image.

2. Convert the image to black and white using the Basic panel.

3. Using the Golden Ratio crop guide, crop in a little tighter.

4. Click Auto Tone to get a starting point for exposure.

5. In evaluating the baseline produced by Auto Tone, it becomes clear that the image is now a little too dark (**Figure 4.33**). Auto Tone added black and decreased the exposure. We increase exposure using the Exposure slider to get the image where we want it. This slider affects the entire image, whereas the Brightness slider affects only the midtones. We need a full shift in our histogram, which is why we choose the Exposure slider.

FIGURE 4.33
We used Auto Tone, but this image is still too dark and will need to be adjusted manually.

6. Now we turn on Clipping Alerts. This will let us know if we've lost any detail in the highlights, shadows, or both. We can activate it simply by pressing I while in the Develop module. Blue represents the shadow areas where we've lost detail, and red shows us the highlights where we've lost detail—for instance, note the red in the man's white shirt (**Figure 4.34**). We can bring that detail back by using the Recovery slider. Move the slider to the right until the red diminishes or disappears (**Figure 4.35**).

**FIGURE 4.34**
The red (highlights) and blue (shadows) near his hands indicate loss of detail.

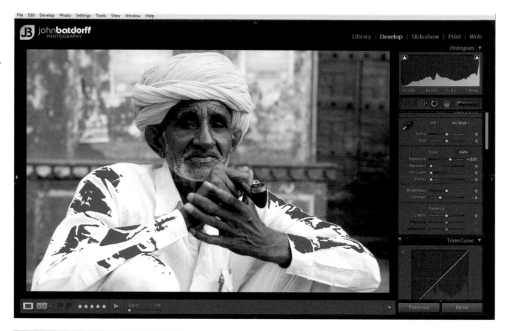

**FIGURE 4.35**
The Recovery slider is a great tool for bringing detail back into blown-out whites.

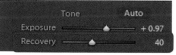

7. Increasing our Recovery slider will darken our image a little, so we may need to balance that once again with the Exposure slider until we find our happy medium.

8. Once we've finished making adjustments, we'll turn clipping off so that it doesn't distract us, by selecting J on the keyboard. Check it periodically while you are making adjustments to ensure that you aren't losing details. Remember, you will naturally lose some details in some images. Just make sure that you are willing to sacrifice them in creating your vision.

9. Next, darken the background by using the brush and burning in the background (**Figure 4.36**). We burn to darken and dodge to lighten. I like having Mask Overlay turned on so that I can see what I'm doing. Click on the Brush tool, or hit K, then click the box that says Show Selected Mask Overlay or click O on your keyboard. This will turn the areas you are brushing red.

10. Next, select a brush size. Generally I use a brush size of 10–12 when I need to cover a large area, as we are doing with the background of this image. I like having my Feather setting at 75 and Flow at 35.

11. Now, let's paint in the background around the subject while holding down the mouse and covering the areas we want to darken with the brush. Once finished, we'll uncheck the Show Selected Mask Overlay box or hit O again, and use the

Brightness slider to burn or darken the midtones in the background. This helps the subject come forward from the background.

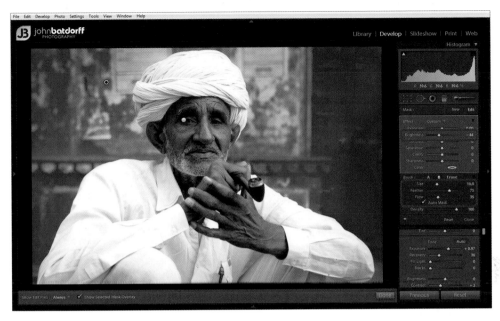

12. The subject's eyes are still a little dark, so we use a much smaller brush this time to dodge the area around his eyes. Once finished, we increase the exposure to brighten the areas where we've brushed (**Figure 4.37**).

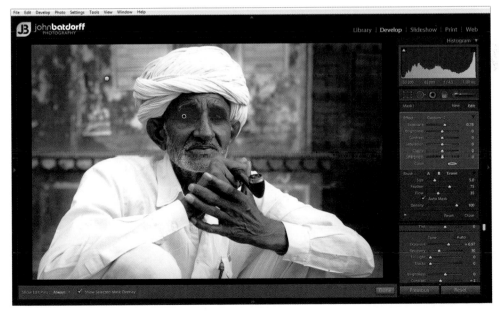

FIGURE 4.37
We use a smaller brush size for the delicate work of painting around the eyes.

13. We also want to lighten the subject's turban, so we go to the HSL/Color/B&W panel and use the Targeted Adjustment tool to click on his turban. Then we use the keyboard's arrow up key to lighten it (**Figure 4.38**).

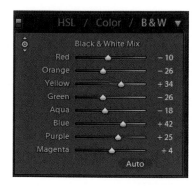

**FIGURE 4.38**
The selection tool lets us target a particular area of an image.

14. This is when I typically add contrast to my image. The easiest way to do this is to use the Contrast slider in the Basic panel. But I prefer using the Targeted Adjustment tool in the Tone Curve panel. We use the tool to select areas on the image that we think need to be darkened or lightened. Click on a point in his face to lighten it and a point in the background to darken it. In the end, we put a very small S-shape in the Tone Curve graph (**Figure 4.39**). (If you're a beginner, begin with the Contrast slider and work your way up to the Tone Curve panel.)

15. In many portraits I add a small vignette. Here, we choose the Highlight Priority style vignette that is located in the Effects panel. I don't like to go overboard, but I think a small vignette does a nice job of focusing your attention on your subject (**Figure 4.40**).

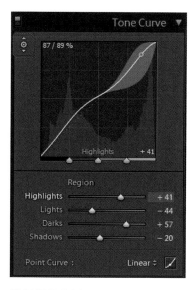

**FIGURE 4.39**
Our work has produced a small S-shape in the tone curve.

**FIGURE 4.40**
I like creating a light vignette using the Highlight Priority preset.

16. Finally, we sharpen the image a little using the Wide Edges preset that is standard with Lightroom. It is located in the presets under Sharpening (**Figure 4.41**).

17. To review our final image, we hit the L key twice to turn the lights out. This gives us a true sense of how our final product will look (**Figure 4.42**). If we're happy with it, we'll give it a green label (press 8 on your keyboard). For me, that means it's ready to be shared on my blog or printed.

| | Sharpening - Narrow Edges (Sc... |
| | Sharpening - Wide Edges (Faces) |

**FIGURE 4.41**
I use Lightroom's Wide Edges preset for sharpening portraits.

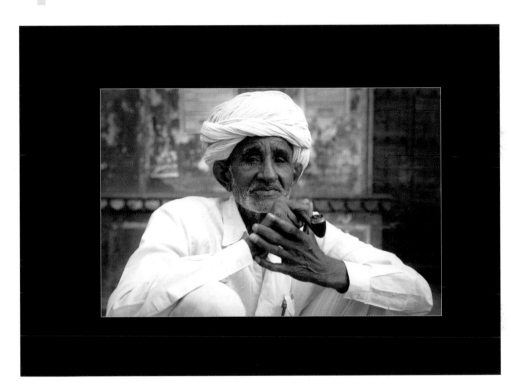

**FIGURE 4.42**
I review all my final images in Lights Out mode.

## HOT TIP

When using Lights Out mode, select L once to dim your screen, twice to view only the image, and three times to go back to your original screen.

# Chapter 4 Assignments

### Create a New Preset

A simple way to create your own preset is to begin by modifying an existing one. Click on an existing preset and make adjustments that suit your style of photography, then rename and save it as a new preset.

### Organize Your Presets

Once you've been working in Lightroom for a while, I recommend organizing your presets based upon your workflow. If you find yourself working with particular presets over and over, consider grouping them in their own folder.

### Organize Your Library

Lightroom provides great tools for organizing your image library. Create a system using star ratings, color labels, and flags to help you get a grip on your growing collection of images.

### Understanding History

Make several adjustments (cropping, exposure, and so on) to an image in the Develop module. Now review those changes in the History panel, located on the left side of the screen. Practice moving your cursor down the History panel and selecting previous edits. Notice how your image reverts to that stage in the history. Understanding the History panel helps you avoid resetting the entire image to its initial state.

*Share your results with the book's Flickr group!*

*Join the group here: www.flickr.com/groups/blackandwhitefromsnapshotstogreatshots*

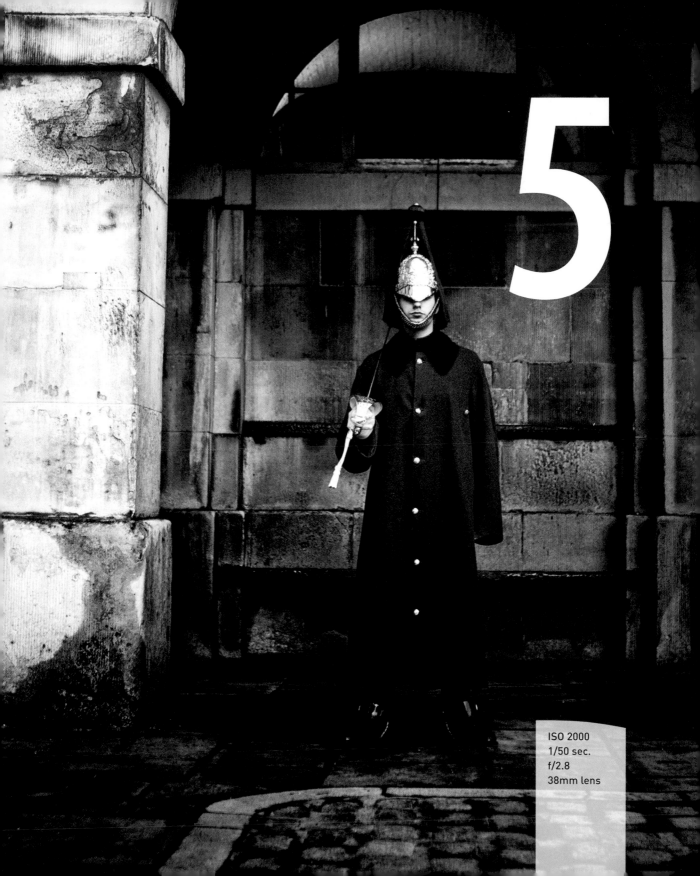

5

ISO 2000
1/50 sec.
f/2.8
38mm lens

# Black-and-White Effects

## DEFINING YOUR STYLE USING SILVER EFEX PRO

Nothing has changed the way I edit black-and-white images more than Nik Software's Silver Efex Pro. There are a lot of third-party software plug-ins that streamline our post work, but when it comes to black-and-white postprocessing, nothing in my opinion is as easy, fun, and powerful as this program. I've broken this chapter up into three lessons. First, we're going to take a brief tour of Silver Efex Pro's interface, then I'll discuss how I get my images into SEP, and finally, we're going to edit some images from beginning to end.

I was visiting a temple in India when I saw this young monk pacing the courtyard and reading. His stature and brightly colored clothes grabbed my attention. To my surprise, when I processed the image in color, it just didn't work. Unfortunately, its black-and-white counterpart wasn't any better. It wasn't until I used Silver Efex Pro's Selective Colorization feature that I created the image I had envisioned, by bringing together the best of both worlds.

Using a fairly wide aperture of f/4 allowed me to blur the background.

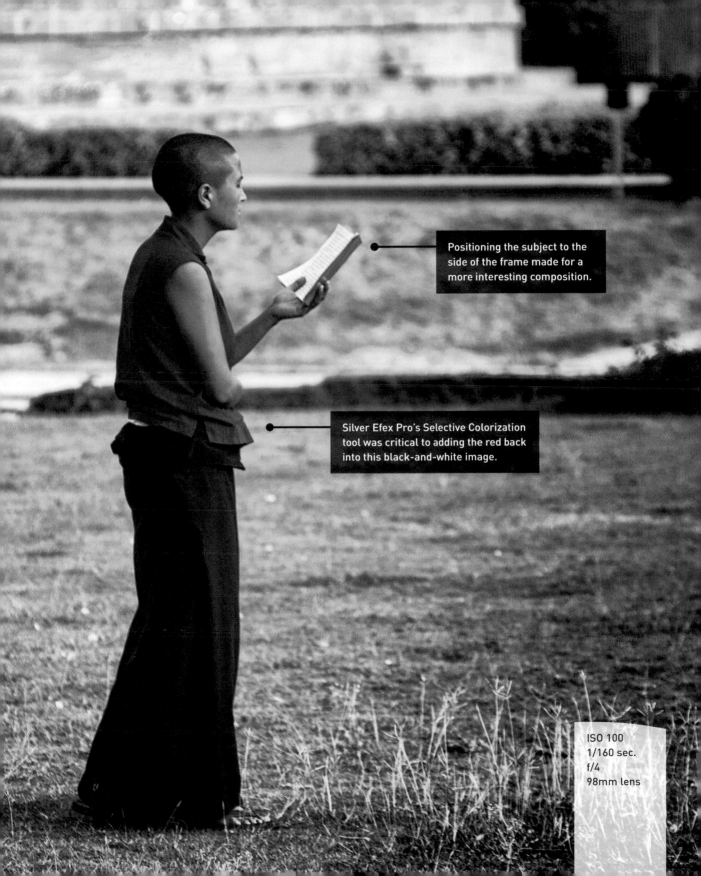

Positioning the subject to the side of the frame made for a more interesting composition.

Silver Efex Pro's Selective Colorization tool was critical to adding the red back into this black-and-white image.

ISO 100
1/160 sec.
f/4
98mm lens

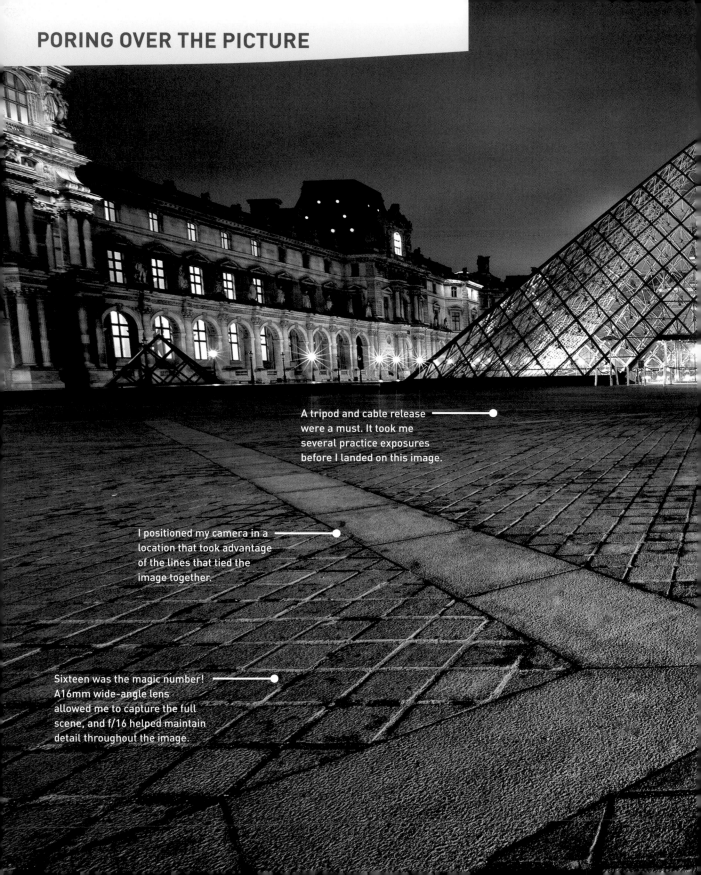

# PORING OVER THE PICTURE

A tripod and cable release were a must. It took me several practice exposures before I landed on this image.

I positioned my camera in a location that took advantage of the lines that tied the image together.

Sixteen was the magic number! A 16mm wide-angle lens allowed me to capture the full scene, and f/16 helped maintain detail throughout the image.

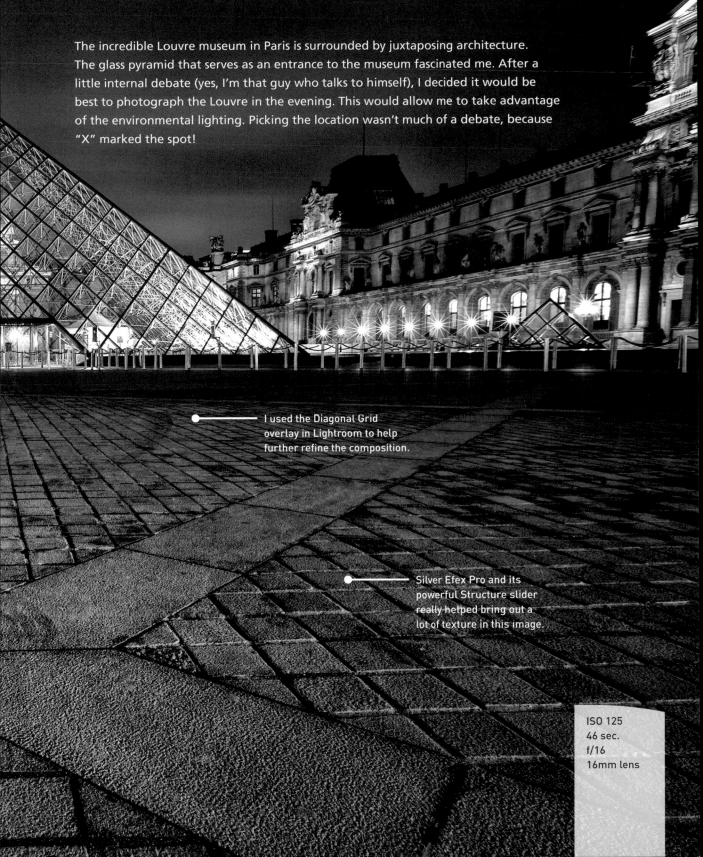

The incredible Louvre museum in Paris is surrounded by juxtaposing architecture. The glass pyramid that serves as an entrance to the museum fascinated me. After a little internal debate (yes, I'm that guy who talks to himself), I decided it would be best to photograph the Louvre in the evening. This would allow me to take advantage of the environmental lighting. Picking the location wasn't much of a debate, because "X" marked the spot!

I used the Diagonal Grid overlay in Lightroom to help further refine the composition.

Silver Efex Pro and its powerful Structure slider really helped bring out a lot of texture in this image.

ISO 125
46 sec.
f/16
16mm lens

While visiting Nairobi I spent some time wandering the backstreets, scoping out local markets for images. Sometimes we need to use all of our senses to find images and not rely solely on our eyes. In this case, my nose led me to this gregarious street vendor peddling freshly charred bushbuck. I was tempted to sample his fare, but having learned my lesson about food-borne illness less than a year before in India, I decided to pass and settle for some memories instead.

I was in tight quarters, so a 40mm focal length lens on my full-frame body allowed me to capture the scene.

I used a Silver Efex Pro Film preset as a starting point for my adjustments.

Using a guide can help break language barriers while traveling abroad.

I decided to use the food as the main focus for this image.

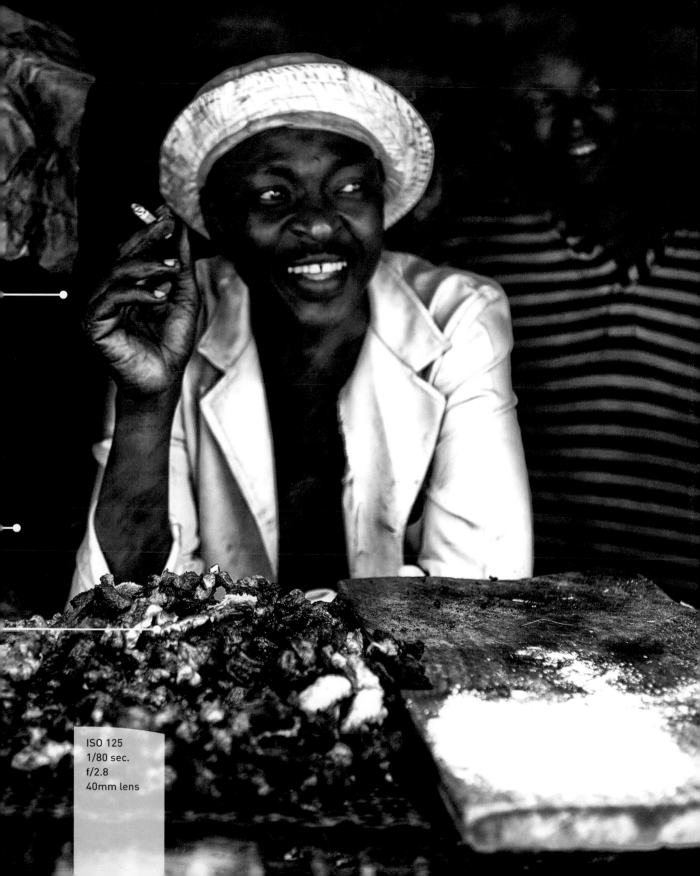

ISO 125
1/80 sec.
f/2.8
40mm lens

# SILVER EFEX PRO

No other plug-in has done as much for digital black-and-white photographers as Nik Software's Silver Efex Pro (SEP). What makes Silver Efex Pro so unique isn't the interface (which I love) but the behind-the-scenes algorithms that have been created from the ground up. These algorithms have been specifically designed with one intention only—to provide a rich set of features, that work seamlessly together in creating exceptional contrast and tonal control throughout a black-and-white image (**Figure 5.1**).

I'm not here to sell you plug-ins, but in all honesty, it's hard for me not to get excited when I'm talking to other black-and-white photographers about SEP. Let's move forward and explore some of SEP's features, and you'll understand why.

FIGURE 5.1
I used SEP Soft
Contrast to add
depth to this image.

ISO 400
1/200 sec.
f/7.1
70mm lens

## SILVER EFEX PRO VS. SILVER EFEX PRO 2

I started using Silver Efex Pro many years ago when it was first released, and the control it gave me over my black-and-white photography felt revolutionary. But there were things the program didn't do well: Namely, it lacked the ability to look through the user's history and had limited selective points. Thankfully, the good folks at Nik Software listened to photographers and made enhancements to the algorithms and interface to provide even more control.

Now, if you own Silver Efex Pro you can still make beautiful black-and-whites (I have for years), but if you spend a lot of time in the program and want to take it to the next level, then I really recommend the upgrade to Silver Efex Pro 2. For our purposes, I'll be working with the second version of Silver Efex Pro. Many of the features I'll be outlining will work in both versions. To review a complete list of enhancements, please go to www.niksoftware.com.

## GETTING TO KNOW SEP

Let's spend a few minutes reviewing Silver Efex Pro's interface and some of the basic tools you'll be using during editing. I think you will find that the interface is very easy to navigate once you've worked with it for a bit. If you're familiar with Lightroom, then Silver Efex Pro's layout will feel like second nature in no time. Let's take a stroll around the interface (**Figure 5.2**).

FIGURE 5.2
This is the main display, where we'll be doing our editing.

## TOP MENU

We'll take a look at the following features, from left to right.

### BROWSER CONTROL

**FIGURE 5.3**
Change your browser view by selecting one of three options.

Our first three options in the menu primarily control the left panel view but also gain us access to important features, such as history. You can collapse the left panel by selecting the Hide Preset browser (**Figure 5.3, A**). To navigate back to the Presets view, select the Show Preset browser (**B**). To view image adjustment history, click the Show History browser (**C**).

### IMAGE PREVIEW MODES

**FIGURE 5.4**
Select single image view or one of the two image-compare views.

One of the first things I do in SEP is set up how I'll be viewing images. You have the option to view your image in single image view (**Figure 5.4, A**), split preview (**B**), or side-by-side preview (**C**). You can alter your view simply by clicking on any one of the three boxes. I begin most of my image edits in the default split-screen mode. This allows me to make sure that I like the changes I'm making by seeing the before and after in split screen. Once I've decided on a direction in my processing, I'll select single image view so that I can view the image larger and focus on the details.

### COMPARE BUTTON

**FIGURE 5.5**
Press the Compare button to toggle between the before and after views.

The Compare button allows you to toggle between the newly edited black-and-white, the original converted image, or any of the states selected by the History State selector. Keep in mind, the Compare button works only in single image view mode. Simply press the button to compare the images (**Figure 5.5**).

### ZOOM TOOL

The Zoom tool is excellent for reviewing images and identifying potential problems such as dust, noise, or halos. To activate, simply click on the magnifying glass or press your spacebar, and the Navigator window will pop up, enabling you to pan around the image (**Figure 5.6**). To toggle back to your original view or change your viewing percentage, click on the magnifying glass a second time or press your spacebar. The default is 100%, but you can change the percentage to suit your needs.

We can change the background color by pressing the Lightbulb icon, shown in **Figure 5.7 (A)**, located directly to the right of the Zoom tool. Your background options are similar to those in Lightroom: black, gray, and white. Once again, I prefer to work with a black background because it helps me visualize the contrast within an image. Just as in Lightroom, you'll want to set this based on your preference.

The last tool in the top menu is the Hide or View Adjustments panel. You can choose to hide the right panel simply by clicking on the rectangular-shaped icon (**B**), or you can press the Tab key to close both the left and right panels at the same time. This may be helpful when you are previewing a final image and want a less cluttered view. Press the rectangular icon or the Tab key again to return the panels back to the screen view.

**A    B**

## THE BROWSER PANEL

The left panel is where you'll find two very important tools: Presets and the History browser. Let's review each of these features further.

### HISTORY BROWSER

This is another terrific new feature of the updated version of SEP. It allows you to see all of the adjustments you've made to an image in chronological order. Clicking on any adjustment will take you back to that state in time of your image. This is especially helpful if you get carried away and realize you don't like the path you're on. Just click on a previous point and continue on a different path.

Remember, if you make any adjustments after clicking on a previous place in your editing history, you will permanently lose everything you did after that. However, if you don't make any adjustments, you can click on your most recent state and continue editing your image.

A great way to determine if you like the changes you've made is to use the History State selector (**Figure 5.8**). Slide it down in your history to select a state in your editing that you'd like to compare with your current image. You can even go as far back as your original color image, or use the originally converted black-and-white state (000 Neutral) to compare with your final image.

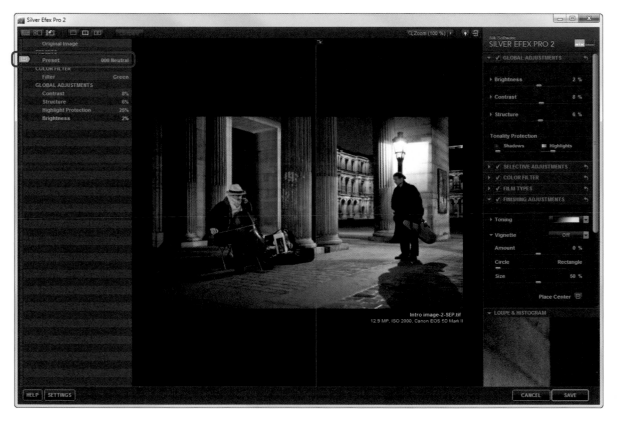

FIGURE 5.8
Use the History browser to view and compare previous stages in the edit.

## PRESETS

The Preset Categories panel, on the left of the screen, organizes all of your standard presets as well as any newly imported or customized ones. SEP ships with nearly 40 presets, which have been broken down into one of three categories: Modern, Classic, or Vintage. You can view all of the presets by selecting All (**Figure 5.9**) or just view Favorites. To add a preset to Favorites, simply click the star at the bottom of any preset and it will be added to your Favorites list.

It is important to note that your original imported image will always be at the top preset, labeled 000 Neutral. I think of this as the reset preset. At any point along the way, if you want to go back to your original image, simply press the Neutral preset and you'll be taken back to your starting point.

Whenever you select a preset, it makes adjustments that can be viewed on the right panel. In this aspen leaf image, I selected the High Structure (smooth) preset. Notice the adjustments it made to the Structure slider (**Figure 5.10**). It increased the Structure and Midtones settings while decreasing the Fine Structure setting.

Each preset has a unique look and will affect the right panel differently. While we'll be discussing the right panel controls in a bit, it's a good habit to select presets and review their effects on the Adjustments panel. If you like the look of a given preset, this will help you visualize the individual changes that are being made. Then you'll know what to look for when you are using custom editing tools.

It is very easy to add more presets. You can create your own and save them as custom presets or import new presets from a number of sources. The source I typically use is Nik Software's website. It offers well over 40 additional presets for free download (**Figure 5.11**).

**FIGURE 5.9**
Choose to view presets by category, or peruse them all.

**FIGURE 5.10**
This is one of my favorite sliders—I use it on almost all of my images.

**FIGURE 5.11**
You'll find many more presets to download on Nik Software's online site.

# THE ADJUSTMENTS PANEL

I think of the right panel as the darkroom's digital toolset. It is here that we get to be creative and truly take control of our image. As in Lightroom, many of the editing tools have been laid out in a typical workflow fashion, meaning you make adjustments starting at the top (Global Adjustments) and work your way down (Finishing Adjustments). There is nothing wrong with clicking on a preset and calling it good if you're satisfied, but sometimes a preset just doesn't get your image where you want it. Let's quickly review the Adjustments panel and then move on to its practical use in processing images.

## GLOBAL ADJUSTMENTS

The Global Adjustments tools, Brightness, Contrast, and Structure, will make corrections to an entire image. Each slider can be adjusted independently, and if you want greater control within that slider, simply expand it by clicking on the triangle (**Figure 5.12**). The Structure slider is similar to Lightroom's Clarity slider, but in my opinion SEP's Structure slider does a much better job of adding dimension and texture. SEP's algorithm is written specifically for black-and-white images, and you can really tell the difference with this slider. SEP's algorithm maps your image into zones, so when you make adjustments it changes the pixels based on their individual placement, brightness, and an array of other factors. Remember, you can reset any adjustment you make by clicking the reset arrow on the right.

Tonality Protection allows photographers to avoid loss of detail in an image's shadows or highlights (**Figure 5.13**). This feature is very similar to Lightroom's Recovery slider.

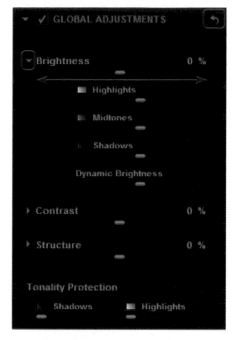

**FIGURE 5.12**
Make adjustments to an entire image using the Brightness, Contrast, and Structure sliders.

**FIGURE 5.13**
Make sure you're not losing any detail in your highlights or shadows by using this feature.

## SELECTIVE ADJUSTMENTS

Moving down the panel, now we come to the Selective Adjustments section. You can create a selective adjustment by clicking Add Control Point and positioning the control point on a desired location on your image (**Figure 5.14**). This is my favorite feature, possibly the number one reason I use Silver Efex Pro 2. Using Nik Software's U Point technology, we are able to control the tonality, structure, and selective color of any particular region of our image. The ease and precision with which I'm able to navigate these adjustments allows me to focus more on the image and worry less about the technical how-to.

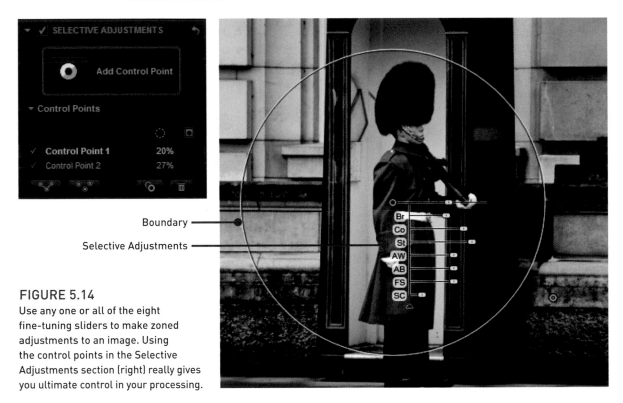

Boundary

Selective Adjustments

### FIGURE 5.14
Use any one or all of the eight fine-tuning sliders to make zoned adjustments to an image. Using the control points in the Selective Adjustments section (right) really gives you ultimate control in your processing.

If you wish to see the specific region of your image that is being affected by a particular control point, then click on that control point's Show Selection box (**Figure 5.15**). This is extremely helpful when you're trying to isolate an individual region of an image and not alter any other regions.

I find it helpful to group control points that are performing similar functions (such as selective color). To group the points, highlight the points in the panel by holding down the Shift key and selecting all of them. Now, click on the Group Selected Control Points button (**Figure 5.16, A**), which we'll call Group for short, immediately below to group them. Make your adjustments to the grouped control points using the sliders. To ungroup the control points, simply select the master point and click Ungroup button (**B**). To duplicate a control point (**C**), highlight the control point you wish to duplicate and press Ctrl+D (PC) or Command+D (Mac). You can delete a control point by selecting it and clicking on the trash can (**D**) or by selecting the point and pressing the Delete key.

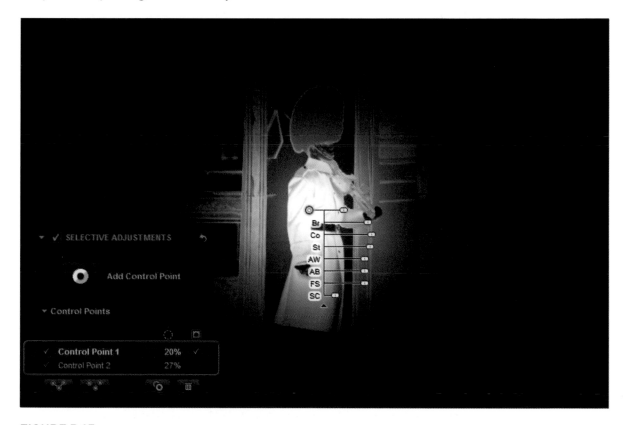

**FIGURE 5.15**
Select the Show Selection box to see what area of the image you are isolating when making adjustments.

A       B           C   D

**FIGURE 5.16**
Grouping your control points can remove a lot of clutter.

## COLOR FILTERS

As I mentioned in earlier chapters, this is where I apply almost all of my color filter effects (**Figure 5.17**). SEP ships with six easy-to-use filter presets: Neutral (no color effect), Red, Orange, Yellow, Green, and Blue. Use any of the six for a quick adjustment, or if you wish to take more control, use the Hue and Strength sliders. Remember, you can toggle between your before and after views by clicking the check mark next to Color Filters.

**FIGURE 5.17**
Click the check mark box on and off to preview the before and after effects.

## FILM TYPES

Those of you yearning for the good ol' days of film are going to enjoy working with the Film Types section of SEP. You get 18 types of film to choose from, and each simulates a film's sensitivity to color, grain, and tone (**Figure 5.18**). These film presets will affect the Color, Grain, and Tone Curve settings (**Figure 5.19**). As with the other presets, you can click and be done with the edit or customize further by using the Grain and Hardness sliders.

|  | Neutral |
| --- | --- |
| ISO 32 | Kodak ISO 32 Panatomic X |
| ISO 50 | Ilford PAN F Plus 50 |
| ISO 100 | Agfa APX Pro 100 |
|  | Fuji Neopan ACROS 100 |
|  | Ilford Delta 100 Pro |
|  | Kodak 100 TMAX Pro |
| ISO 125 | Ilford FP4 Plus 125 |
|  | Kodak Plus-X 125PX Pro |
| ISO 400 | Agfa APX 400 |
|  | Ilford Delta 400 Pro |
|  | Ilford HP5 Plus 400 |
|  | Ilford XP2 Super 400 |
|  | Kodak 400 TMAX Pro |
|  | Kodak BW 400CN Pro |
|  | Kodak Tri-X 400TX Pro |
| ISO 1600 | Fuji Neopan Pro 1600 |
| ISO 3200 | Ilford Delta 3200 Pro |
|  | Kodak P3200 TMAX Pro |
| Custom | Custom |

**FIGURE 5.18**
Use the film presets to give your digital image the look of film.

**FIGURE 5.19**
Customize your film further using the various sliders.

## COLOR SENSITIVITY

Using sliders for colors, we're able to lighten or darken a particular color simply by moving the slider left (darker) or right (lighter) (**Figure 5.20**).

## LEVEL AND CURVES

We use the Levels and Curves feature (**Figure 5.21**) to control the brightness and contrast of our tones. To add a point, either click on the graph, or, using my preferred method, click on the line and drag up or down. To remove a point, double-click on that point.

Darker ← → Lighter

**FIGURE 5.20**
Use these to control individual colors within an image.

**FIGURE 5.21**
Often I'll create a gentle S with the tonal curve.

## FINISHING ADJUSTMENTS

Now that we've briefly discussed global adjustments and selective adjustments, let's move on to finishing adjustments. The Finishing Adjustments section really allows us to get creative with our images by applying old-school darkroom techniques such as toning, vignettes, and burned edges. Toning is a term used in the darkroom for changing the color or tone of a print—sepia and selenium are two popular versions of this technique. The beauty of today's digital darkroom is that we no longer need chemicals to change the silver in an image or the color of the paper. We can use one of the 23 presets or create our own custom tone by using the Silver and Paper sliders. I used the Coffee Tone preset (number 13) to apply a soft, warm filter to this image (**Figure 5.22**).

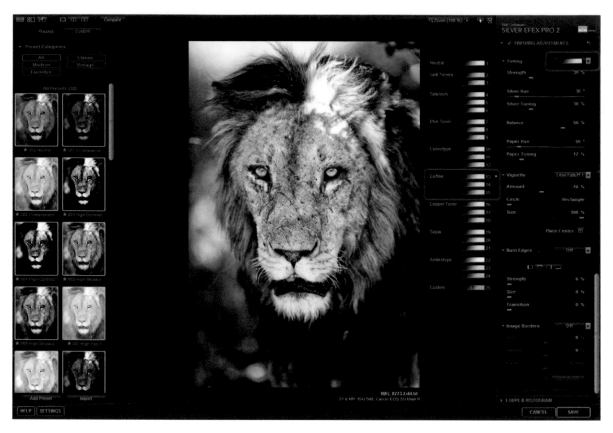

**FIGURE 5.22**
The Coffee Tone preset adds a slight warming effect to this image of a lion.

## VIGNETTES AND BURNED EDGES

A vignette allows us to darken or lighten the edges of an image to give it a natural frame and draw the eye to the focus point. A vignette can be either circular or rectangular. In SEP, you can use one of the seven presets (**Figure 5.23, A**) or manually place the center location of the vignette exactly where you want it using the Place Center tool (**B**).

I'm a big fan of the Lens Falloff presets. In fact, I used the Lens Falloff 1 preset to apply a small vignette to image of the lion.

Burn Edges (**C**) is an incredibly handy tool for directing viewers' attention to your subject. In this image, I burned in around the bottom to draw more attention to the lion's face (Figure 5.23). In order to use this feature in Lightroom, you would need to use the graduated filter or the adjustment brush and paint in the area you want to darken. This feature in SEP saves you a lot of time, especially if you are making a

large, horizontal burn at the bottom, top, or sides of the image. This can also work just like a gradient tool to darken an overexposed sky.

## IMAGE BORDERS

The Image Borders (**D**) feature is a fun way to add a little something to your image. I'm sure these borders will be a favorite among portrait photographers. Select one of the 14 presets, and customize from there using the sliders. When you select certain presets, you have the option of the Vary Border feature. This is a slick tool that generates border variations of any particular style. Click through them to see the variations on your selected border.

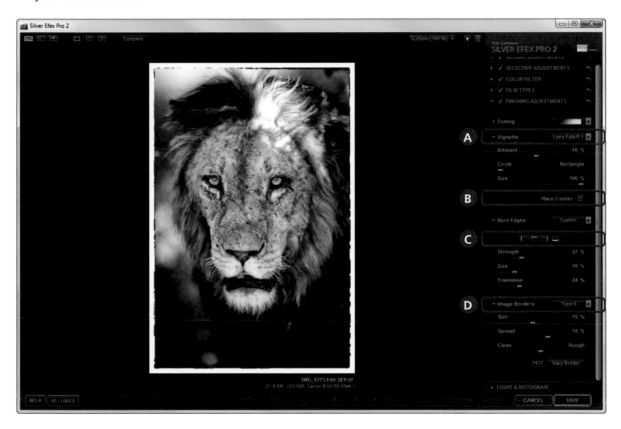

**FIGURE 5.23**
Choose exactly where you want the center of your vignette to be by using the Place Center tool.

# SETTING UP FOR SILVER EFEX PRO

Now that we've briefly discussed many of the features of SEP, let's delve into how you get your images into the program to start working with them. First, we're going to set things up for exporting into Silver Efex Pro, then we'll look at how I select images, and finally, we'll run through a few exercises. Now that you know what these features do, I want you to see how I actually put them to work.

## FILE SELECTION

We want to work with the best possible file format in Silver Efex Pro, so it's important to set up our Lightroom external editing preferences correctly. There is no sense in using such a powerful program if we aren't working with the best files possible. So, in Lightroom:

1. In your main Preferences, locate the External Editing tab (**Figure 5.24**).

**FIGURE 5.24**
Customize your settings for the best possible image quality.

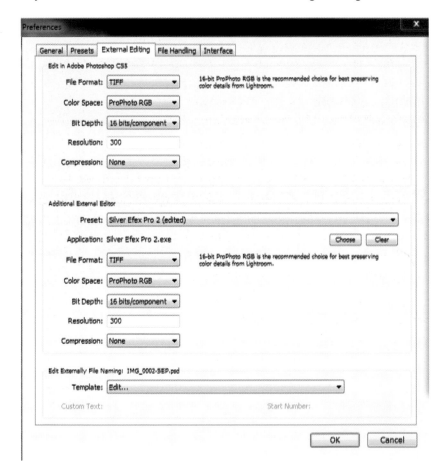

2. Go to the Additional External Editor section and select Silver Efex Pro 2 from the preset list.

3. Leave the file format set to the default TIFF, because that format can be opened and used effectively in other programs.

4. For Color Space, make it match what you're using in Lightroom. This is important. I use ProPhoto RGB for all my work.

5. Choose 16 bits/component. This will preserve the most tonal information.

6. For resolution choose 300 (this is my default resolution).

7. For Compression, choose None.

8. Click OK to save all changes to the External Editing tab.

## SELECTING AND EXPORTING TO SEP

Now that we have everything set up for export, let's discuss how to go about selecting an image to export into Silver Efex Pro. I do this exactly the same way I did in Chapter 4. I use a five-star rating to narrow my field of candidates and use presets to help me determine what direction I want to go with my processing. As a general rule, if it looks decent in a Lightroom preset I know it's going to look great in SEP. Let's go through how to import an image together:

I've selected this photo of a guard from a recent trip to London. I very quickly previewed the image using the Lightroom B&W Creative Look 3 preset (**Figure 5.25**). I liked how the image looked, so I decided to take it into Silver Efex Pro 2. You might be asking, "Why don't you just export into SEP and use its presets?" The answer is, I do that when I know for sure that I want to edit an image as black and white. But, when I'm on the fence, I find previewing using Lightroom's preset to be a real time-saver.

Remember, each time you export out of Lightroom a new file is created, whether you edit it or not. In order to keep things moving along smoothly and to avoid littering my hard drive with files I don't need, I try to be selective in Lightroom first.

**FIGURE 5.25**
Lightroom presets can be helpful when I'm on the fence about exporting into SEP.

Once I've made the commitment to the image, I'll limit my initial Lightroom adjustments to cropping, straightening, and dust removal. After I've finished cleaning up the image and making these basic adjustments, then I'll right-click on the image and select Edit in Silver Efex Pro 2 (**Figure 5.26**).

This action will bring up a dialog box, What to Edit. I always select Edit a Copy with Lightroom Adjustments. That way any changes I've made with the image in Lightroom (cropping, dust removal, and so on) are carried over in the new TIFF file. Second, I make sure the correct choices under Copy File Options have been selected, along with Stack with Original, so once the new file is created it's stacked next to the original in the Lightroom Filmstrip and exported into Silver Efex Pro.

Right-click and select Edit In Silver Efex Pro 2

FIGURE 5.26
Right-clicking on the image will bring up the option to edit into Silver Efex Pro.

# SELECTING A MOOD

One of the benefits to using presets is they can help establish a direction for an image very quickly. When I took this photograph in London, the grit and texture of the surroundings and the unwavering stature of the guard drew me in. I knew I wanted to create a dark, moody image, and by reviewing the presets while in split window mode, I was able to compare the effects against the original image. Remember what we learned in earlier chapters: If we want a moody or gritty image, then we'll probably gravitate toward a low-key image.

I've decided to begin the process by using Low Key 2 preset as a starting point (**Figure 5.27**). I definitely like the drama this preset created, but there are a few places I want to adjust to make it my own.

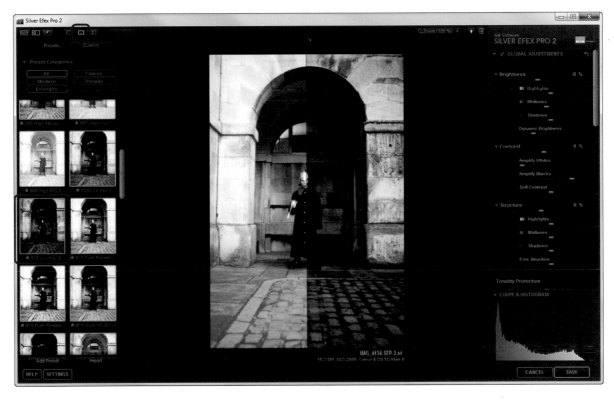

FIGURE 5.27
I find it helpful to use split screen while reviewing presets.

Before I start working on my image, I like to maximize my view by using the Show Image Only browser and removing the split screen so that I'm in single image view. When you're first learning SEP, I think it's good practice to work the Adjustments panel (right panel) top down starting with Global Adjustments, completing the editing process with the Finishing Adjustments controls.

To begin the editing process, I adjust what I call the big three: Brightness, Contrast, and Structure. Here are the adjustments made for this image (**Figure 5.28**):

Brightness (**A**): I increase the brightness from the original Low Key preset to 0, which lightens the overall image. While I increase the overall Brightness slider, I decide to decrease Midtones and Shadows to maintain a moody feeling. I use Dynamic Brightness to darken the image while maintaining my highlights.

### DYNAMIC BRIGHTNESS

This slider is a great tool to use for increasing or decreasing the brightness in an image in a complex way. Moving the slider to the left will darken an image while maintaining detail in the highlights. Moving the slider to the right will brighten an image while preserving shadow detail.

Contrast (**B**): Leaving my main Contrast slider alone, I decide to bump up my contrast by increasing Amplified Whites and decreasing Soft Contrast. Soft Contrast is a great adjustment tool when you want to increase contrast without creating that severe contrast look. If you move the slider to the right it creates a moody contrast with smooth transitions between areas, but if you move it to the left, as done here, it reduces overall contrast while preserving edge contrast.

Structure (**C**): I increase the Structure slider to bring out the texture in the image. I'm a huge fan of the Structure slider, which is probably represented in much of my work. It's very similar to Lightroom's Clarity slider, but I feel the Structure slider does a much better job of adding depth and contrast to an image.

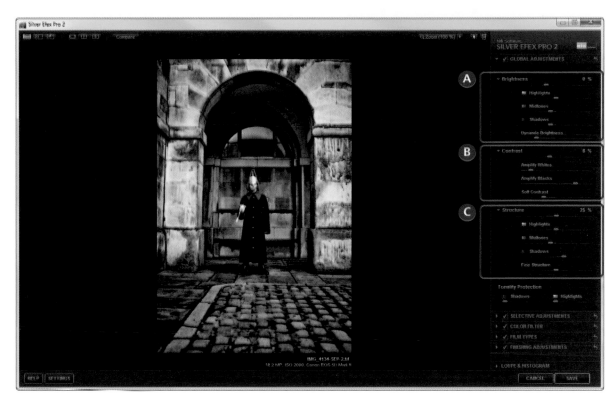

**FIGURE 5.28**
Use global adjustments to adjust the big three: Brightness, Contrast, and Structure.

## SELECTIVE ADJUSTMENTS

Once we're finished making global adjustments, it's time to move on and dissect the image. I like to look for spots where I need to lighten, darken, bring out texture, or introduce color. This is the time that I pause and ask myself, what is it that I see in this image and what are the steps I need to take to bring that vision into focus?

I've been labeled a control freak on occasion, so it's no wonder that my favorite feature in SEP is Control Points. It's not uncommon for one of my images to have 5 to 20 control points, depending on what I'm trying to achieve. I use them to make very small changes to texture, contrast, brightness, and so forth in selected areas of the image.

Remember: Use the Global Adjustments feature to change the entire image and Control Points for more selective changes. In this image I'm primarily looking to dodge and burn a few places. Let's take a look at how I use the Control Points feature in this image of the guard.

The first thing I like to do is place control points on what I call unique texture markers in an image. In this case, I place three control points on the bricks: one on the ground at the brick path the guard is standing on, and two on dark spots on the rock archway on the vertical pillars on either side of the guard (**Figure 5.29**). I create a group by selecting all three control points and clicking the Group button (**Figure 5.30**).

The goal of these three control points is to increase structure and decrease brightness. Using the group we can work one master control point to control all three areas. You still have control of the size of each individual control point, and you can ungroup the control points at any time by selecting the group and clicking the Ungroup button.

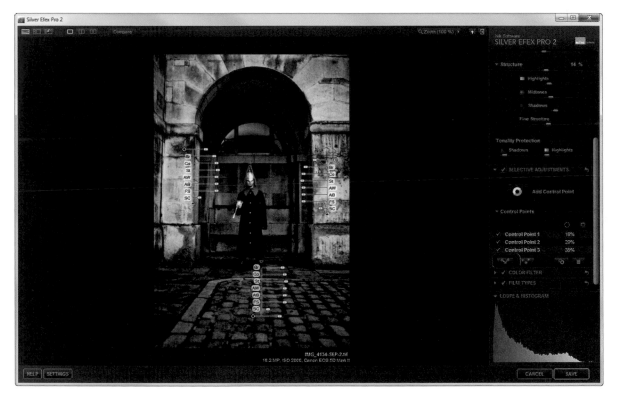

FIGURE 5.29
Use groups to effectively control different points of an image with one control point.

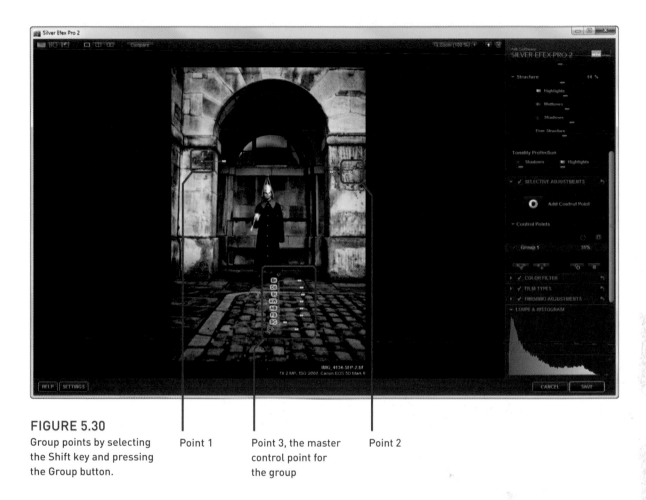

**FIGURE 5.30**
Group points by selecting the Shift key and pressing the Group button.

Point 1

Point 3, the master control point for the group

Point 2

Now we place a control point at the top of the archway to decrease brightness and maintain that dingy look. Next, we place a control point on the guard's jacket to increase brightness and bring some detail back into the jacket. In order to cover the guard's entire jacket we have to use a fairly large control point area, or boundary, which ends up slightly changing the background behind the guard. To view the effects of the control point, we turn on Control Points' Show Selection feature by selecting the box under the Show Selection column (**Figure 5.31**).

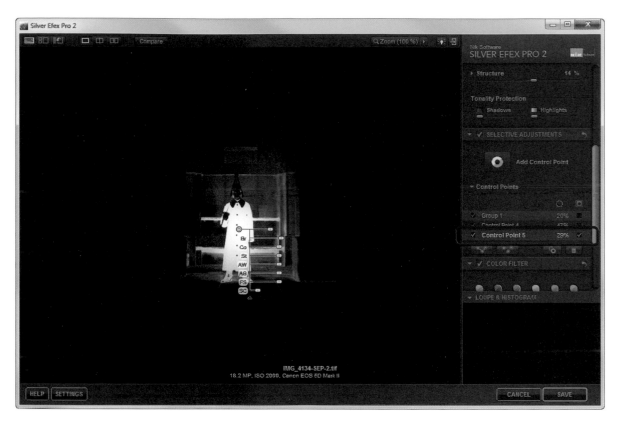

**FIGURE 5.31**
Clicking the Show Selection box for a control point will allow you to see the effects and size of the boundary of your control point.

In order to isolate the guard's jacket entirely, all we need to do is place a neutral control point around the jacket. Let me explain how this works.

Control points work using Nik Software's patented U Point technology. When you place a control point on an image, U Point analyzes that location based on its attributes, such as hue, saturation, brightness, red, blue, green, and texture. If other areas of the image are similar to those attributes, the effects may spill over. To prevent this, you place a neutral control point to tell the program that the two areas are different.

A neutral control point is what is created by default when you click on a new control point. It remains neutral unless you move the sliders. Once you place a neutral control point on an image, it then establishes itself as unique from the other control points, so by placing neutral control points near a control point with color, we're basically saying we don't want this area in color.

I've taken the liberty of placing five neutral control points around the guard. Notice how our original control point is now predominately isolated to the jacket (**Figure 5.32**). This means any adjustments made to that control point will be restricted to the area outlined in white, providing we don't increase the boundary (diameter) of the original adjustment. Let's turn our mask off by clicking on the check mark and we'll continue on.

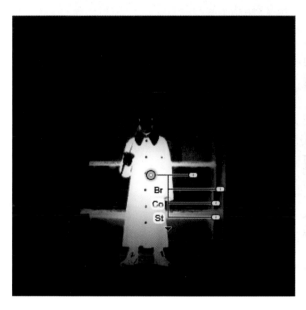 

**FIGURE 5.32**
The white (left) represents the area that this control point will affect. Using neutral control points (right) we're able to control the boundaries of our original control point.

At this point I feel pretty good about this image, but let's work our way through the Finishing Adjustments section to make one final enhancement. I would like to darken the brick walkway a bit, in keeping with the feel of a dark, moody image.

To do this, we're going to use another one of my favorite tools: Burn Edges. We're going to select the bottom edge to burn in the bricks. I like to start off by increasing the Strength slider to 20% so that the burned edge is clearly recognizable (sometimes it's difficult to see if you set the slider too low). Next, we'll increase Size for the burned edge to cover the area we wish to darken. We'll go back to the Strength adjustment and increase or decrease as needed, and then finally, we'll adjust the Transition slider to blend the burned edges into the image (**Figure 5.33**).

**FIGURE 5.33**
The Burn Edges tool burned the brick in all the way to the base of the building.

Now we have the image exactly as I want (**Figure 5.34**). It is dark, moody, and textured, and our eyes are drawn to the guard.

**FIGURE 5.34**
It took a little polishing to do, but now the image works just the way we want it to.

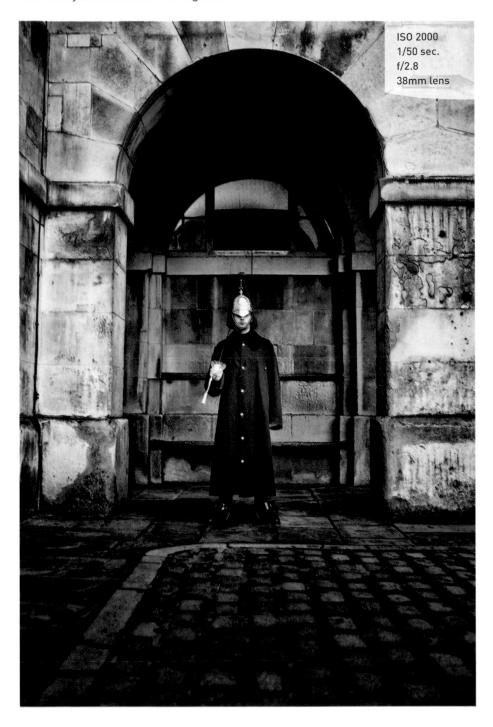

ISO 2000
1/50 sec.
f/2.8
38mm lens

# USING SELECTIVE COLORIZATION

One of the coolest things Silver Efex Pro 2 did with its recent release was to add a selective color option (aka Selective Colorization) to the control points. This means by selecting any part of an image we are able to add color back into a chosen area. Let's add color back into this image of a young monk I photographed in India.

1. Let's start by selecting a preset to create a baseline. In this case, I think High Structure (smooth) should work well (**Figure 5.35**).

FIGURE 5.35
High Structure (smooth) is one of my favorite presets to use for a baseline.

2. Head right over to Selective Adjustments, and let's start placing control points on the skin and clothing of the monk. To add a control point, select Add Control Point or use Ctrl+Shift+A (PC) or Command+Shift+A (Mac). Make the control points smaller so that the boundary doesn't leak too far over the area where

we intend to add color. Once we have all the control points in place, creating one large group will make things easier on us. To create a group, select the first and last control points while holding down the Shift key, and then click next to Group 1 (**Figure 5.36**).

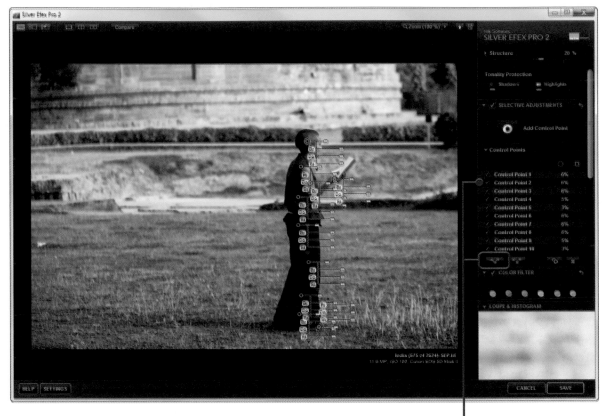

**FIGURE 5.36**
Group control points with identical settings.

Hold Shift while selecting, then click Group 1.

3. Let's use the master control point to increase the Selective Colorization slider to 100%. You'll notice that we have a little spillover of color in the image, but don't worry; we're going to fix that next (**Figure 5.37**).

4. Let's turn Show Selection on for Group 1 (**Figure 5.38**) so that we can see the area that is being affected.

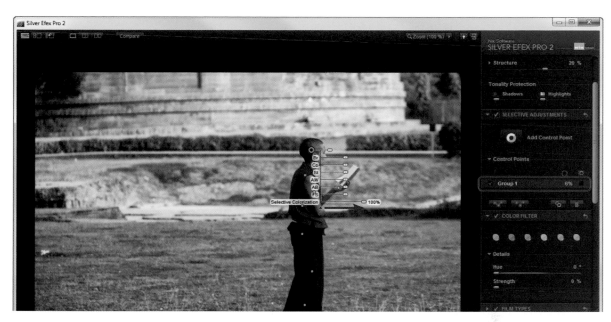

**FIGURE 5.37**
We have now added color back in, but we have a little too much. We need to be more selective.

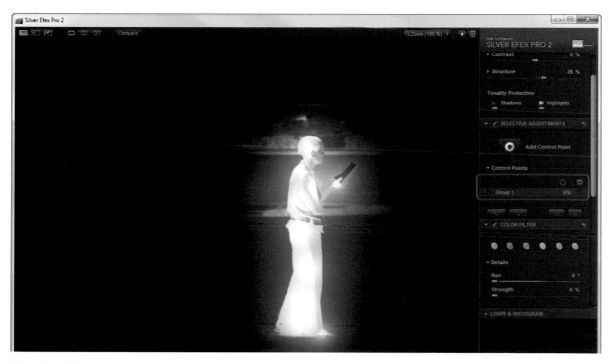

**FIGURE 5.38**
The ghostly outline is the area affected by Group 1 adjustments.

5. Next, we're going to use neutral control points to isolate the area we want in color. Let's place points around the subject. I recommend adjusting the size of these points so that none of the neutral control points overlaps the selective color subject (**Figure 5.39**).

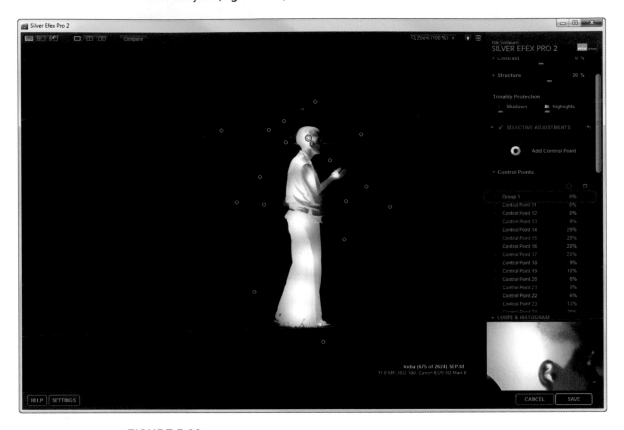

**FIGURE 5.39**
Neutral points allow us to be more accurate with our original selection—we use them to deselect areas we don't want in color.

6. Turn Show Selection off so we can see our subject in color again. You'll notice that we've effectively eliminated the spillover (**Figure 5.40**).

7. To finish this image we make a few more selective adjustments, add a small vignette, and save it back to Lightroom. Once in Lightroom we increase the vibrancy to bring out the selected colors a tad more. Here's our final image (**Figure 5.41**).

**FIGURE 5.40**
Presto—color spillover goes away.

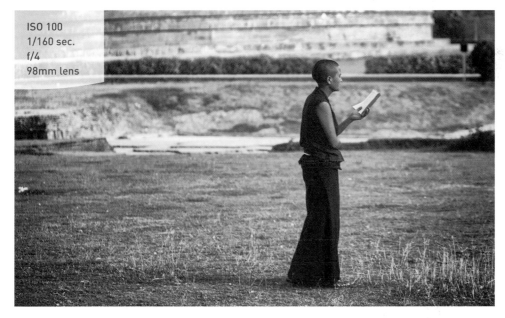

ISO 100
1/160 sec.
f/4
98mm lens

**FIGURE 5.41**
Lightroom's vibrancy adds a little something to the final edits.

# TONING

Another fun way to add color is via the Toning feature in the Finishing Adjustments panel. You can select from any of the 20-plus presets or customize your own. I only use this once in a blue moon, but it's a nice feature if you're looking to add color back to your tones (**Figure 5.42**).

Use the History State selector to identify the "before" view for the split screen, side-by-side screen, or Compare button

## FIGURE 5.42
Never say "once in a blue moon" because this feature will have you coming back for more.

This slider has always been confusing, and I've found it helpful to think of it in these terms:

- **Silver** = dark areas of an image.
- **Paper** = light areas of an image.
- **Strength** increases or decreases the saturation of the tone on the entire image.
- **Silver Hue** is the color that will be applied to the dark tones of an image.
- **Silver (dark area) Toning** is the overall strength of that hue's dark tones.

Balance is the blending of the effect between the dark and light areas of an image. Moving the slider to the left increases the effect applied to the dark areas of an image, and moving the slider to the right affects the toning applied to the light areas of an image.

- **Paper Hue** is the tone applied to the light tones of an image.
- **Paper Toning** is the overall strength of that hue on the light tones.

# FILM EFFECTS

I shot film for years, and while I don't miss working in the darkroom, I do miss the look of a black-and-white image produced from film. SEP has done a really nice job of simulating many of the popular films. Sometimes, instead of using a preset from the Preset browser, I'll begin my work by selecting a film type (**Figure 5.43**). Then, I typically head back to Global Adjustments and work my way down the panel, making a few tweaks here and there.

### CREATE YOUR OWN PRESET

If you come up with a particular film type that you like, I highly recommend creating a preset so that it is available to you for future edits. To create a preset, finish customizing your film style, and click on the Show Preset browser. Next, select Add Preset. A popup window will display. Enter your new preset's name and click OK. Now, you'll have that preset available to you in the custom preset window for future use (**Figure 5.44**).

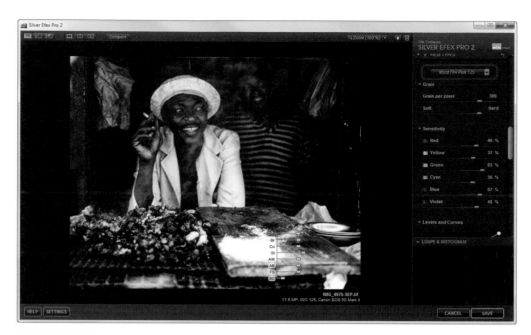

**FIGURE 5.43**
Film presets are another great way to jump-start your image processing.

**FIGURE 5.44**
I like to create custom presets using film effects.

# GOING IT ALONE

There's no doubt that presets are an asset to jump-starting any image, but many times we have a clear vision for our images that can't be accomplished that way.

Let's take a look at this image of an elephant I photographed crossing the grassy plains (**Figure 5.45**). When I framed this image, I wanted to make good use of the negative space but also draw attention to the foreground. I even envisioned a sort of postcard border effect so that I could email the image to my daughter saying, "Hey, I saw an elephant today." Let's walk through the way I created my vision using four simple tools in SEP.

First, we should darken the green grass. Let's head on over to the Color Filter section and hit the blue preset. That is a tad too dark, so let's move the Strength slider to the left to decrease the effect of the filter. Seventy percent seems to do a decent job (**Figure 5.46**).

The next step is to head up to Selective Adjustments and add a control point in the middle of the grass. Let's create a large control point boundary that encompasses the entire field. To adjust the size of the boundary, simply use the top slider on the control point. Now, let's increase Contrast, Structure, and Amplify White, and increase Fine Structure (**Figure 5.47**).

Next, we're going to turn Show Selection on for this control point and add some neutral control points to the sky. This will disable the effect of my original control point on the sky (**Figure 5.48**).

**FIGURE 5.45**
Move the History
State selector to
Original Image
in your History
browser to com-
pare your original
color image to
the current
black-and-white.

**FIGURE 5.46**
Notice how the blue
filter preset dark-
ened the grass.

**FIGURE 5.47**
Use control points to create your own style.

**FIGURE 5.48**
Using Show Selection helps us see what areas of an image a control point is affecting.

Now, let's turn Show Selection off and see how we're doing.

Things are looking pretty good. Let's head over to the Finishing Adjustments section to add a vignette and a border. We could use several of the presets, but instead I think we should create a vignette of our own. Using the sliders, let's make a small rectangular vignette (**Figure 5.49**).

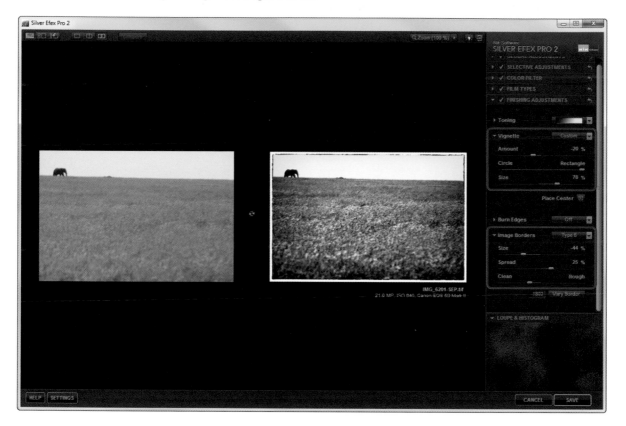

**FIGURE 5.49**
Using side-by-side view we can compare our original color image with our newly edited black-and-white.

We are almost there. We can add a border using one of the 14 presets available. In this case, I think Type 6 will do a nice job. Remember, just like with all the other presets in SEP, you can start with a preset and make adjustments from there. The Size slider controls the width of the border. The Spread slider controls the depth of the border. Move the slider to the left, and you decrease the width of the border; slide it to the right and you increase its width while decreasing the image area. The Clean/Rough slider can be used to tone down or exaggerate the style of the border. The Vary Border button will create random borders based upon your three previous settings.

I think this is a postcard I'd be happy to send home (**Figure 5.50**).

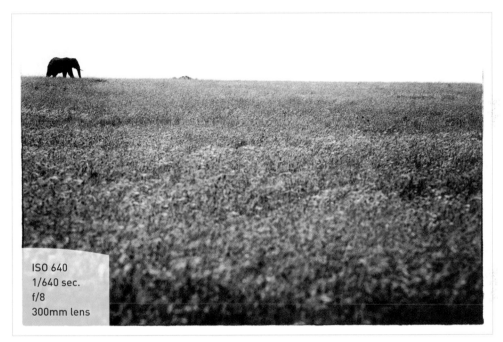

ISO 640
1/640 sec.
f/8
300mm lens

**FIGURE 5.50**
After some fairly easy tweaks, we're satisfied at last.

## KEYBOARD SHORTCUTS FOR SILVER EFEX PRO 2

| INTERFACE | WINDOWS | MACINTOSH |
| --- | --- | --- |
| Undo | Ctrl+Z | Command+Z |
| Redo | Ctrl+Y | Command+Y |
| Full screen | F | F |
| Compare/Preview | P | P |
| Zoom | spacebar | spacebar |
| Show/hide panels | Tab | Tab |
| Save | Enter | Return |
| Close application | Esc | Esc |

| CONTROL POINTS | WINDOWS | MACINTOSH |
| --- | --- | --- |
| Add control point | Ctrl+Shift+A | Command+Shift+A |
| Delete control point (while selected) | Delete | Delete |
| Duplicate control point | Ctrl+D | Command+D |
| Copy control point | Ctrl+C | Command+C |
| Paste control point | Ctrl+V | Command+V |
| Expand/Collapse control points | E | E |
| Group control points (while selected) | Ctrl+G | Command+G |
| Ungroup control points (while selected) | Ctrl+Shift+G | Command+Shift+G |

# Chapter 5 Assignments

### Get to Know Your Presets

Click on a preset, in the right-side panel, and review the adjustments it makes. This is a good way to become familiar with the effects of any given preset. Keep in mind, results will vary depending on your image, but understanding the overall effects can be useful when creating your own presets. Do this with two or three presets.

### Use Selective Colorization

Take a close-up portrait of your favorite subject and import it into SEP. Once it's in SEP, enlarge your view of the subject with the Zoom tool or the spacebar. Create two small control points and place one on each of your subject's eyes. Using the Selective Colorization slider, increase the color by moving the slider to the right. Create additional control points as needed to add more color to the image. Tip: The Loupe view section can be very helpful when placing control points.

### Add Contrast with Color Sensitivity

Let's practice adding contrast to certain colors in our image. Select the Show History browser and drag the History State selector up until the original image is selected. In side-by-side view you should see your original color image as well as the neutral black-and-white conversion. Now, navigate to the Film Types panel and scroll down to Color Sensitivity Detail. Identify colors in your image that you would like to lighten or darken. Using the appropriate slider, move it to the right to lighten or left to darken.

*Share your results with the book's Flickr group!*

*Join the group here: www.flickr.com/groups/blackandwhitefromsnapshotstogreatshots*

6

ISO 200
1/90 sec.
f/6.3
35mm lens

# Print, Post, and Share

## SHOWCASING YOUR FINAL IMAGES

As a photographer, I like to think I take images for myself, but when I really think about it, the true pleasure comes in sharing my experiences with others. I can't think of a more exciting time to be sharing this craft, whether on a casual level with friends and family or as a more serious portfolio with potential clients.

In this chapter, we're going to discuss how to take all the hard work that goes into an image and share it with the world. Some of you love the feeling of a print in your hands, and others are more concerned with getting their images online. Luckily for you I happen to love both mediums, so let's get started and show our work to others.

# PORING OVER THE PICTURE

The nasty truth about photography is that in order to get better, you need take a lot of images. And as you gain more and more experience with shooting, you'll likely find your tastes will change, too. My style has changed a lot over the years. Often, I'll go back through my archives looking for an old image to rework with my new tool set of ideas and techniques in mind. Mining old images and creating new gems can be quite rewarding if you keep an open mind.

Prior to importing into Silver Efex Pro, I used Lightroom's adjustment brush to burn in some of the lines in the image.

Using SEP's Amplify Black slider I was able to increase the black in the dark clouds without affecting the entire image.

I wanted a sharp image, so in order to photograph at f/13 I had to increase my ISO to 500.

ISO 500
1/250 sec.
f/13
125mm lens

# PORING OVER THE PICTURE

I would like to tell you that every time I press the shutter I know exactly what the outcome will be, but the truth is I don't. Half the fun of photography is experimenting and learning. I took this image of Buckingham Palace on a bright Sunday afternoon using a Lee Filter 10 Stop ND, appropriately named the Big Stopper. This filter is so dark it's impossible to focus through it. I set the shot up knowing we should get some really interesting blur effects, but the final outcome didn't reveal itself until I was in postprocessing.

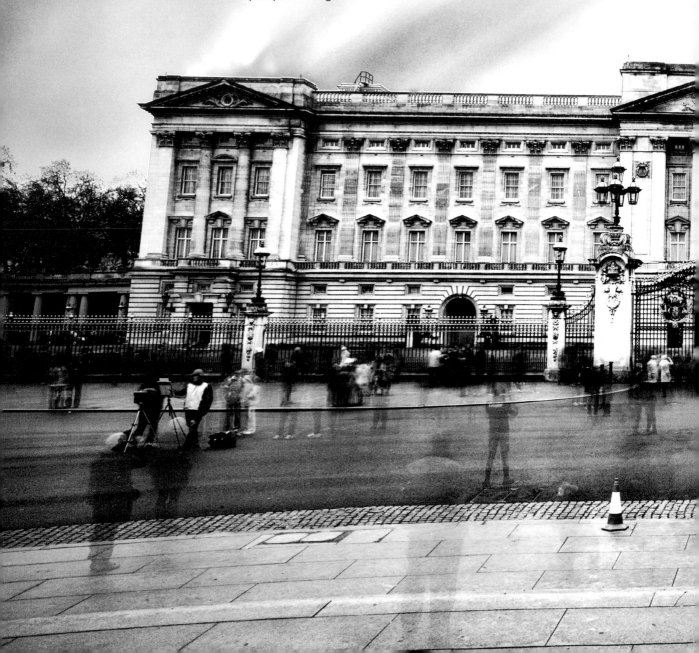

The Lee Big Stopper filter allowed me to take a very long exposure in the middle of a bright afternoon.

I further increased my exposure time by using a very small f-stop.

By using a long exposure I was able to show motion in the crowd as well as the clouds. To achieve this I used a 10 Stop ND filter.

ISO 100
90 sec.
f/22
18mm lens

# FINISHING TOUCHES

I try to scrutinize my images one last time before the first pixel ever hits the Web or lands on paper. I find that if I spend too much time early on in the processing stage looking for every last dust spot, fiber, or small imperfection, it simply throws me off my creative train of thought. I would rather work the image to fit my vision and worry about the small details at a later stage in the game.

I'm not talking about the dust spots the size of quarters, I'm talking about the little ones that you would have needed a microscope to see, but now that your 40 x 60 image is hanging in a gallery, that flaw is staring right back at you saying, "Yeah, you missed me!"

Let's take a look at this image of Devils Tower (**Figure 6.1**). I spent time removing obvious dust spots from this image prior to converting it to black and white, but now that it's in monochrome form, spots that seemed less obvious in color are more apparent.

**FIGURE 6.1**
Use the Heal or Clone brush to remove spots and unwanted artifacts from your image.

ISO 200
1/80 sec.
f/16
22mm lens

While in Loupe view in Lightroom, I like to use the rectangle in the Navigator window to scan my image, systematically looking for aberrations. I find that using a 3:1 view and starting the process at one of the top corners, then slowly working my way back and forth across the image, provides me with the best assurance that I'll catch most of the unwanted pixels.

Whenever I locate dust I use the Spot Removal tool (the Q key), with the Heal setting selected, with Opacity set to 100 (**Figure 6.2**). You can increase or decrease the size of the spot removal circle by using the Size slider or the bracket keys, [ for smaller and ] for larger.

I rarely use the Clone brush in Lightroom, but if the adjustment is fairly simple and straightforward, I'll use that tool. Otherwise, for more complicated cloning, I'll open the image up in Photoshop to make the adjustment.

FIGURE 6.2
Pan your image using a 3:1 view.

# PRINTING YOUR WORK

As a photographer, it is extremely rewarding to see your work in its printed form. I spent many years printing my own work using an Epson 2400 printer, and it's only recently that I've found myself sending more and more images to outside print houses as a means to reduce costs and gain access to the latest print technology.

But, with that said, I realize that many people still love to print their own images. Let's explore how to print in-house first, then discuss our options for sending prints elsewhere.

## HOW LONG WILL IT LAST?

Inkjet printers have evolved a long way in the last decade, and now it is safe to say that some of the higher quality printers and inks are able to produce an archival quality print that will last hundreds of years.

The longevity and stability of prints varies depending upon type of paper, humidity levels, and exposure to moisture, display settings, exposure to sunlight, and a host of other variables. But if it makes you feel any better, a black-and-white image will last nearly twice as long as its color counterpart under identical conditions.

### HOT TIP

To avoid fading in your print, frame your image under glass and avoid exposing it to direct light, cigarette smoke, and cooking fumes. UV-filtered framing glass can add 10 to 40 percent to the life span of a print, but typically comes at a higher cost.

## PAPER

There are so many types of paper on the market that it can be overwhelming to decide on one. My recommendation is to keep it simple. Start by using only a couple of papers until you have the process dialed in. I highly recommend picking a semi-gloss paper and matte paper to begin your printing career. Personally, I'm fond of Epson's Ultra Premium Luster and Brilliant Museum Satin Matte White and have found them to print with wonderful results.

### MATTE

Matte paper is a heavy stock paper with a nonglossy appearance. It is resistant to fingerprints, can be viewed under most lighting conditions, and won't reflect glare. Most matte papers will have a larger dot gain due to the porous nature of the medium, thus creating a softer-looking image. You can either use this look to your advantage or compensate for it by changing your Print Sharpening setting, which we'll discuss later.

Matte papers typically display less contrast than their glossy or semigloss counterparts due to the limitations of the dynamic range of the paper. To help compensate for this variety in brightness, finishes are available ranging from naturally fibrous feeling to smooth and unbleached to bright white.

Personally, I think black-and-whites display beautifully on a nice matte paper. I often use matte paper for an image with a lot of texture and motion, like this image of a gentleman's hands stacking charcoal (**Figure 6.3**).

ISO 100
1/30 sec.
f/4
85mm lens

FIGURE 6.3
This printed beautifully on my favorite matte paper.

## SEMIGLOSS OR LUSTER

I consider semigloss paper to be a nice cross between matte paper and gloss paper, offering some of the benefits of both. Gloss paper has a high dynamic range, which allows prints to cover a large range of tonal values. The downside of gloss is that it appears shiny or wet, shows fingerprints, and has a lot of glare.

Paper is always about personal preference, but I've never really enjoyed looking at high-gloss black-and-white images. Semigloss has a less shiny surface, reflects less light, and is more resistant to fingerprints than its glossy cousin. Semigloss still has a large dynamic range and a very low dot gain, so images appear sharp, with excellent tonal reproduction. Many of my high-contrast or streetscape shots are printed on luster paper (**Figure 6.4**).

**FIGURE 6.4**
Luster paper
works well with
this modern scene.

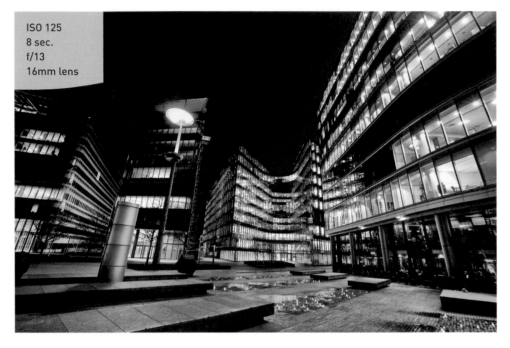

ISO 125
8 sec.
f/13
16mm lens

You'll find your own path and ways to express your images as you become more comfortable with the printing process. I recommend visiting your local camera store and talking with the professionals to see what they recommend and to feel the different types of paper before you make a purchase. You can also order a sample package from vendors such as Red River, Brilliant Paper, Epson, Hahnemühle, Ilford, and Moab (by Legend Paper), to name just a few.

## PRINTER

When it comes time to buy a printer for outputting your black-and-white images, you should consider several factors.

### WHAT SHOULD YOU LOOK FOR IN A PRINTER?

**What's your price range?** A good archival-quality printer will set you back nearly $500, and it goes up from there.

**How large do you want to be able to print?** There's a pretty big price difference between a 13 -inch-wide printer and a 17-inch-wide.

**Do you plan to print panoramics?** If so, then you'll want to consider an inkjet that can handle rolled paper. One of the benefits to rolled paper, beyond printing panoramics, is it's generally cheaper per square foot than cut sheets. However, it can be a pain to work with.

**What's the accessibility of the printer's ink?** I've been in the middle of many print jobs just to find myself running out of ink and having to wait three to four days for delivery, if I don't have a store nearby that supplies it—often the case when I'm in the mountains.

### WHICH PRINTER DO I PREFER?

I've printed for years on my Epson R2400 with wonderful results. I have found Epson inks to be top-notch and to pair very well with a variety of papers. Most important, I love what Epson has done for black-and-white printers by providing them with multiple black and gray inks as well as matte-only black ink. Last, the company has provided an incredible set of advanced black-and-white features in its print driver, dedicated for photographers just like us.

Bear in mind, this is just one man's opinion. Canon and Hewlett-Packard might also have excellent products, but I stick with Epson because that is what I am familiar with and because it's consistently worked well for me. I think you'll find when it comes to printing, it's about committing to a system. In order for your work to be consistent, it's important to understand how certain paper, ink, and printer combinations will affect your overall printed work.

## PRINTER AND PAPER PROFILES

One of the benefits of owning a nice printer and buying good-quality paper is our ability to use printer profiles. In simple terms, paper profiles give a printer a lookup table of how certain colors or blacks will reproduce on its particular paper. These standardized profiles are critical for us to accurately and consistently reproduce quality images.

The good news is, many paper manufacturers provide profiles that can be downloaded free of charge for today's most popular photo printers. If a particular paper manufacturer doesn't have a profile for your printer, then just use the generic profiles that shipped with your printer.

# PRINTING FROM LIGHTROOM

Lightroom's Print module has a robust set of features for today's photographers. We're going to hone in on how to proof our images, create printing templates, and set up our printer. Let's first review the Print module layout (**Figure 6.5**).

FIGURE 6.5
Lightroom makes printing easy.

Lightroom templates offer a variety of layouts for photographers, and they work exactly the same way as presets do. You simply click on a template and select your image or multiple images.

What I like best about the templates is they're a great way to get fresh ideas far beyond the simple 4 x 6, 5 x 7, and 8 x 10. In this example, I selected the template Custom Overlap x3 Border (**Figure 6.6**). This template is standard in Lightroom 3, and I thought it would work well with my images of Masai women.

FIGURE 6.6
Click on a template preset that you think will best showcase your images.

You can further customize many of the cells in the Custom templates by selecting the image's location (cell) and moving it. Once the images are in place, right-click on any picture and then make adjustments to how the images overlap one another (**Figure 6.7**). You can also adjust the photo's border in the Image Settings panel (**Figure 6.8**).

Select any photo
with your cursor
and drag it to
your desired
location.

Right-click on any
image to make
adjustments to
that image's cell.

The possibilities are endless, so tweak an existing layout for one-time use, or customize
your own and save it as a template for future use.

## TEST PRINTS

Monitor calibration, which we discussed in Chapter 1, is the first step in creating predictable prints. The next step is creating test prints and comparing them to what's on the monitor.

Unless you do a ton of printing and stick to a very strict diet of one or two papers, chances are you'll need to run test prints every now and then. Test prints can also be helpful in diagnosing a host of image reproduction issues, including exposure, tonal contrast, clarity, and the simple aesthetic value of printing on a matte or a luster paper.

I like to use a large 5 x 7 contact sheet (**Figure 6.9**) that allows me to put two images on a single sheet of 8.5 x 11 paper. I feel that the 5 x 7 provides a nice viewable area and works well for both the landscape and portrait orientations. Plus, it's more cost-effective to group two images together, and if I hit a home run off the bat, then I simply cut the images, stick them in a frame, or present them as gifts.

To ensure two images are displayed on a single page, make sure this is not selected.

FIGURE 6.9
If I haven't printed in a while I'll run test prints.

## PRINT JOB

Every print we make, whether it be a test or the real deal, funnels through the Print Job panel (**Figure 6.10**). This is one panel where we need to take the extra time to make sure everything is set up correctly so that we get the best and most consistent reproductions possible. Let's start by examining the features.

### PRINT DESTINATION

To send the file to your printer, make sure Print to: is set to Printer. However, in some situations I've wanted to share contact sheets with clients. In those cases, select Print to JPEG File (**Figure 6.11**) and use the Print to File button. This way you can email samples of a layout or contact sheets with ease.

### PRINT RESOLUTION

Lightroom will automatically determine your print resolution based upon page setup and layout. You need to select this only when you need to manually override the resolution.

### PRINT SHARPENING

Select your sharpening based upon the media you're using and your personal preference. Lightroom will adjust the Standard setting based upon the paper selected. Keep in mind, these changes won't be apparent onscreen and will only be applied as the image is being printed. As a general rule, I choose Standard under Print Sharpening for most of my images, and use High for images that are 13 x 19 or larger.

The results do vary by image and sometimes require me to print full-size test sheets to dial in the correct sharpness (**Figure 6.12**).

FIGURE 6.10
Take your time and set it up right to avoid wasting supplies and time.

FIGURE 6.11
Use this feature to email contact sheets or print layouts.

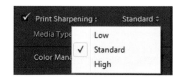

FIGURE 6.12
Select your desired level of sharpening for your image.

## MEDIA TYPE

Under Media Type, you have the choice of Matte or Glossy. Glossy is the setting you'll use even for semigloss or luster.

## COLOR MANAGEMENT

Managed by Printer is the basic selection under Color Management, and frankly, one that I never use. Instead, I generally use a paper profile. In this case, I'm selecting BrlMusSatMatWhtEp2400MK— short for the Brilliant Museum Satin Matte White profile that's been created specifically for my Epson R2400 (**Figure 6.13**).

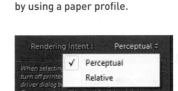

**FIGURE 6.13**
Get the most out of your printer by using a paper profile.

## RENDERING INTENT

Here's my advice when deciding whether to use Perceptual or Relative under Rendering Intent (**Figure 6.14**): Create a print test like I described earlier in the chapter using images that reflect your personal style. Now, print one set using Perceptual and the other using Relative and make sure to mark the back of your images so you don't get them confused.

**FIGURE 6.14**
Select your rendering option.

Once you're done, simply compare the results and decide which rendering selection does a better job with your paper and printer combination. I have found different Rendering Intent techniques work better on different paper. As a general rule I'll use Relative for my color work and black-and-white luster and Perceptual for my matte black-and-whites.

## PRINT

Select the Print button to open up the Print dialog box.

On a PC: Make sure your printer is selected on the list of available printers and select Properties (**Figure 6.15**).

Next, it's very important to make sure the correct paper type has been selected (**Figure 6.16**) to guarantee the proper quality settings. Most printers have several levels of print quality ranging from draft to best. Make sure you select the highest photo setting available. Next, locate your printer's Color Management section and make sure all color adjustments are turned off so that they don't interfere with the printer profile (**Figure 6.17**).

FIGURE 6.15

Select your printer, then select Properties if using a PC.

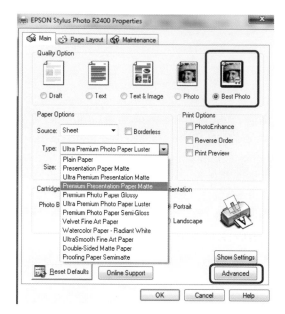

FIGURE 6.16

Select your paper grade and the best available photo setting.

FIGURE 6.17

Printer Color Management should be set to Off (No Color Adjustment).

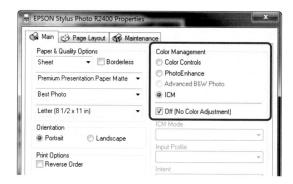

**On a Mac**: After you choose your printer in the Print dialog box, select Print Settings (**Figure 6.18**). Once in the Print Settings menu make sure the correct Media Type is selected and that Color Settings has been turned to the Off (No Color Adjustment) position (**Figure 6.19**). Next, you'll want to make sure to set Print Quality to its highest standard.

Once you have all the settings right, just make sure your printer is loaded with the correct paper, and hit the Print button.

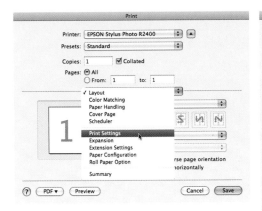

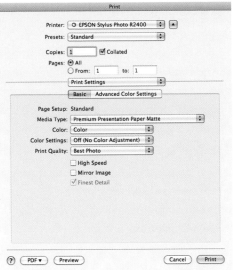

**FIGURE 6.18**
On a Mac, select Print Settings from the
drop-down menu.

**FIGURE 6.19**
Select your paper and print quality and select
Color Settings Off (No Color Adjustment).

Once I have my printer set for a particular paper and layout, I like to create a template with these new configurations to save time in the future. To create a template, navigate to the Template browser and select the Create button under New Template (**Figure 6.20**). Then, name your template and save it to the appropriate folder. Now, every time you wish to print using those exact settings, simply choose the preset and bypass the Print dialog by selecting the Print One button.

**FIGURE 6.20**
Create custom presets for your layouts
and paper settings.

# USING A PRINT HOUSE

Keeping up on the latest in printers, inks, and papers can be overwhelming and expensive, so print houses serve as an excellent way to reduce that investment and leverage the latest in technology. Several outside printers do wonderful work, but most of my experience has been with Mpix (a division of Miller Profession Imaging) and Artistic Photo Canvas (APC). Whatever service you decide to use, make sure it has a good reputation for customer service and a 100 percent satisfaction guarantee backed by either a reprint or money-back policy.

## PRINTS

When I first started printing with Mpix, I uploaded two identical images: one that I color-corrected and one that I had the technicians at Mpix color-correct as part of the company's free service. (Yes, it's called color correction—which includes contrast, density adjustments, and so on—even though they were black-and-whites.) When I received the two images in the mail, I compared them to my computer screen to see how well they matched and recalibrated my monitor to get as close a match as possible.

If your goal is to handle the color-correcting yourself, then it's advisable to speak to a representative of your printer company about calibrating your monitor to its printer. Many shops will send you a calibration system at a very low cost to help you in calibrating to its printers.

In addition, it's always good practice to get a sample of available papers so that you're familiar with the specs of each grade. Finally, don't be afraid to order smaller prints as proofs to make sure you have exactly what you want before you spend a lot of money on a larger print.

## CANVAS

Why limit yourself to traditional prints? Consider using other media. In recent years I've found myself buying more canvas prints of my work than ever before. For me it's about how things look, and a beautiful black-and-white image looks amazing on a large canvas. What I love the most about a gallery wrap canvas is there's no framing necessary (unless you want to, of course). Canvases are very easy to transport, and hanging them is a breeze: Simply find a stud (I'll skip the obvious joke), drive a nail in, and hang up your work.

The day we decided on using the image of the elephants as the cover for this book, guess what I did? That's right! I ordered up a huge 40 x 60 print on canvas from APC that would have been nearly impossible to order on traditional paper. The canvas has the depth and feel I love in a good black-and-white. The shot is now hanging above my couch in the dining room, and it is quite beautiful, if I do say so myself.

# FRAMING

Framing is an art form unto itself. Many standard frames can be purchased at any major retailer, and as long as you've cropped your image using standard aspect ratios, you'll have no problem finding a frame. You can also find a custom framing shop to provide a finished product for either your print or canvas.

An economical method is to create your own custom frames. This works especially well if you have an image that you just don't want to squeeze into a standard crop size, but you also don't want to spend big money on a custom framing shop. In my household this falls under the purview of another department, but here's what I've gleaned from the years of watching.

There are many custom-framing companies on the Internet. We have been successful using American Frame. You can upload the image that you want to frame so that you can see what you are working with when choosing a matching archival mat board, frame color, and size. Once you make your decisions, they will ship it all to you to be assembled.

You can also purchase the tools from the framing company's website or from your local art store, and they will give you the directions for assembly. Instead of glass, these companies will typically ship Plexiglas, which works well, is lightweight, and will not break. However, if you want real glass, you can get custom-cut glass from most hardware stores.

When you are choosing paper to print an image that will be framed, I highly recommend having the image pasted to archival-quality foam core. This will keep the print from wrinkling and stretching, and make it really look great under glass.

Doing your own custom framing takes a little extra work, unless you enlist a handy household member to do it for you, but the end product is very gratifying. It allows you to have total control over the process and saves you money to boot.

## SHARING YOUR IMAGES

One of the things Lightroom 3 has done really well is to integrate image-sharing tools with sites like Facebook, Flickr, and Smugmug. Once set up, these services work like collections; you simply drag your image over to your favorite Publish Services collection and hit Publish when you're done (**Figure 6.21**).

Facebook is an incredibly powerful social media tool, and with well over 600 million members, it's a sure bet that at least a few people you know belong. I have found Facebook to be a great way to promote my business and connect with fellow photographers. Often potential clients will contact me using Facebook's mail system prior to calling or emailing me directly.

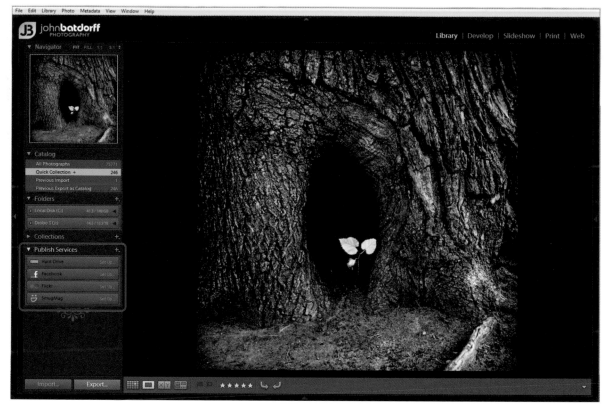

**FIGURE 6.21**
Select your favorite website to upload your images.

If you're starting a photography business or looking to get your feet wet, then a Facebook page is a good place to start. You can check my page out at www.facebook.com/JohnBatdorffPhotography (**Figure 6.22**).

**FIGURE 6.22**
Facebook pages are a great way to promote your art.

Now, let's review how you can post images to your profile:

Click on the Facebook icon under Publish Services (**Figure 6.23**).

Next, we need to authorize Facebook (**Figure 6.24**). You'll need to be logged into the Facebook account for which you wish to grant authorization.

Once Facebook is authorized, you have the ability to make several adjustments to your image prior to uploading. Let's review some of the most important settings (**Figure 6.25**).

**FIGURE 6.23**
Select the Facebook tab to set up.

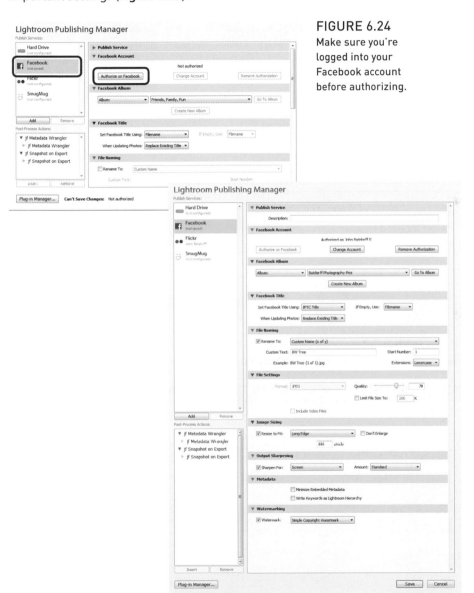

**FIGURE 6.24**
Make sure you're logged into your Facebook account before authorizing.

**FIGURE 6.25**
Make sure to carefully select your settings prior to uploading.

1. Select the album where you wish to share your image, or create a new album by selecting the Create New Album button.

2. Consider renaming your files so that they make sense to the viewer.

3. In File Settings, change the settings as desired. A lot of people worry about image theft, and one way to deter high-quality reproduction is by uploading only lower-resolution images. I like to set Quality between 60 and 80, depending upon the size of the image. You don't want to lose so much quality that your image is grainy and unappealing. You can also limit the size of the file by selecting the Limit File Size feature.

4. In Image Sizing, adjust the settings as desired. This is where we control how large someone will be able to view our image. I recommend experimenting with the sizing to determine what best suits your personal taste. I find for most images, viewing between 500 and 750 is adequate.

5. In Output Sharpening, choose Screen; next to Amount, choose Standard.

6. In the Watermarking pulldown: If you wish, choose Text for Watermark Style, or choose Graphic instead (**Figure 6.26**).

7. Drag an image in from your Library or Filmstrip, place it over in the Facebook collection folder, and select Publish (**Figure 6.27**).

**FIGURE 6.26**
Type your name to create a simple text watermark.

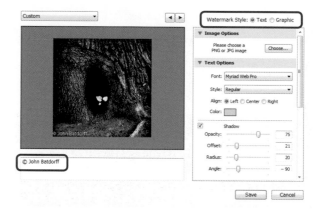

**FIGURE 6.27**
Drag the image you wish to publish to the Facebook collection and press the Publish button.

# WATERMARKS

Watermarks serve the dual purpose of both branding our image and deterring image theft. A common concern among photographers displaying their work online is, "Can someone steal my image?" The answer is yes, and it's a heck of lot easier to steal an image online then to steal a print out of a gallery, but the consequences are the same.

I'll be the first to acknowledge that the only way to avoid image theft online is to avoid posting anything online. However, the Internet is a powerful marketing tool that I am unwilling to forgo. Instead, I suggest taking measures that help protect your images from theft, and a watermark is a great way to do that. Let's create one together.

Before we start making a watermark, we'll need to launch the Watermark editor by selecting Edit Watermarks from the Lightroom menu.

## TEXT WATERMARK

1. Type your name or business name in the bottom left corner, next to the copyright symbol at the bottom page (**Figure 6.28**).

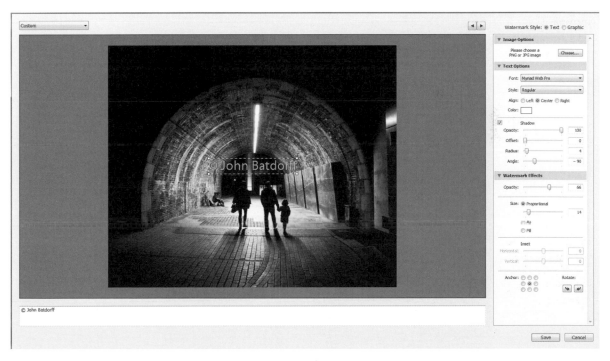

FIGURE 6.28
Use the Watermark editor to customize your watermark.

2. Highlight your name and adjust the font and style. I recommend changing your color to neutral gray, versus the stark white default for black-and white-images.

3. Create drop-shadow effects if desired by using the Shadow controls.

4. Dial back the Opacity for a classier feel—I'm not a big fan of watermarks that shout out your name. Opacity is probably the second most important setting in this group (the Anchor settings are the most critical).

5. Use the Proportional slider to size the watermark.

6. Most important, adjust the Anchor settings to determine the location of the watermark. Those using watermarks solely for purposes of image protection often select the center anchor. When I use a watermark I try to stick to the corners, but then, I'm less concerned with image theft and more concerned with maintaining the integrity of my image.

## GRAPHIC WATERMARK

We also have the ability to use a graphic watermark by choosing PNG or JPG image file options (**Figure 6.29**). This is my preferred method for when I'm looking to brand my name with my image.

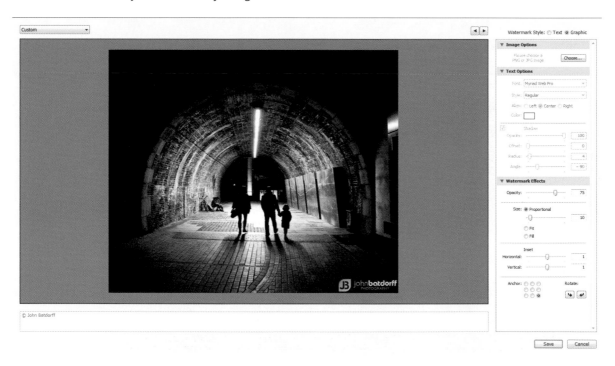

FIGURE 6.29
Using a graphic watermark is a nice finishing touch.

Now, it probably won't come as a surprise to some of you that I'm a horrible graphic designer. I may have an eye for images, but I have a hard time making a logo look good. If you're in the same boat, then making a nice-looking graphic might come as a challenge to you as well. I suggest trading services with a friend, hiring a local graphic artist, or using an online service like LogoMyWay, where hundreds of graphic designers from around the world can compete to create your logo.

## DIGITAL WATERMARK

My preferred method for deterring image theft is using digital watermarks. Digital watermarks embed a unique set of data into your image identifying you as the owner of the photograph. When someone downloads your image or takes a screen-shot, your information is still in place even if they try to manipulate the image.

The benefit for me is that the ownership follows the image so that even if someone crops or clones out my logo, the Digimarc embedded information is still in place. Also, you can't easily see the watermark, so the integrity of my image is maintained. The watermark plug-in comes with Photoshop, but to activate it you'll need to be a Digimarc customer. Here's a quick run-through on how I embed watermarks in blog images:

1. Resize your image before applying the watermark—this is important. I usually do this when exporting out of Lightroom and into a folder labeled Blog.

2. Next, open the image with Photoshop.

3. Select Filter, drop down to Digimarc, and select Embed Watermark (**Figure 6.30**).

FIGURE 6.30
Select Embed Watermark.

4. The Embed Watermark pop-up screen will be displayed, where you can set Watermark Durability, Copyright Year(s), and image attributes such as Do Not Copy. I find that using 3 or 4 for Watermark Durability provides excellent security (**Figure 6.31**). The higher the number, the more visible the mark may be in areas of continuous tones, such as skies. You'll want to monitor this and adjust according to personal preference.

5. Click the OK button and the watermark filter will embed the image. Once that's completed, a pop-up box will notify you of the watermark's strength, along with image attributes (**Figure 6.32**).

FIGURE 6.31
Set Watermark Durability and press OK.

FIGURE 6.32
Check the pop-up box for accuracy.

Now your ownership information and restrictions are digitally embedded in your image. Another cool benefit of this service, although it costs a little extra money, is that Digimarc will scour the Internet looking for websites that are using your images. You can log in to your Digimarc account and run reports to see if your images are being used by any unauthorized sites. It's a pretty slick system for those of us who are a tad on the paranoid side.

## KEEPING IT ALL IN FOCUS

We've covered a lot of ground over the last six chapters, discussing color theory, composition, equipment, and postprocessing, and finishing up with how to share our images. All of these things we discussed are crucial ingredients to making a beautiful black-and-white image.

But beyond all this theory, practical know-how, and postprocessing magic, I have not yet mentioned the most important ingredient of all: honesty. For me, a good black-and-white image tells me as much about the photographer as about the image

itself. It's a two-way mirror. Keep it sincere and stay true to yourself, and you'll find a style that honestly reflects you—the artist—in every image.

Now go shoot and have some fun!

# Chapter 6 Assignments

### Perceptual Versus Relative Rendering

Make sure your printer is loaded with your favorite black-and-white paper. Set up your print job and change Rendering Intent to Perceptual. Once that sheet has finished printing, mark the back with a P. Next, go back to your print job and switch Rendering Intent to Relative. Once the sheet has finished printing, mark it with an R for future reference. Now, compare the prints and determine which rendering technique provided the best outcome.

### Create a Watermark

Using the Watermark editor, create a textural watermark and save it as a preset for later use.

### Start Marketing Your Work

If you've been considering starting your own photography business, there's no better way to start marketing yourself than on Facebook. Don't sell yourself short; five years ago I took the plunge and never looked back. Create a Facebook profile for your business and start sharing your photos using Lightroom's Publish Services feature.

### Calibrate Your System for a Print House

If you don't want to hassle with deluxe printers, inks, and papers, then consider outsourcing your printing. Talk to fellow photographers and local camera stores for suggestions on outside print services. Most important, once the honeymoon begins with your new printing service, run some tests and calibrate your system so that you know what to expect when you receive your work.

*Share your results with the book's Flickr group!*

*Join the group here: www.flickr.com/groups/blackandwhitefromsnapshotstogreatshots*

# INDEX